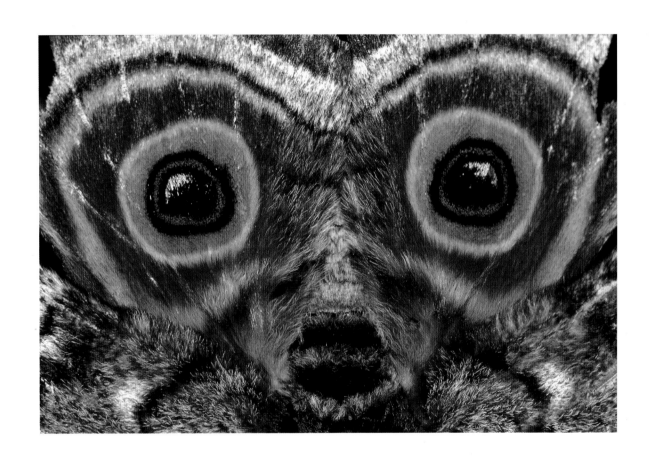

Wildlife Photographer of the Year

Portfolio 15

Wildlife Photographer of the Year

Portfolio 15

BOOKS

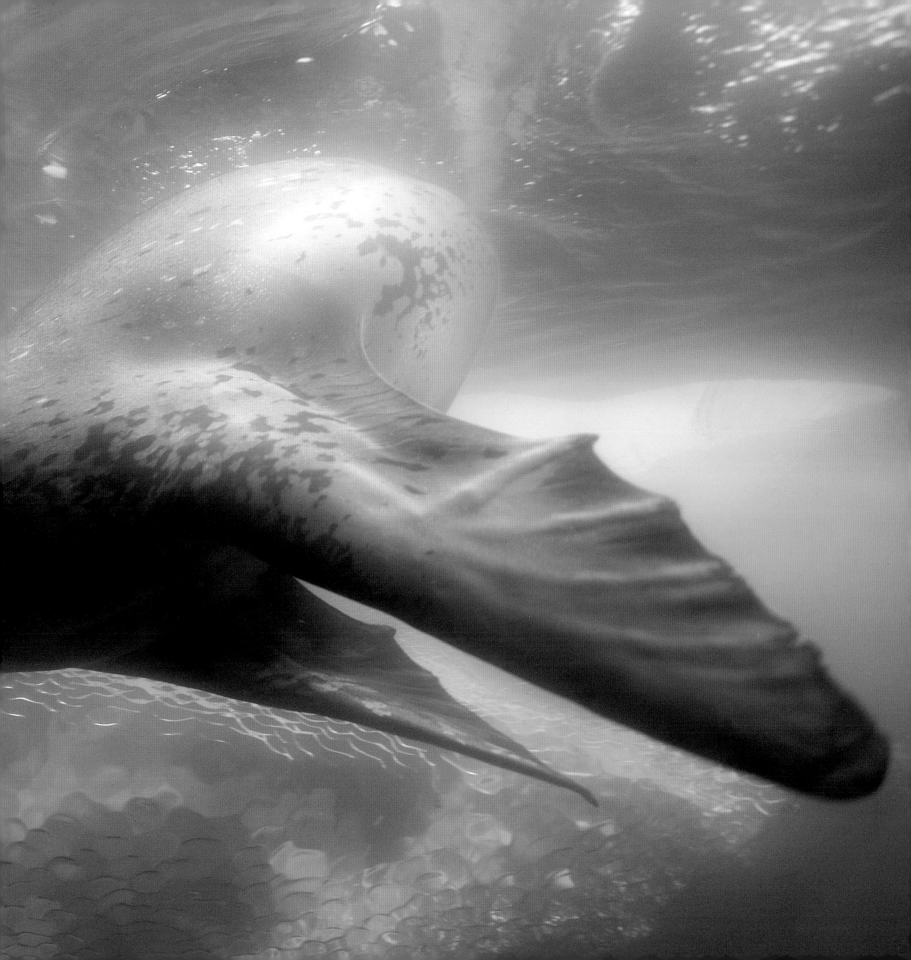

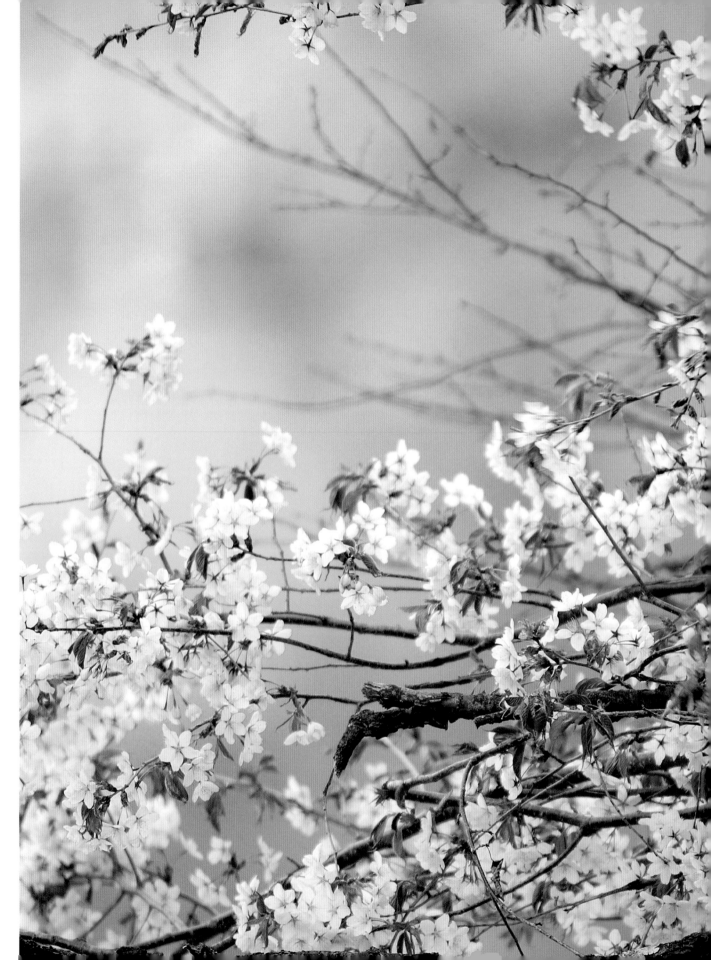

Published by BBC Books
BBC Worldwide Limited
80 Wood Lane
London W12 0TT

First published 2005

Managing editor
Rosamund Kidman Cox
Designer
Simon Bishop
Caption writers
Rachel Ashton
Tamsin Constable
Production controller
David Brimble
Competition manager
Deborah Sage
Competition officer
Gemma Webster

ISBN 0563 52278 X

Colour separations by
Butler & Tanner Origination
Printed and bound in
Great Britain by
Butler & Tanner Limited

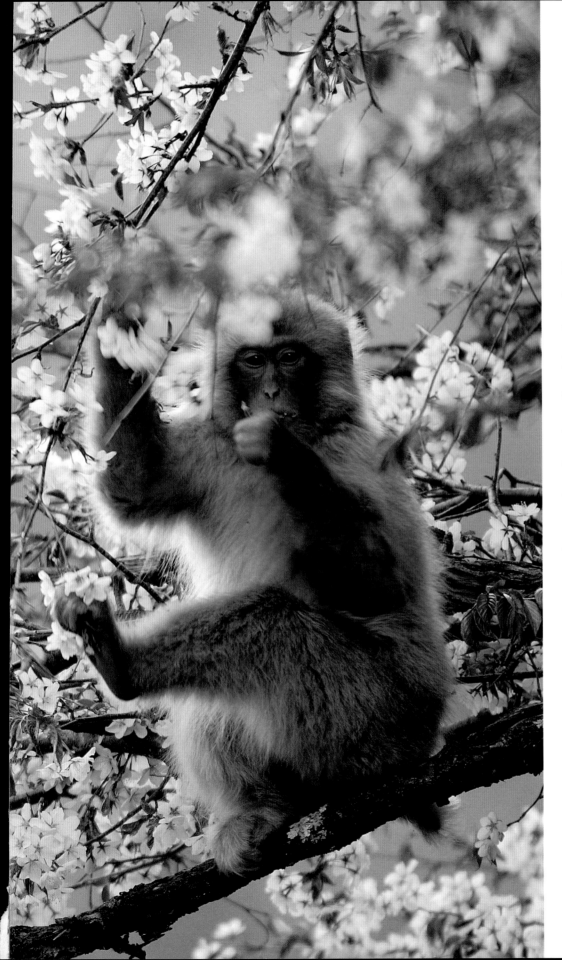

Contents

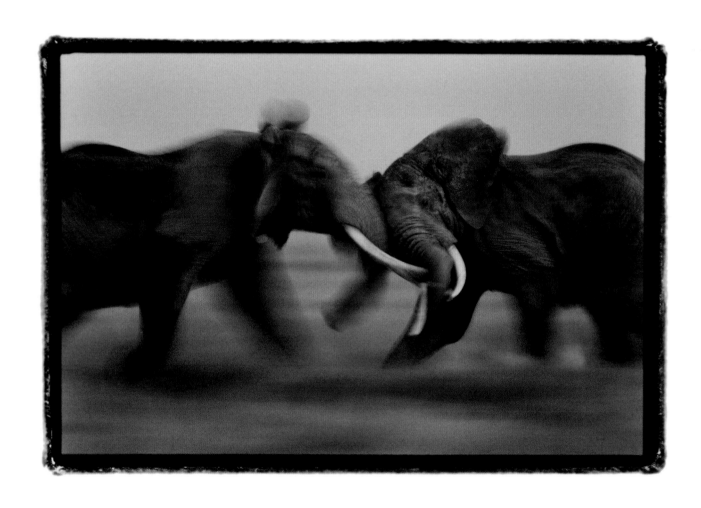

Foreword

by Art Wolfe

It is no wonder that the rise of the environmental movement began in earnest with the launch of the space programme. The image of our fragile, blue Earth floating in limitless space is a compelling one. There are no international boundaries; we are simply one globe hovering in the void – there are no second chances and nowhere else to go. In itself, this should provoke us into acts of conservation. From making the decision to buy local, organic produce to setting up an environmental foundation, each act is important, no matter how small or large. As a nature photographer, I feel both obliged and challenged to elicit this response from people.

The centre of a nature photographer's work is the environment. Whether the depiction is natural beauty or human degradation, nature photographs are essentially political documents. These photos have power, sometimes hidden and, some would say, even subversive against the political status quo, which supports and is succoured by big-business interests. Unlike any other medium, photographs have the ability to energise the public. Moved by an image of an oil spill along the California coast, a group of lawyers started an environmental organisation in 1969 that has since grown into the Natural Resources Defense Council –

one of the largest and most successful in the United States.

Photography allows millions a glimpse of nature that most will sadly never see in person. Through photography we can study and ultimately save struggling species and the landscapes they inhabit. Exposure to nature images helps us identify with species and engage with the planet – reminds us of our dependencies and interactions, that we cannot think of ourselves as separate, unnatural entities.

We are part of the whole system – a troublesome part – and we cannot keep ourselves out of nature. When we hurt it, we hurt ourselves, but when we care, we consciously make better choices for the environment and for our communities. Photography may not make the problems we face less overwhelming, but as both art and commentary, it lessens the abstraction of habitat and species loss.

Can nature photographers do a better job? Of course. There is always a tendency to rest on one's laurels and sink into conservatism with how and what we shoot. We need to stay fresh and aim for the shot that really matters – the shot that goes beyond our previous visions of certain locations, animals or indigenous human cultures. Just as photographers have a duty to expand the viewer's

horizons and to reflect the natural diversity in the world, so publications also have a responsibility to place value on work from underexposed areas. Nearly two million species have been named, with more to be discovered. As a nature photographer since I was a teenager, I have barely scratched the surface, photographing maybe a thousand or so species. When the public sees a constant stream of imagery from the same places of the same animals, it may begin to feel that these are the only ones worth saving.

Saving nature has always been exhilarating, frustrating and controversial. It is becoming more so as conservation is increasingly in conflict with ideas of social justice, human rights and economic aspirations. Nature photographers help lift environmental activists and their organisations, give them representation through association in books and other products, direct people to them and even provide a blueprint for activism.

As I've made a living from my interest in the natural world, so I feel a need to put more of my energy back for the benefit of the environment. I want to capture the imagination with a photograph. I try to dazzle my audience with extreme beauty, places that are unseen. And each time I go out, I try to do it that little bit better.

The competition

This is a showcase for the very best photography worldwide featuring natural subjects. It is organised by two UK institutions that pride themselves on revealing and championing the diversity of life on Earth – the Natural History Museum and BBC Wildlife Magazine.

Its origins go back as far as 1964, when the magazine was called Animals and there were just three categories and about 600 entries.

It grew in stature over the years, and in 1984, BBC Wildlife Magazine and the Natural History Museum joined forces to create the competition as it is today, with the categories and awards you see in this book.

Now there are an average of 20,000 entries, and exhibitions touring through the year, not only in the UK but also worldwide, from the US, the Caribbean and South Africa, through Europe and across to China, Japan and Australia. As a result, the photographs are now seen by millions of people.

The aims of the competition are
- to be the world's most respected forum for wildlife photographic art, showcasing the very best photographic images of nature to a worldwide audience;
- to inspire a new generation of photographic artists to produce visionary and expressive interpretations of nature;
- to use its collection of inspirational photographs to make people worldwide wonder at the splendour, drama and variety of life on Earth;
- to raise the status of wildlife photography into that of mainstream art.

The judges put aesthetic criteria above all others but at the same time place great emphasis on photographs taken in wild and free conditions, considering that the welfare of the subject is paramount.

Winning a prize in this competition is something that most wildlife photographers, worldwide, aspire to. Professionals do win many of the prizes, but amateurs succeed, too. And that's because achieving the perfect picture is down to a mixture of vision, luck and knowledge of nature, which doesn't necessarily require an armoury of equipment and global travel, as the pictures by young photographers so often emphasise.

Wildlife photographer of the year

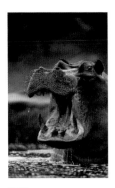

1991
Frans Lanting

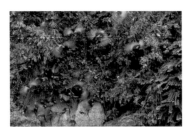

1992 André Bärtschi

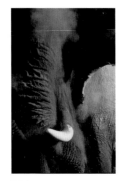

1993
Martyn Colbeck

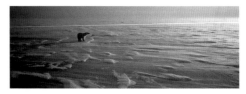

1994 Thomas D Mangelsen

1995
Cherry Alexander

1996
Jason Venus

Past award-winners

Organisers

NATURAL HISTORY MUSEUM

Home to a world-class natural history collection, a leading scientific research institution and one of London's most beautiful landmarks, the Natural History Museum is also highly regarded for its pioneering approach to exhibitions, welcoming this year nearly three million visitors of all ages and levels of interest.

Wildlife Photographer of the Year is one of the museum's most successful and long-running special exhibitions, and it is proud to have helped make it the most prestigious competition of its kind in the world. The annual exhibition of award-winning images attracts a large audience who come not only to admire the stunning images, but also to gain an insight into important global concerns such as conservation, pollution and biodiversity – issues at the heart of the museum's work.

In 2002, the museum opened Phase One of the Darwin Centre, a significant new development that reveals for the first time the incredible range of its collections and the scientific research they support. Phase Two is scheduled to open in 2008. Both the Darwin Centre and Wildlife Photographer of the Year celebrate the beauty and importance of the natural world and encourage visitors to see the environment around them with new eyes.

Further information
Visit www.nhm.ac.uk for further information about activities. You can also call +44 (0)20 7942 5000, email information@nhm.ac.uk or write to: Information Enquiries, The Natural History Museum, Cromwell Road, London SW7 5BD.

BBC Wildlife MAGAZINE

BBC Wildlife Magazine is the UK's leading monthly magazine on nature and the environment. It prides itself on world-class photography and the best and most informative writing of any consumer magazine in its field. The contents include photographic portfolios, the latest biological discoveries, insights, views and news on wildlife, conservation and environmental issues in the UK and worldwide and a monthly illustrated guide to natural history you can see for yourself.

The magazine's aim is to inspire readers with the sheer wonder of nature and highlight our dependence on it, and to present them with a view of the natural world that has relevance to their lives.

It has been an organiser of the competition since 1964, when it first began, publishing all the winning pictures and showcasing more work by the world's best photographers.

Further information
BBC Wildlife Magazine,
Origin Publishing,
14th Floor, Tower House,
Fairfax Street,
Bristol
BS1 3BN
wildlifemagazine@origin
publishing.co.uk

Subscriptions
Tel: +44 (0) 870 4447013
Fax: +44 (0) 870 4442565
wildlife@galleon.co.uk
Quote WLPF05 for the latest subscription offer.

Judges

Frances Abraham
Picture researcher

Simon Bishop
Art editor, *BBC Wildlife* Magazine

Lewis Blackwell
Group creative director, Getty Images

Mark Carwardine
Zoologist, writer and photographer

Ceri Crump
Picture editor, *BBC Wildlife Magazine*

Laura Goodchild
Picture editor

Rob Jordan
Wildlife photographer

Rosamund Kidman Cox
Editor and writer

Tim Parmenter
Special projects manager, the Natural History Museum

John Norris Wood
Professor of natural history illustration and ecological studies

Kevin Schafer
Wildlife photographer and author

Jan Töve
Landscape photographer

Vickie Walters
Picture researcher

Art Wolfe
Nature photographer

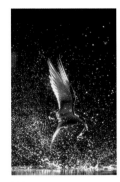

1997
Tapani Räsänen

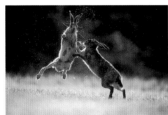

1998
Manfred Danegger

1999
Jamie Thom

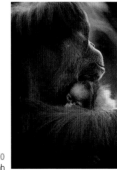

2000
Manoj Shah

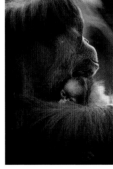

2001
Tobias Bernhard

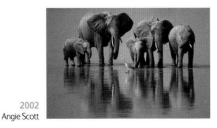

2002
Angie Scott

2003
Gerhard Schulz

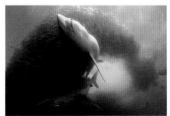

2004
Doug Perrine

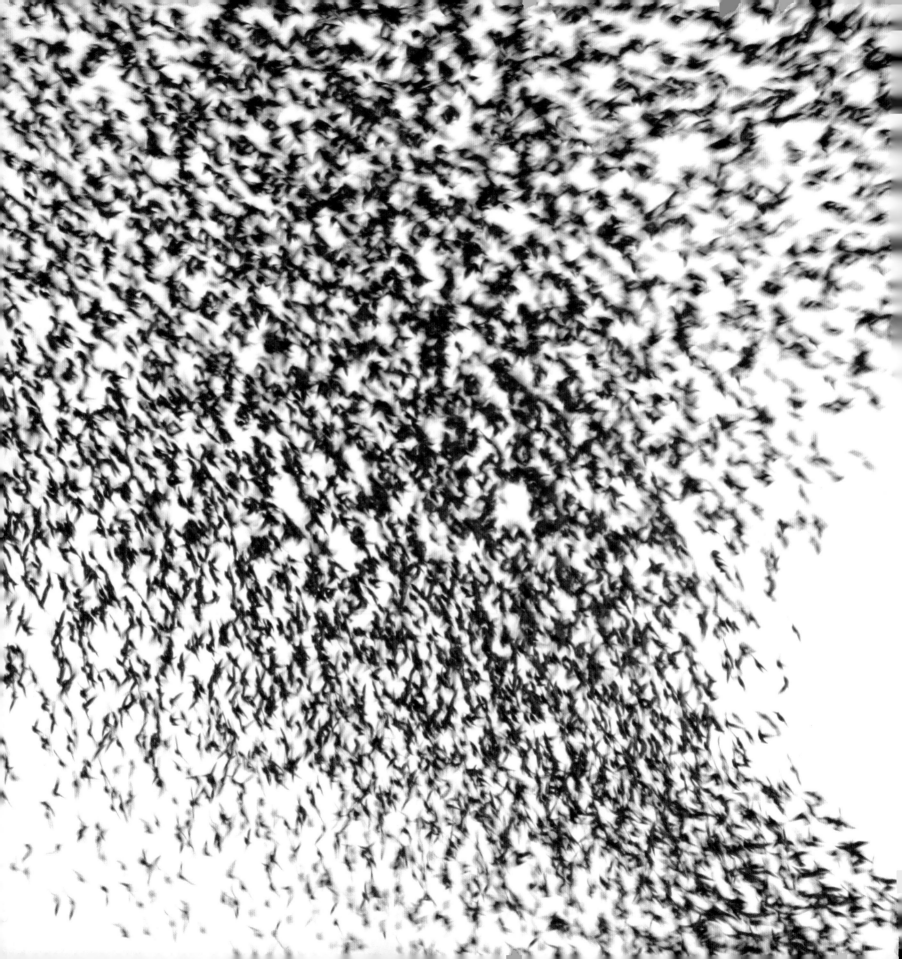

Wildlife Photographer of the Year Award
Manuel Presti

This is the photographer whose picture has been voted as being the most striking and memorable of all the competition's entries. The award-winner receives a big cash prize and the coveted title Wildlife Photographer of the Year.

Until he was 16, Manuel's most treasured possession was a pair of binoculars. Then his father gave him his first camera. He has been photographing wildlife ever since, inspired by his grandfather's and mother's love of nature, and his pictures have been published widely. Though he has a doctorate in engineering, his passion is still wildlife photography: "It's a way to find harmony and peace. I also learn a lot about life through observing animals – it reminds me that we are animals, too, and should respect our fellow creatures." He was born in Rome, and after working abroad has returned to Italy. His aim is to use photography "to move emotions and so lead people towards a greater sensitivity to the natural world."

SKY CHASE
Thousands upon thousands of starlings, pursued by a peregrine – but it's more than that. It's a picture that morphs from an instant moment of action to an abstract creation – from iron shavings being swept by a magnet to sardine slicks being hounded by sharks. Every sunset in winter, such huge flocks of starlings swirl over a small city park in Rome as they prepare to roost. And every evening, the resident pair of peregrines dive-bombs the flocks. The show finally finishes when the starlings disappear into the trees at around 5.30pm. Manuel became absorbed with the dynamics between these huge gatherings and the peregrines. "When the falcon plunges into the flock," he says, "the countless starlings spread in all directions to confuse the predator. Killings are sporadic: some evenings a couple of birds, other evenings none at all."
(See also page 40.)

Innovation Award
Michel Loup

This award exists to encourage innovative ways of looking at nature. It is given for the photograph that best illustrates originality of both composition and execution.

For many years, Michel has travelled the world, working as a photographer, but he has finally returned to the countryside he loves best – the mountainous region of Jura in eastern France. Water and light and the interplay between them are what inspire him and have led to a recurring theme in his photography and in the two books of his nature photographs. It has also led him to explore under water, mainly in the lakes of Jura and in rivers in Bresilian, in a quest to reveal the nature of life below the surface.

RIVER OF DREAMS
Wandering alongside the Hérisson river on a warm June day, through the beautiful eastern French countryside, close to the lakes of Jura, Michel came across this stretch of river and was drawn to the scene's absolute tranquillity. The water was as still as glass, and rays of the noonday sun overhead were filtering down through the dense beech foliage, bathing the riverbed in golden light. With a careful choice of angle, exposure, frame and focus, he set out to contrast darkness and light and merge actuality with reflection, to create a multidimensional sense of space that would conjure up the magic of the moment.

Nikon F5 with 80-200mm lens; 1/8 sec at f11; Fujichrome Velvia 50; tripod.

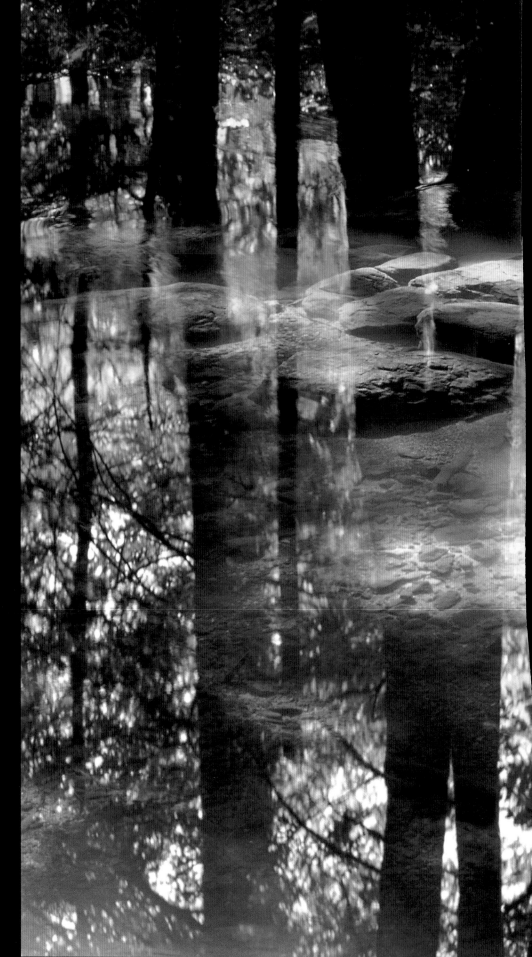

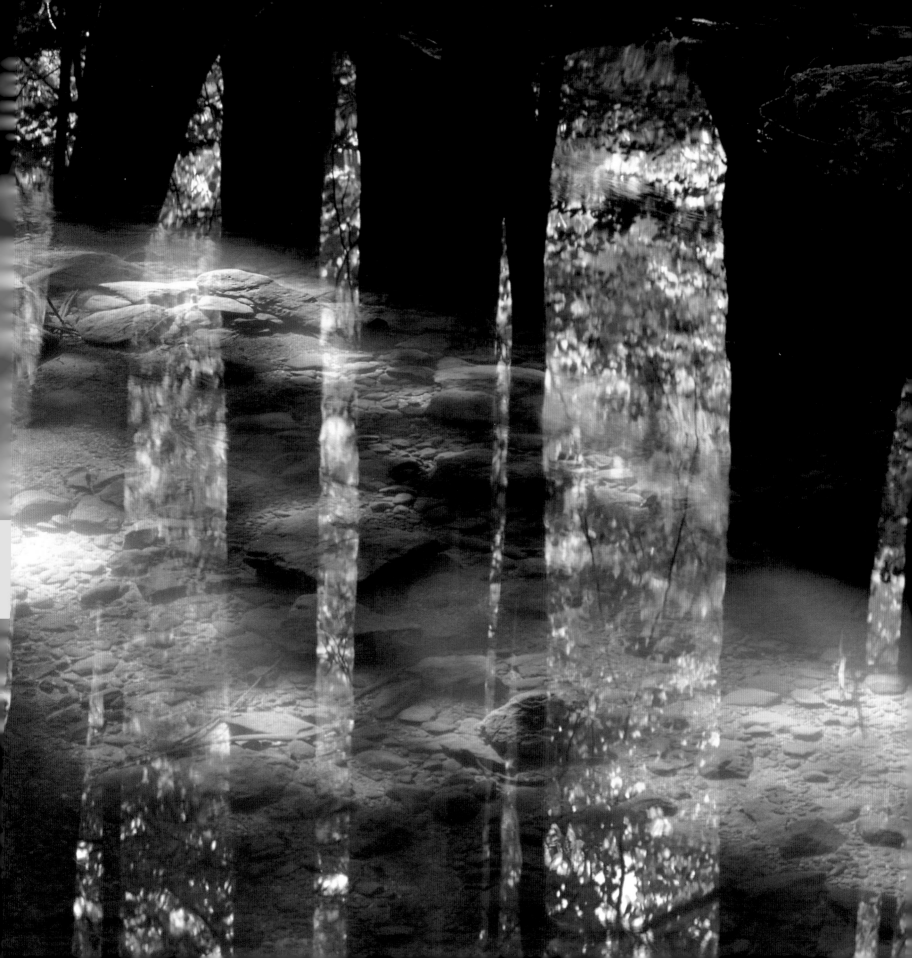

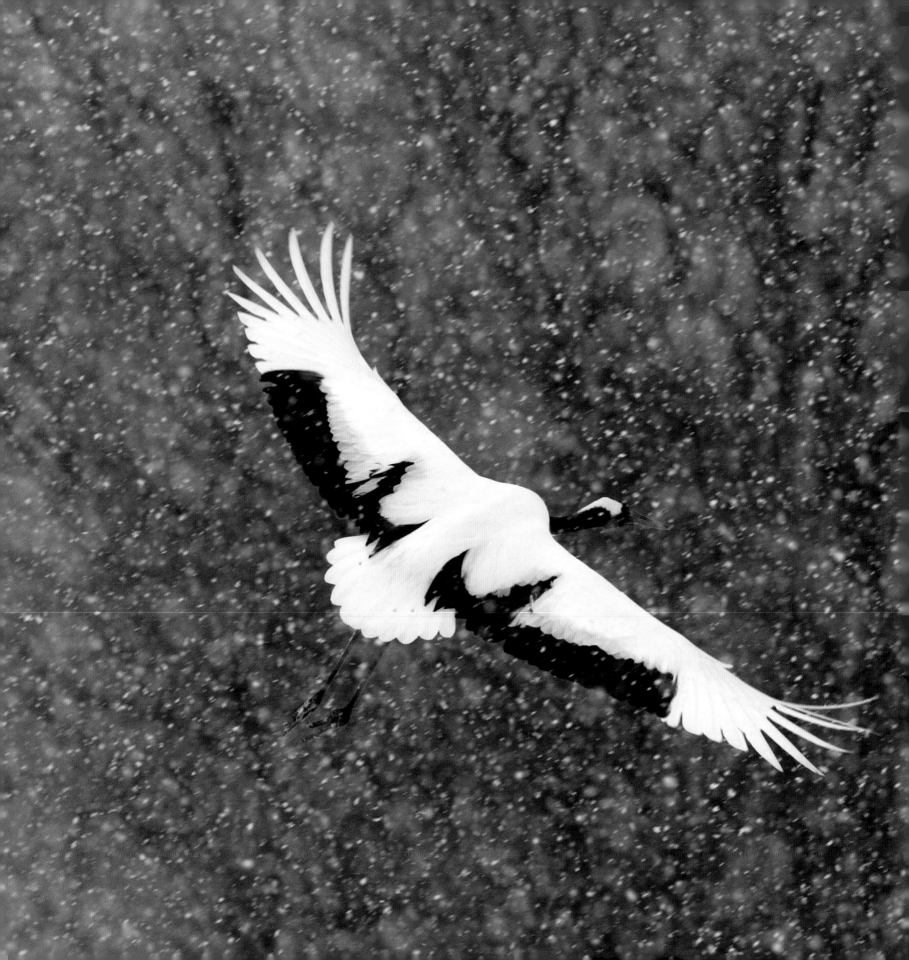

Gerald Durrell Award for endangered wildlife

This award commemorates the late Gerald Durrell's work with endangered species and his long-standing involvement with the competition. The subject is species that are critically endangered, endangered, vulnerable or at risk (as officially listed in the IUCN Red List of Threatened Species).

 WINNER

Martin grew up in the countryside in Germany in close contact with nature. He soon became an active member of conservation groups and started his career leading bird tours, teaching participants to identify the birds by their calls. Photography was a natural extension of his love of wildlife. With his pictures, he aims to show the true nature of his wild subjects and to inspire people to "keep their eyes and their minds open to nature for longer than just a glimpse." To achieve his aim, he first tries to get as deep an understanding of the animal as possible and then approach it in such a way that his presence is accepted. "Only by doing that," he says, "can you capture truly intimate moments in their lives, whether peaceful or dynamic."

Martin Eisenhawer
Germany

CRANE SNOWFLIGHT
The endangered red-crowned crane is found only in north-eastern Asia and is resident only in Japan, chiefly on the northern island of Hokkaido. Here the population numbers about 900 birds – up from just 20 in the early part of the past century, thanks to the establishment of feeding sites. Martin watched the cranes at a winter feeding ground. As dusk fell, they would leave for a safe roosting area nearby. "Most of the time, they went off in troops," says Martin, "but what I wanted was a solo flight, and I spent days waiting for snow and a grey sky as a setting for the crane's beautiful plumage." The bonus for his patience was the background pattern of outstretched tree branches, "adding to the sense of mystery I wanted to create."

Canon 1D mark II with Canon 500mm f4 IS lens; 1/250 sec at f7.1; 320 ISO; fluid-head tripod.

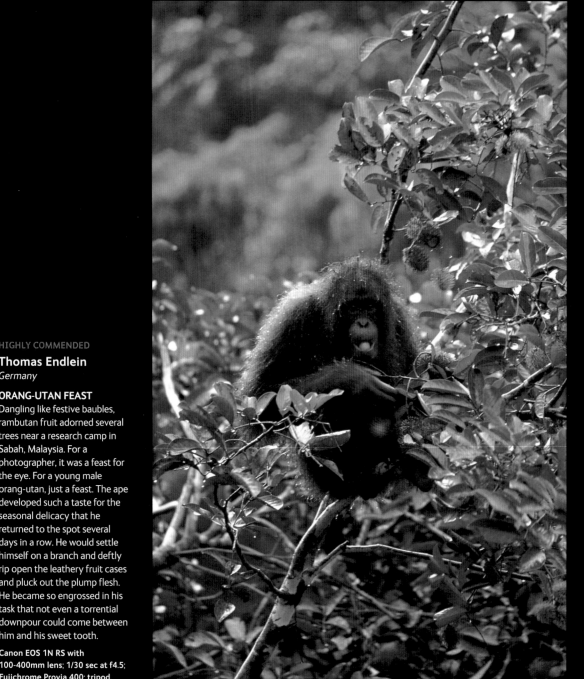

HIGHLY COMMENDED
Thomas Endlein
Germany

ORANG-UTAN FEAST

Dangling like festive baubles, rambutan fruit adorned several trees near a research camp in Sabah, Malaysia. For a photographer, it was a feast for the eye. For a young male orang-utan, just a feast. The ape developed such a taste for the seasonal delicacy that he returned to the spot several days in a row. He would settle himself on a branch and deftly rip open the leathery fruit cases and pluck out the plump flesh. He became so engrossed in his task that not even a torrential downpour could come between him and his sweet tooth.

Canon EOS 1N RS with 100-400mm lens; 1/30 sec at f4.5; Fujichrome Provia 400; tripod.

HIGHLY COMMENDED
A L Harrington
UK

WOLF PATROL AT EASE

Ethiopian wolves have virtually identical cream-on-rust coat patterns, which makes life difficult for wildlife researchers trying to identify individuals in the remaining packs of these highly endangered canids. Even after three weeks photographing this trio in the Bale Highlands, Andrew couldn't tell them apart. The way the wolves' bodies are turned towards each other, though, speaks volumes about their strong social bonds. Alert but relaxed, they were taking a break from their dawn patrol to watch the Land Cruiser Andrew had hired, which had become stuck in a bog. Andrew took advantage of their curiosity to take a shot showing the wolves blending into their habitat, while at the same time revealing their striking cream markings. As soon as the Land Cruiser moved away, the wolves trotted off in separate directions to hunt alone, fox-like, for rodents.

Nikon F5 with 500mm lens; 1/125 sec at f4; Fujichrome Provia 100.

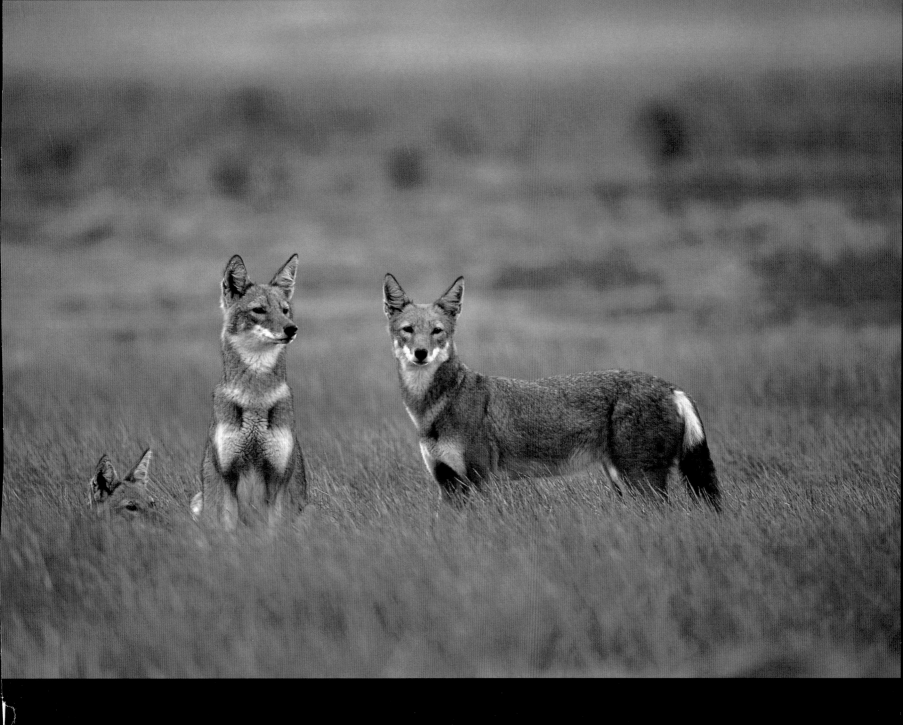

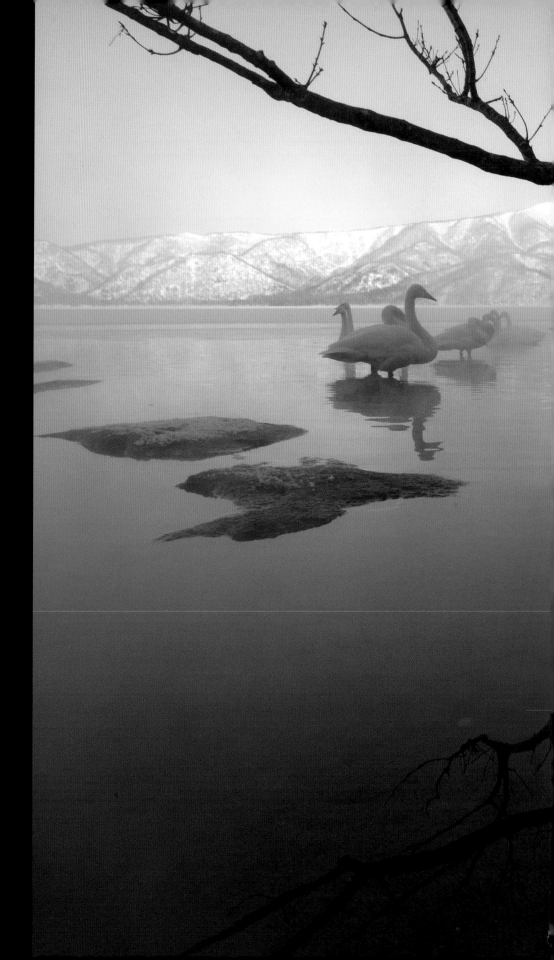

Animals in their environment

In this category, a photograph must convey a sense of the relationship between the plant or animal and its habitat, which must be as important a part of the picture as is the subject.

 WINNER

Martin Eisenhawer
Germany

**WHOOPER SWANS
AT DAWN**
In February, temperatures in Hokkaido, Japan, can plunge to -20˚C (-4˚F). Overwintering swans (migrants from Scandinavia) therefore seek out thermal lakes, where there are always patches of melted ice. Martin wanted to frame the peaceful, misty scene with an overhanging branch and its reflection and spent a long time trying to find the ideal spot. Having found his viewpoint, he had to bend over the water and wait in this position until the cold wind dropped for a moment, the swans settled down and the water was mirror-smooth enough to create the picture he had visualised.

Canon 1D mark II with Canon 17-40mm lens; 1/60 sec at f16; 200 ISO.

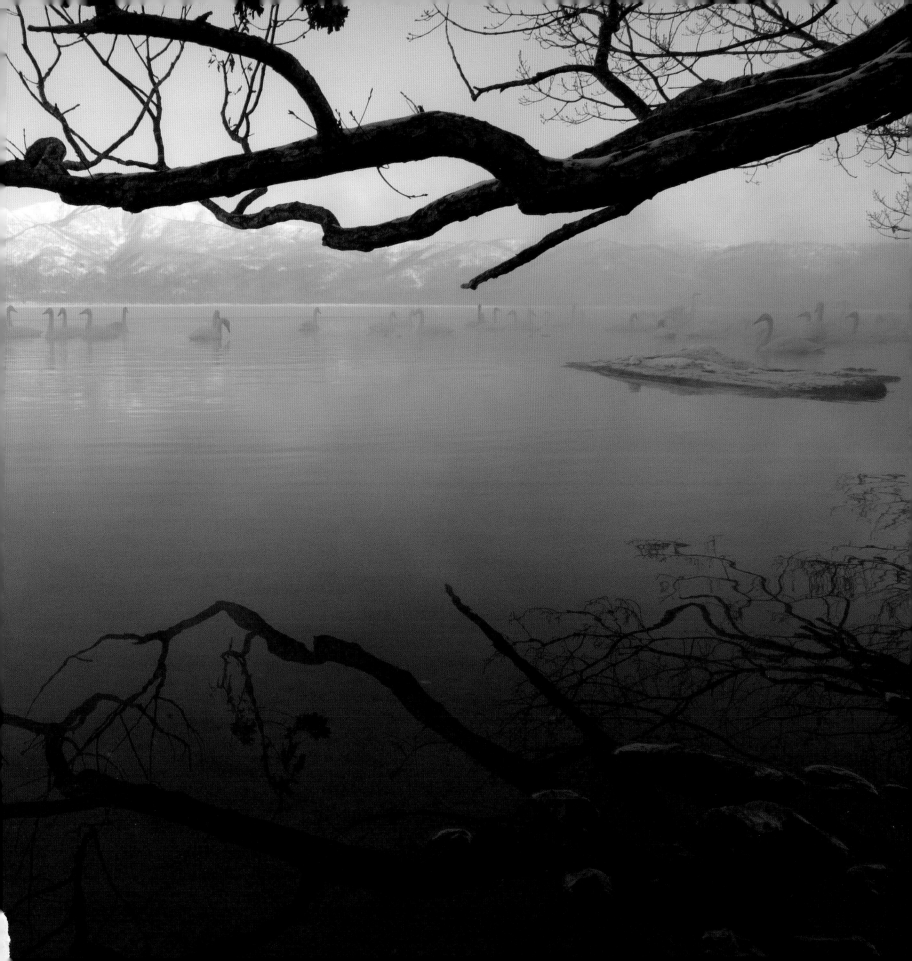

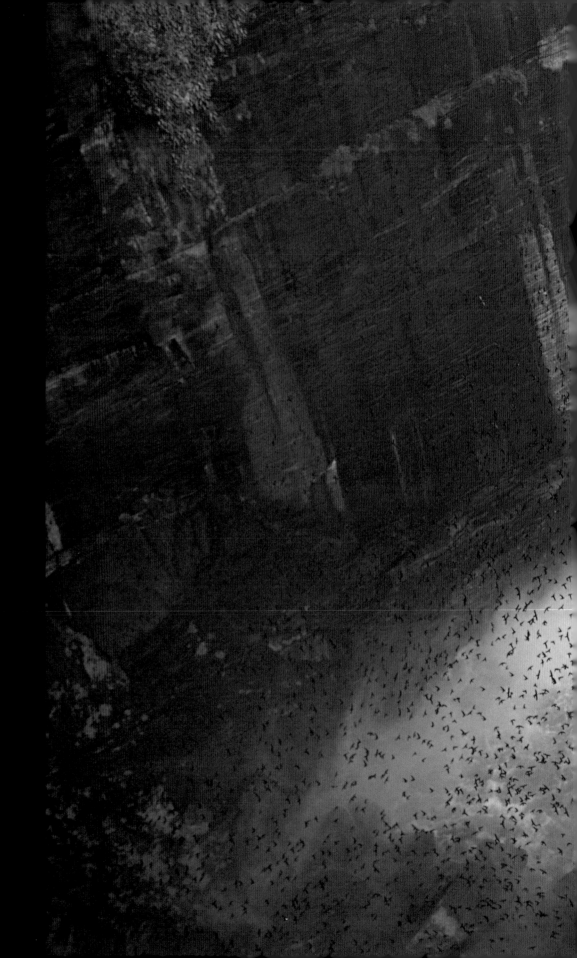

 RUNNER-UP

Sérgio Brant Rocha
Brazil

SWIFTS ASCENDING
Sérgio regularly gazed down at this giddy sight as he flew over the Aripuanã river on his way to and from a project in the Brazilian Amazon. Here at the Dardanelos Falls, the river plunges into a churning canyon 130 metres (426 feet) deep. Thousands of great dusky swifts dart in and out of the thundering water, nesting and sleeping on the vertical rocky walls behind. To negotiate the falls, says Sérgio, "they move in columns, descending and ascending vertically when they change perches on the walls." The aerial perspective created something of a trompe l'œil – the water itself seeming to froth with swifts – and a truly extraordinary picture.

Nikon F4s with Nikon 180mm f2.8 ED-IF lens; 1/1000 sec; Fujichrome Velvia 100.

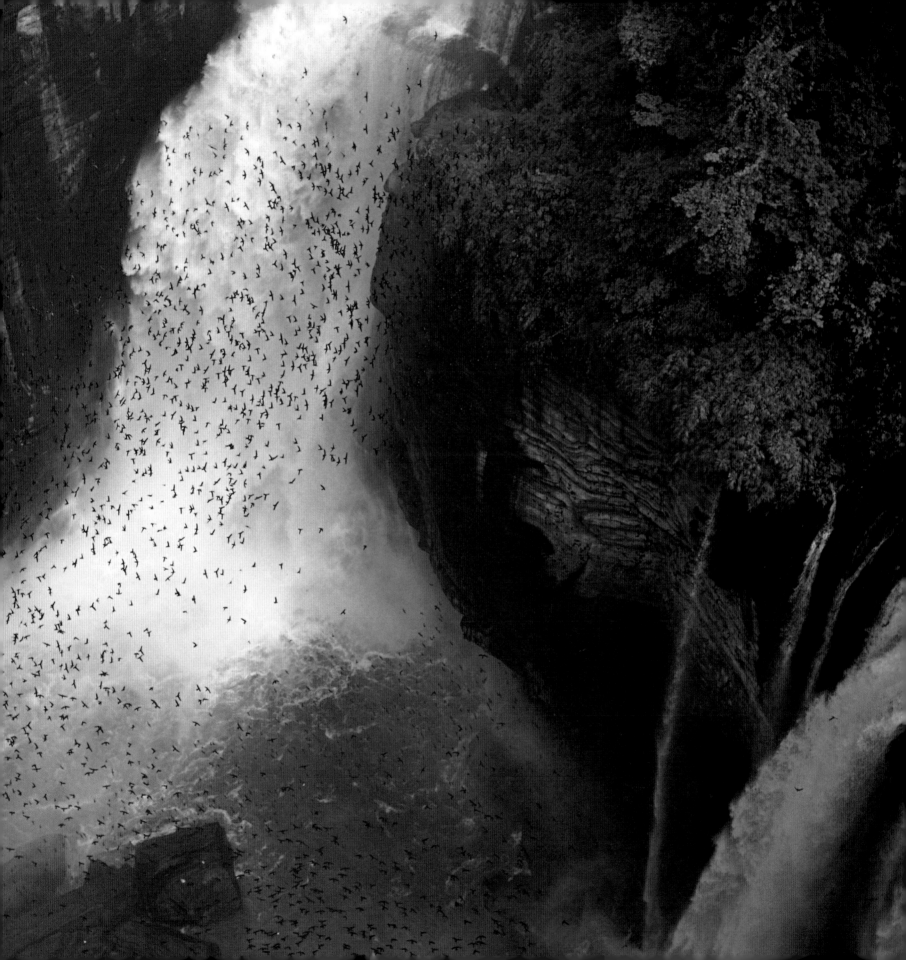

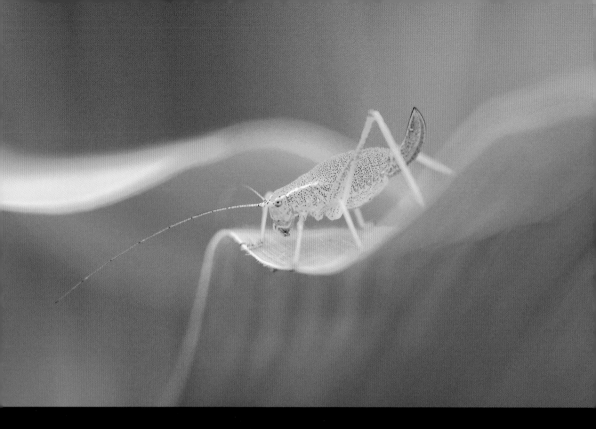

Frédéric Réglain
France

BUSH CRICKET POSE

Hunting for insects in a huge field of maize in northern France, Frédéric was excited to spot this superbly camouflaged bush cricket in the ocean of green. Despite being fairly common in Europe, speckled bush crickets are difficult both to see and to hear, with calls that are barely audible to humans. This young female waited patiently while Frédéric took her portrait, watching him all the while. He framed her among the leaves, using their curves to mirror the sweep of her antennae and her scimitar-shaped, egg-laying ovipositor.

Canon EOS 10D with macro Sigma 105mm f2.8 lens; 1/40 sec at f5.6; 400 ISO

HIGHLY COMMENDED

Thomas Endlein
Germany

ORANG-UTAN IN THE RAIN

It started out as a lopsided relationship – the human, Thomas Endlein, doing the photographing, the orang-utan being photographed. But one misty morning, nature made equals of these two apes. Thomas had spent many hours perched on a small wooden observation platform at the top of a huge dipterocarp tree in Sabah, Borneo. Orang-utans regularly rambled through the nearby canopy, swinging from impossibly thin lianas to reach fruit. But on this morning, there was a heavy downpour. "I had a feeling of companionship," Thomas said. "We waited together at the top of our respective trees, both of us soaked to the skin. Two intelligent primates at the mercy of the elements."

Canon EOS 1N RS with 100-400mm lens; 1/30 sec at f4.5; Fujichrome Provia 400; remote-control release, tripod.

Hans Wolkers
The Netherlands

CAVE BEAR

Bears have personalities. It just takes a while to get to know them. When the salmon migrate up the rivers in South-east Alaska and the bears gather to feed on them, it's the big, bold bears that are usually photographed. Hans spent a week watching bears fishing, but the one that really caught his eye was a shy black bear. His first sighting of it was a glint among the rocks – a wet nose as the bear peeked out. Once the male was sure that there were no other, more dominant bears around, he crept out, rushed down to the river, snatched a salmon and then bounded back to his cave to eat it in safety.

Canon EOS 1V HS with 500mm f4 lens and 1.4x extender; 1/30 sec at f8; Fujichrome Velvia 50 rated at 80; tripod.

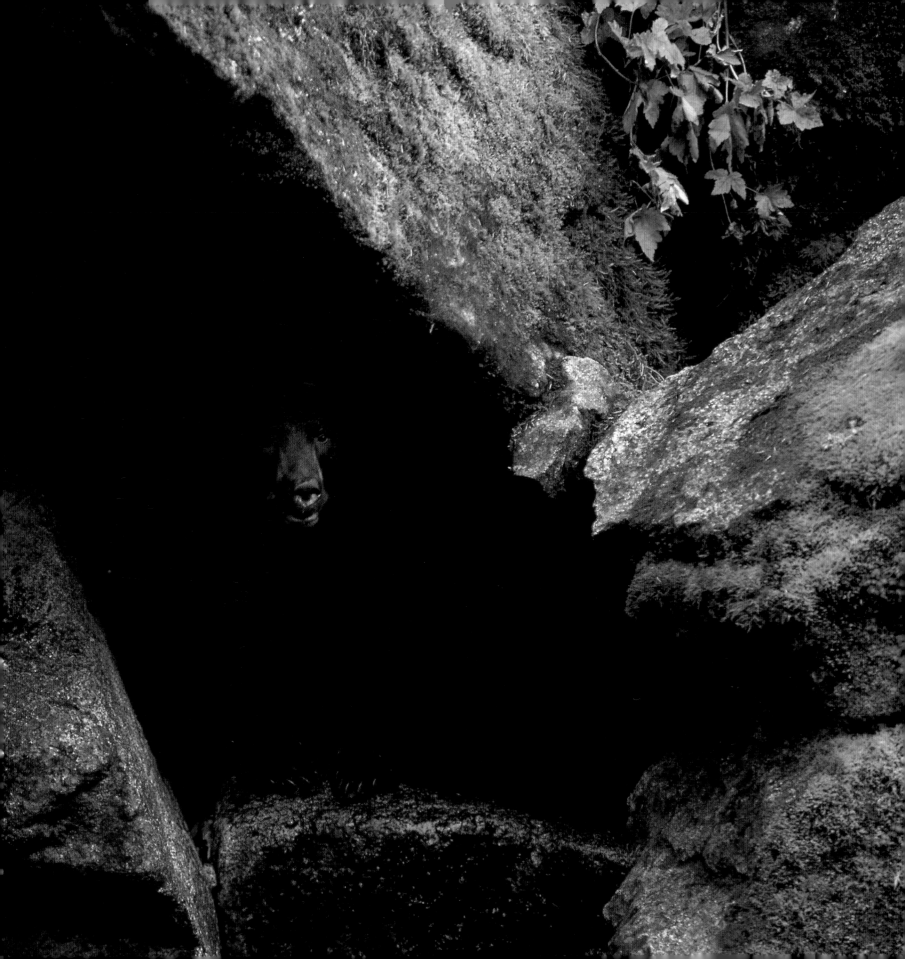

Todd Pusser
USA

DOLPHIN SEASCAPE
Todd had travelled to the
Bahamas to photograph a
well-studied population of wild
Atlantic spotted dolphins.
On this particular day, the ocean
stretched out so smoothly you
could even appreciate the curve
of the Earth's horizon. A group
of dolphins approached the
boat and started to bow-ride.
Standing on the bow, Todd
photographed this one in
the clear water as it circled
round to join the group, taking
as wide a view as possible to
place the dolphin within the
vast seascape.

Canon EOS 3 with 17-35mm lens;
1/500 sec at f8; Fujichrome Provia
100F; polariser.

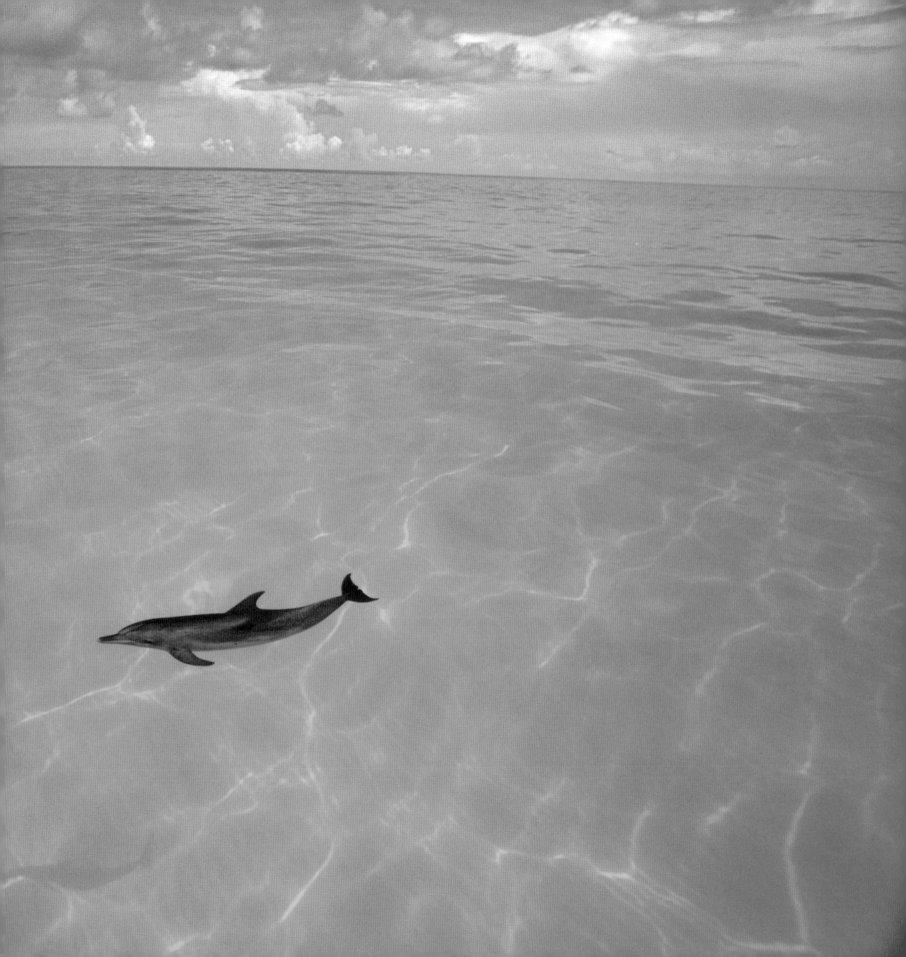

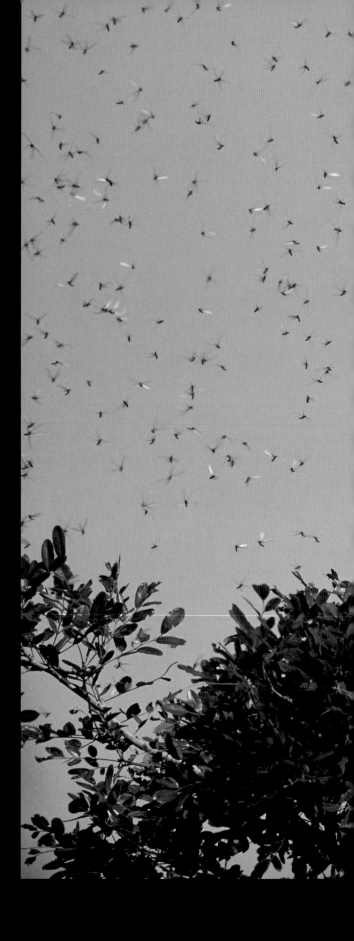

Animal
behaviour
Mammals

These photographs are selected for both their interest value and their aesthetic appeal, showing familiar as well as seldom-seen behaviour.

 WINNER

Kristin J Mosher
USA

TERMITE CATCHING
Kristin Mosher was following the five-year-old chimpanzee twins Glitter and Goldi while they foraged in Tanzania's Gombe National Park. Suddenly, they dashed excitedly to a tree ahead and climbed it. Kristin watched in astonishment at the scene that unfolded. "Winged termites were swarming in the canopy, something I'd never seen before," she said. "Usually the chimps stand on the ground and catch them as they crawl out of mounds. So when the twins started to grab recklessly at the cloud of flying termites, I knew it was special." Here, Glitter balances precariously at the top of the tree, snatching them out of the air. "To me, the image is powerfully symbolic," says Kristin. "It reflects the condition of the whole species – teetering on the edge of extinction."

Canon EOS-1N with 100-400mm f4.5-5.6 IS Ultrasonic zoom lens; 1/100 sec at f6.3; Fujichrome Provia 100F.

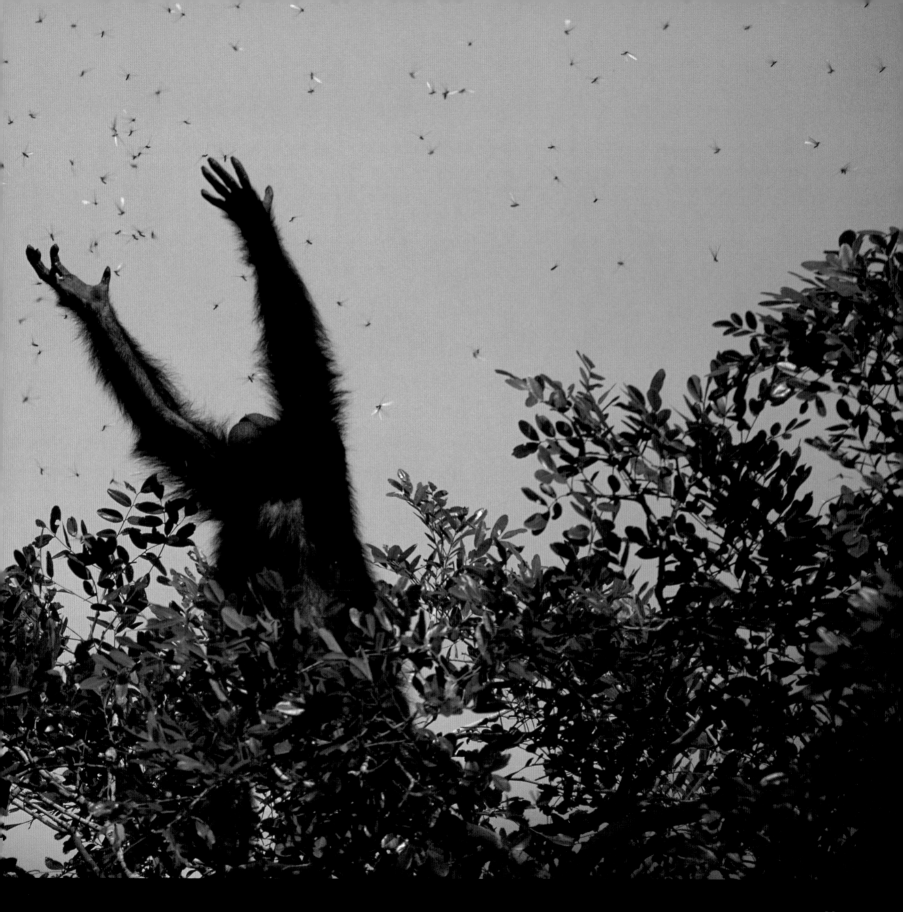

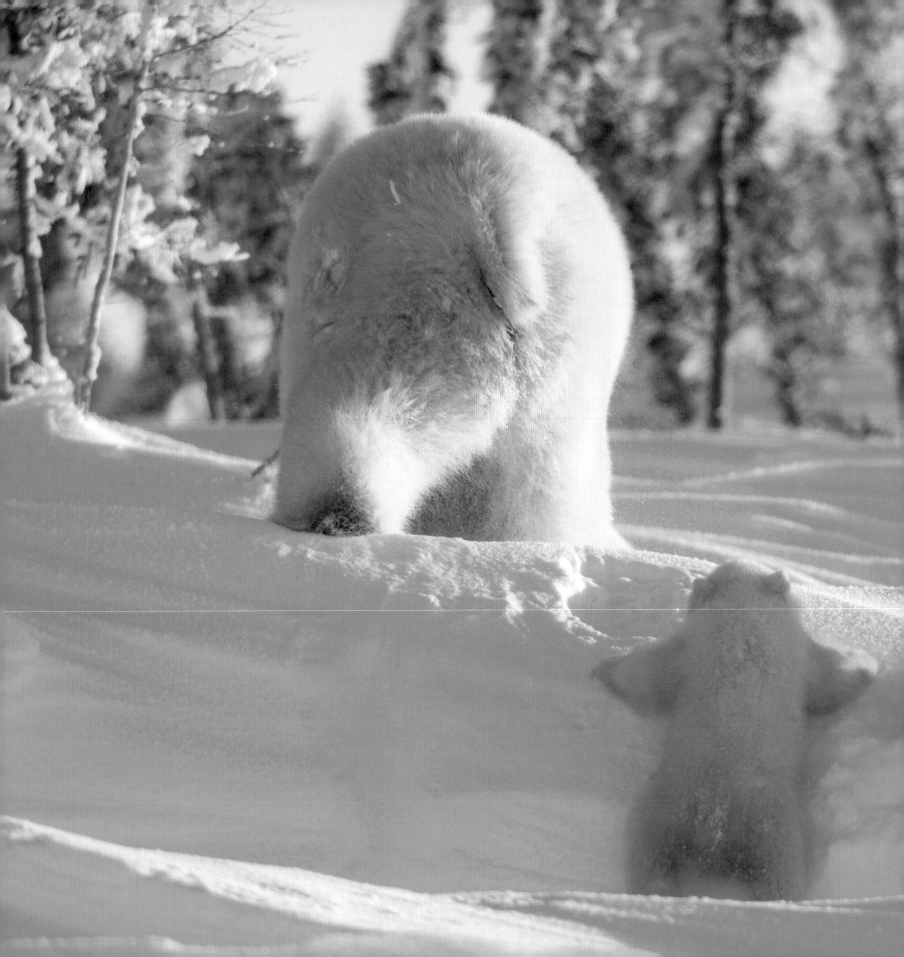

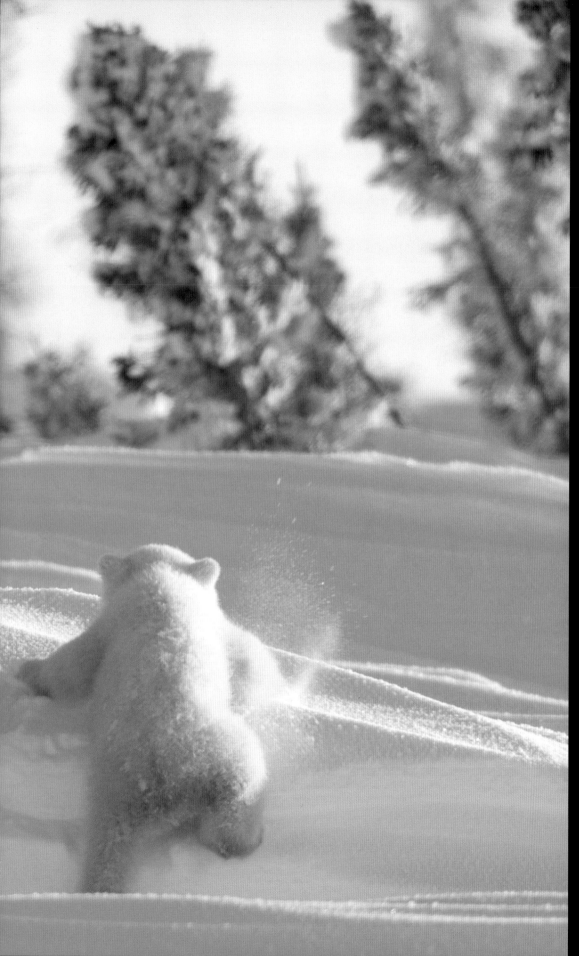

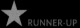 RUNNER-UP

Thorsten Milse
Germany

POLAR TREK

The female polar bear is ravenous: she hasn't eaten for eight months. For much of that time, she lived in a cramped snow-hole in Canada's Wapusk National Park, giving birth to and suckling twins – an astonishing physiological feat. Now it's March, and she is taking her three-month-old cubs on a 70-kilometre (43-mile) trek to Hudson Bay. The sea-ice there will have frozen again, and for a few bountiful weeks, she will be able to fatten up on seal meat. But she hasn't got long: the ice melts again in July. "You could sense the urgency," says Thorsten. "The tiny cubs whimpered to their mother as they sank into steep snowdrifts." He watched as the female was tugged in different directions by two mighty instincts: forwards by hunger, and backwards by her youngsters.

Canon EOS 1DS mark II with Canon EF 600mm f4 IS lens and 1.4x teleconverter; 1/250 sec at f8; tripod.

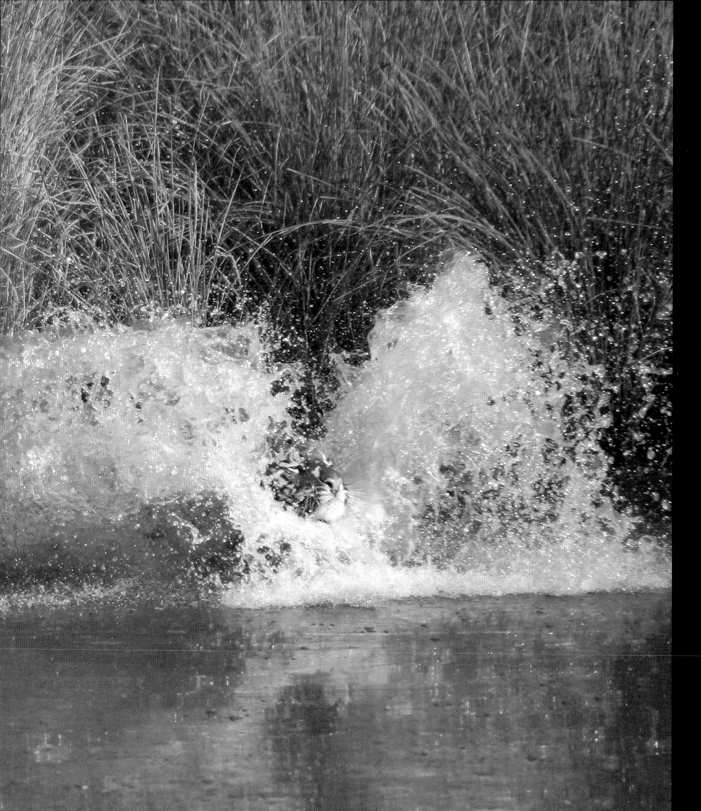

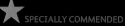 SPECIALLY COMMENDED

Elliott Neep
UK

TIGER PLAY

The setting is Bandhavgarh National Park, Madhya Pradesh, India. The twins launched the day's entertainment with a bout of boxing, rearing up on their hind legs and swiping at each other. Elliott watched in the morning from the back of an elephant. "The cubs were 18 months old, nearly adult, and it got quite rough at times," he recalls. In the afternoon came cormorant-teasing. One minute, it was peace and quiet at the water hole, the next, cacophony. The adolescents crashed out of the long grass and into the shallows, sending the birds squawking. They then used up their leftover energy on tiger-tag. "They chased each other up and down the bank until the first cub dodged and leapt straight into the water, with its playmate in hot pursuit."

Canon EOS 10D with Sigma 500mm lens; 1/800 sec at f5.6; 200 ISO; Manfrotto 055PROB tripod with 329RC4 head.

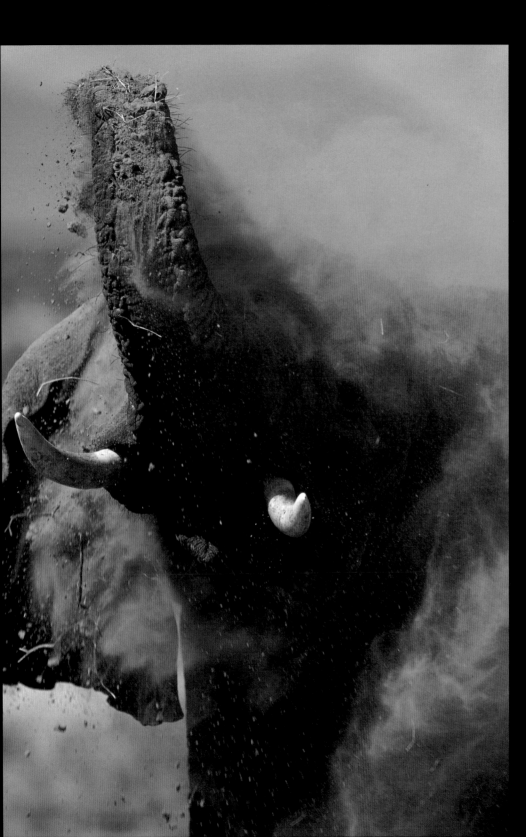

Mary Ann McDonald
USA

THE DUST BATH

Trunk and tusks – you don't need to see any more of the elephant to experience her power and size. She's in her element, throwing and blowing the dust and dirt over her back. She was one of a herd being followed by Mary Ann in Kenya's Samburu Game Reserve. "After crossing the river, the elephants stopped close by and started to dust-bathe, completely relaxed," she says. The cloud of red Samburu dust is enriched by the late-evening sun, with an azure-blue sky adding the finishing touch to the composition.

Canon EOS3 with 500mm f4 lens; 1/500 sec at f8; Kodak EB2 100.

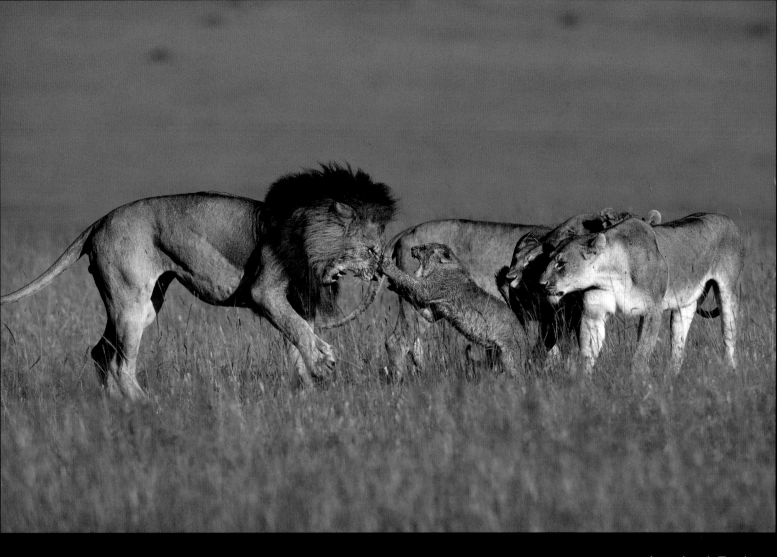

HIGHLY COMMENDED

Michel Denis-Huot
France

MISTAKEN IDENTITY

By the time he took this shot, Michel knew the cub was in terrible danger. In the pride's haste to investigate a hyena kill in Kenya's Masai Mara, it had lost three of its cubs. A couple of days later, two of them turned up. The bolder one approached a female, possibly its mother, and was quickly hitting the male. Then the female attacked, and within a few minutes, the cub was seriously injured. An hour later, he was dead, and his badly injured sibling had vanished. "The lioness kept sniffing him, as though trying to confirm his identity," Michel says. "Maybe after two days away from the pride, he smelt strange, like an impostor." The end was gruesome. "The lioness dragged the small corpse into the shade. Then, alone, she ate him."

Yukihiro Fukuda
Japan

JAPANESE MACAQUE EATING CHERRY BLOSSOM
Japan's most famous animal and most famous floral display in one shot – the ideal Japanese nature picture. It was what Yukihiro set out to create in spring, when the cherry trees at Jigokudani in Nagano Prefecture were thick with blossom and when the monkeys had moved down to the orchards to feast on it. But the task was no easy one. "The macaques are so capricious," he says, "that it's impossible to predict which tree they will climb next or which flower they will reach for." Yukihiro visited the mountains every day during the cherry-blossom season and took hundreds of shots before his diligence was finally rewarded.

Canon EOS 1D mark II with Canon EF 500mm f4 IS lens; 1/125 sec at f4; 200 ISO; tripod.

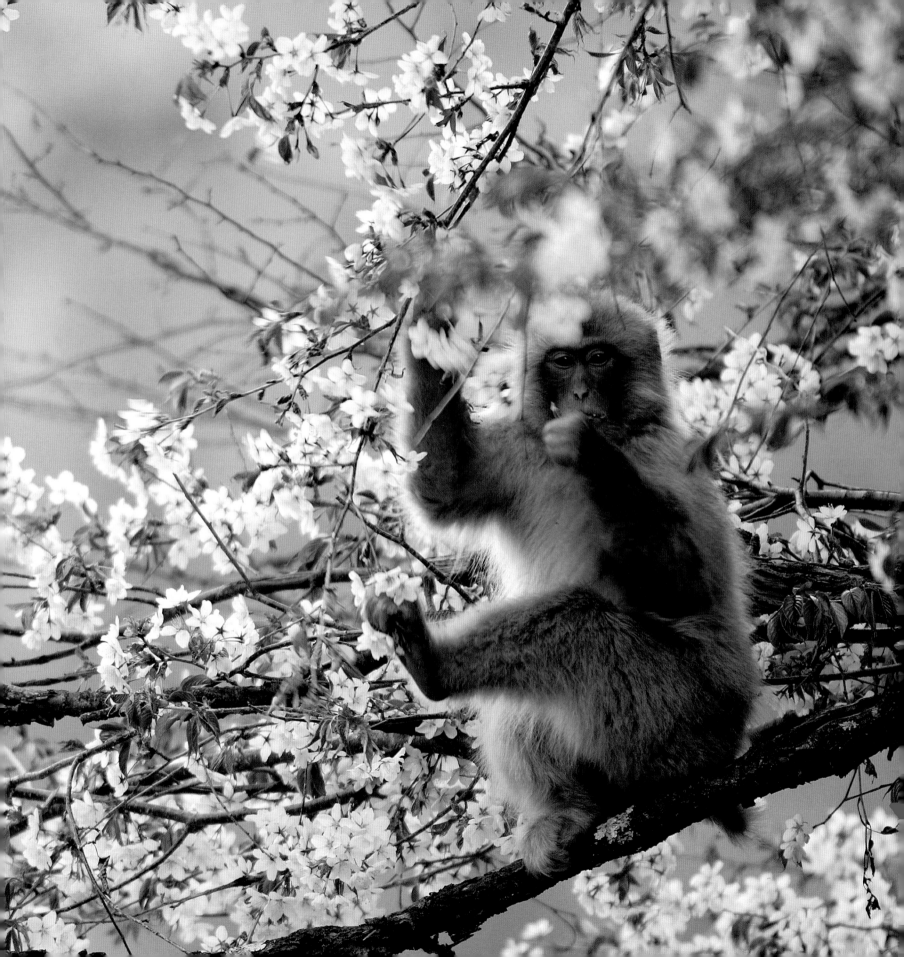

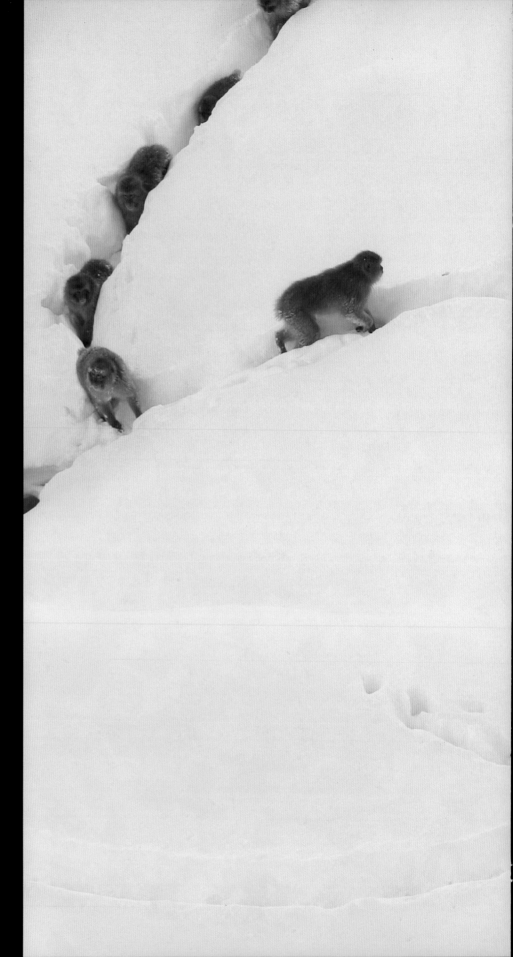

Yukihiro Fukuda
Japan

SNOW TRAILS

Japanese macaques hate deep snow. "They're reluctant to venture out after a heavy fall, because they know how hard it is to wade through the drifts," says Yukihiro . Their home, Jigokudani, in Japan's Nagano Prefecture, is at an altitude of 800 metres (2,624 feet), and as much as a metre of snow can fall there in a single night. One morning, Yukihiro watched the snow-bound macaques to see what they would do. Eventually, and reluctantly, one monkey took the role of snowplough, creating a path for the others to follow. An hour or so later, their movements had created a criss-crossing pattern of snow trails.

Canon EOS 10D with Canon EF 70-200mm f2.8 IS lens; 1/400 sec at f5.6; 200 ISO; tripod.

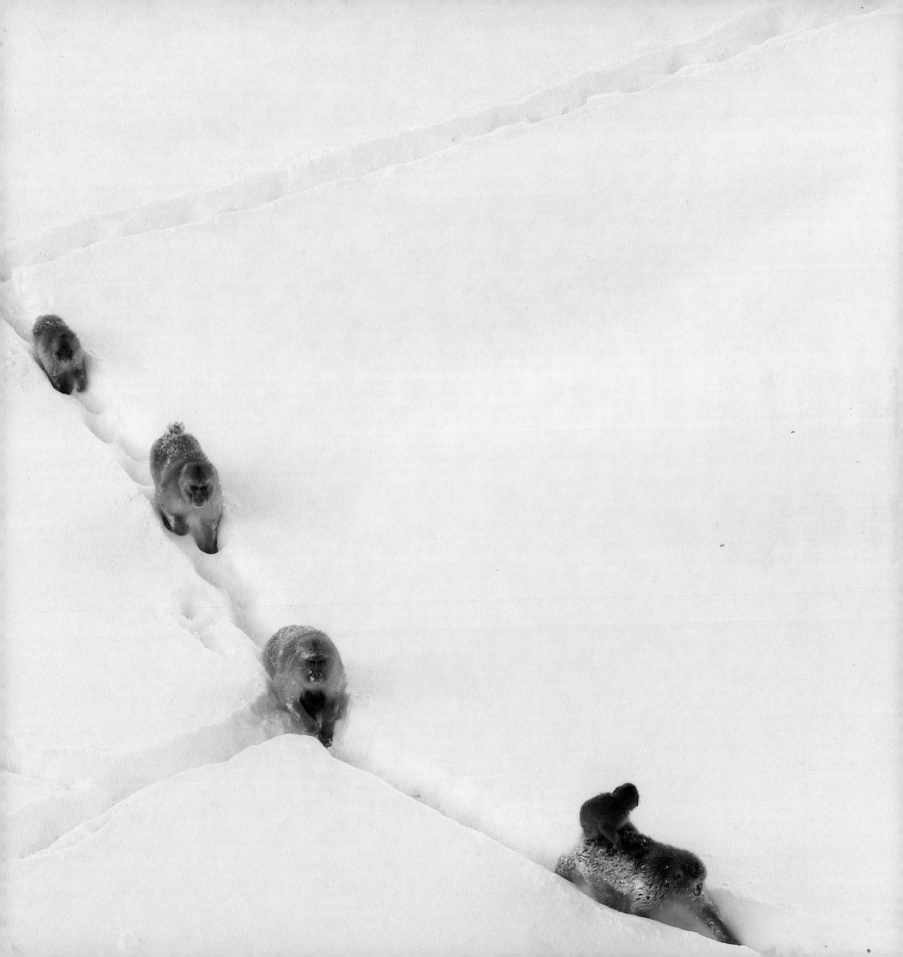

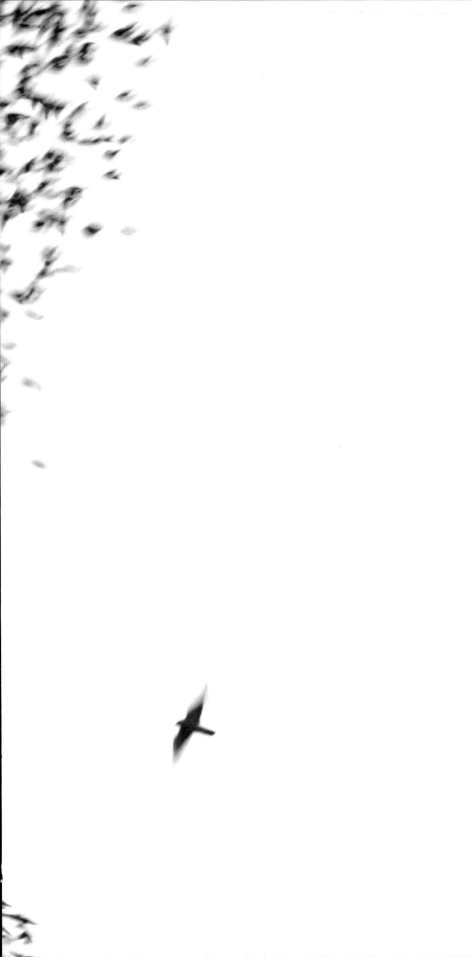

Animal behaviour
Birds

The pictures in this category must show action and have interest value as well as aesthetic appeal.

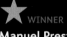 WINNER

Manuel Presti
Italy

SKY CHASE

Massive gatherings of starlings choose to roost in city parks in Rome, where it is warmer than the surrounding countryside and usually safer – except for the resident peregrines. When photographing the phenomenon, Manuel chose to work with two cameras: one a hand-held zoom, so he could rapidly follow the flocks as they swirled and whirled across the skies, merging into bigger and bigger clouds; the other on a tripod with a long lens to capture details. "This allowed me to take pictures of the amazing flock shapes as well as the dynamics of the peregrine attacks," he says. It's a stark, dramatic picture of one of the world's great natural spectacles – a spectacle becoming rarer and rarer with the rapid decline in starling populations throughout Europe. (See also page 10.)

Canon EOS 10D with Canon 500mm f4 IS USM lens and 1.4x converter; 1/50 sec at f5.6; 800 ISO; tripod.

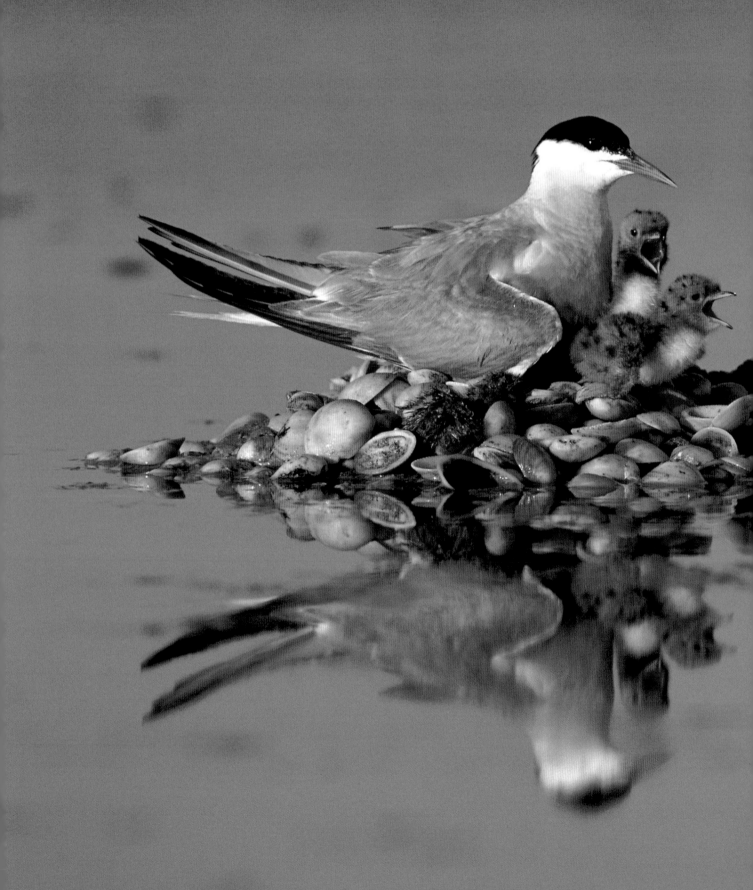

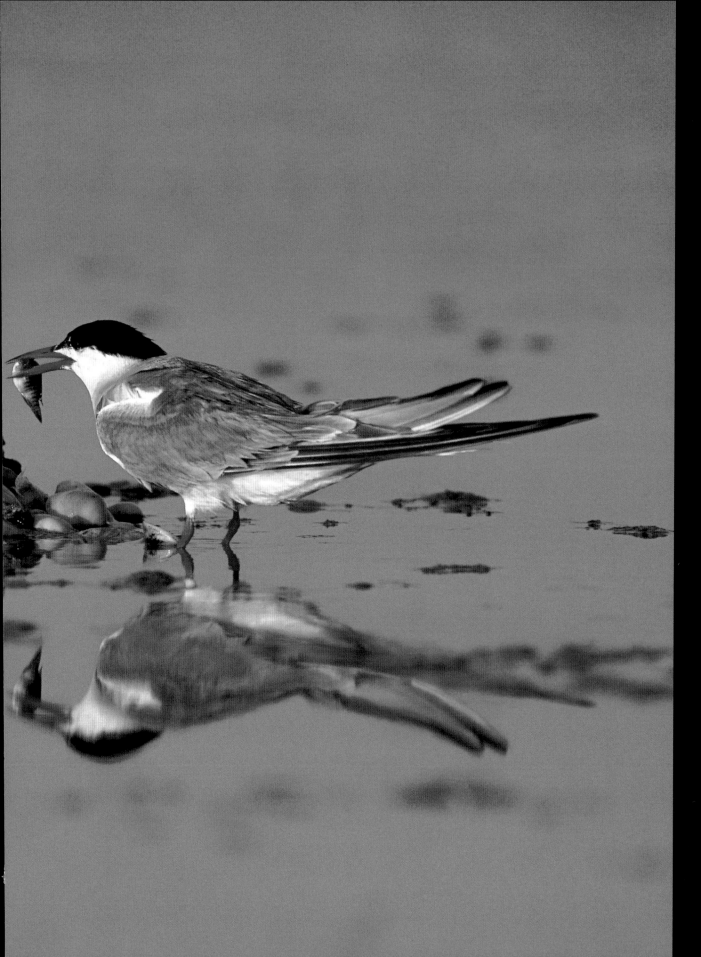

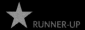 RUNNER-UP

Yossi Eshbol
Israel

COMMON TERN FAMILY
A lick of fresh mud and a new
seashell carpet, and the old nest
was as good as new. A few days
after the common terns moved
in, three eggs appeared, and
23 days later, the chicks
hatched. Yossi wasn't sure why
the abandoned black-winged
stilt nest so appealed to the
common terns, but several pairs
of terns nesting near his home
in Israel preferred to upgrade
these old nests rather than build
their own. Every spring the
common terns arrive from
Africa, and as soon as they do,
Yossi sets up his hide and starts
photographing them,
continuing to do so throughout
the breeding season. "I love the
male's courtship rituals. He
dances around the female with
a fish in his beak before giving it
to her as a 'wedding present'."

Nikon F5 with 600mm AF-S lens;
Fujichrome Velvia 50 rated at 100;
tripod; hide.

43

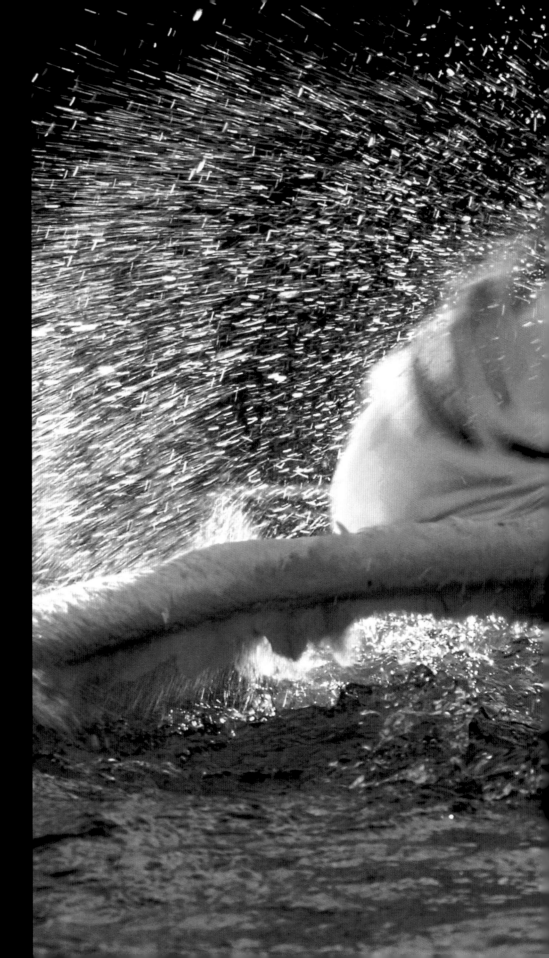

Maik Aschemann
Germany

PELICAN BATH

A great white pelican doesn't skimp on personal grooming. With its huge wings and fishing lifestyle, it needs to keep its feathers in impeccable condition. Maik often spends hours watching the pelicans at Hanover Zoo, Germany, especially early in the morning when they come to the water to preen. Just as the sun was rising, this pelican swam to the middle of the lake to begin its daily ablutions, using the little hook at the end of its beak to comb its feathers into style and oil from its preen glands to waterproof them. Ablutions over, it suddenly began to beat its wings on the water. Maik was ready with his camera at eye level to capture a dynamic picture.

Canon EOS 1V with Canon 28-300mm 3-5.6f IS lens; 1/1250 sec at f8; Kodak Elite 200; tripod.

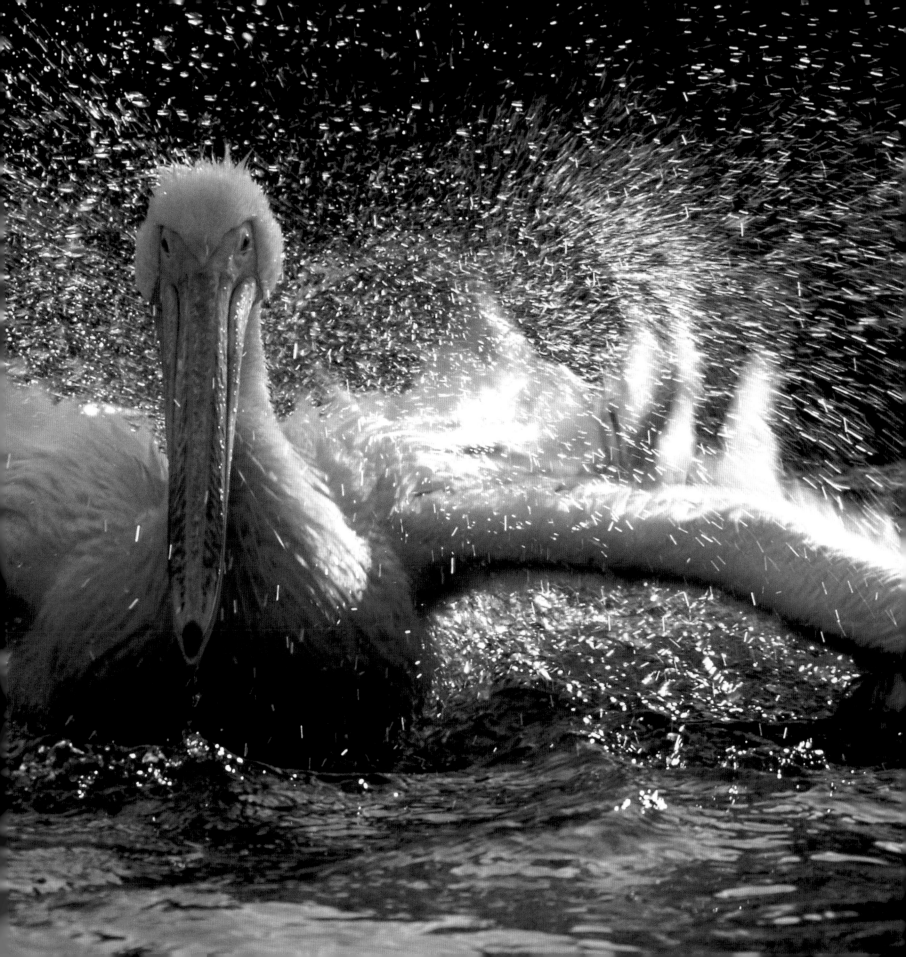

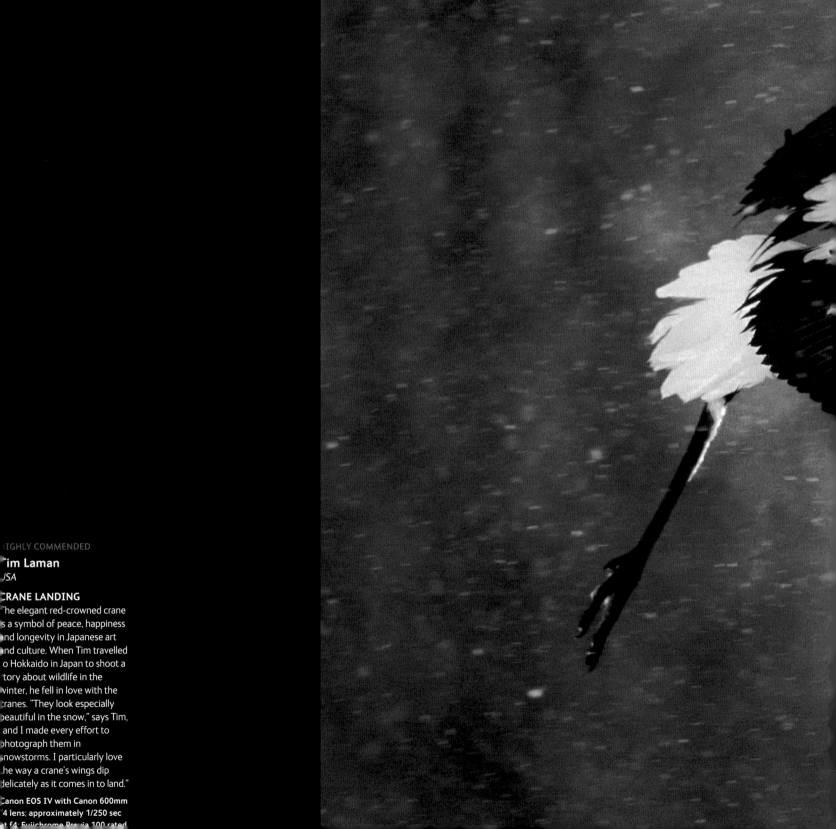

HIGHLY COMMENDED

Tim Laman
USA

CRANE LANDING

The elegant red-crowned crane
is a symbol of peace, happiness
and longevity in Japanese art
and culture. When Tim travelled
to Hokkaido in Japan to shoot a
story about wildlife in the
winter, he fell in love with the
cranes. "They look especially
beautiful in the snow," says Tim,
"and I made every effort to
photograph them in
snowstorms. I particularly love
the way a crane's wings dip
delicately as it comes in to land."

**Canon EOS 1V with Canon 600mm
f4 lens; approximately 1/250 sec
at f4; Fujichrome Provia 100 rated**

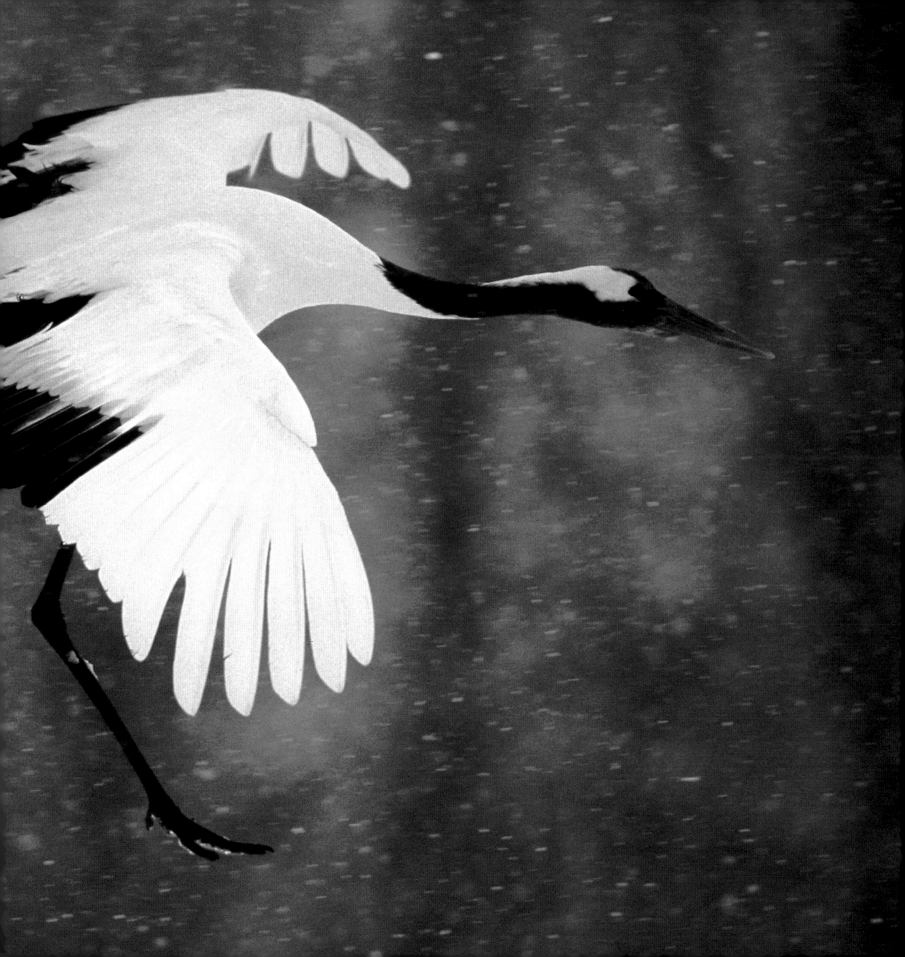

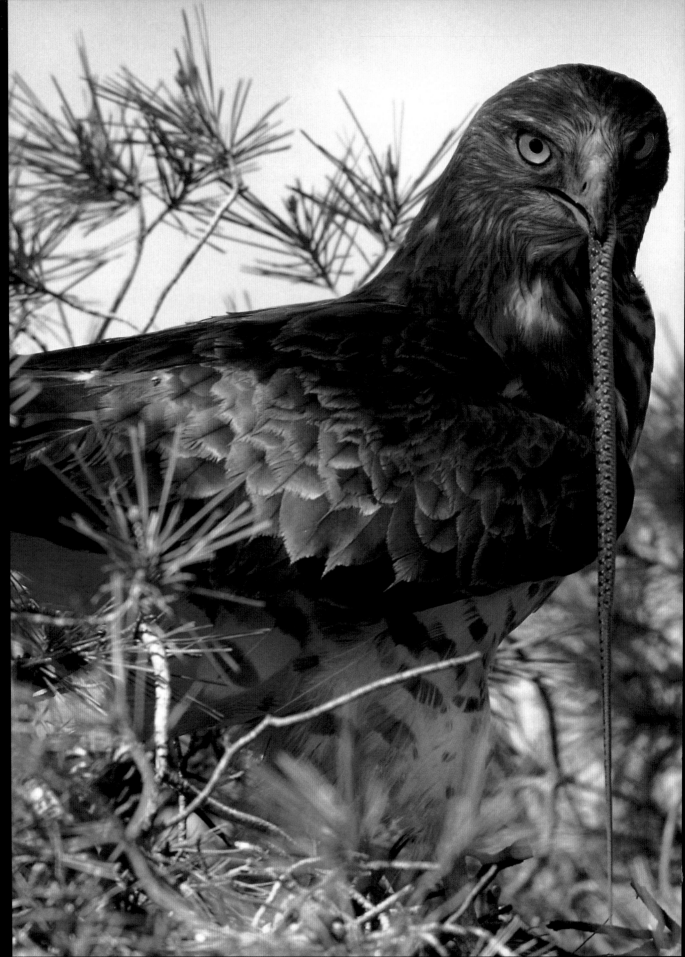

José B Ruiz
Spain

THE SNAKE EAGLE FAMILY

This is a portrait of a family unit: father poised with a smooth snake for the awaiting chick, mother with an extra sprig of home-building material. It says a lot about the species' lifestyle. Short-toed snake eagles eat mainly snakes, and for nesting, they favour pine trees – the bigger the better (though deforestation has made big ones quite rare in Spain). "I spent some weeks in a hide near this nest high in an Aleppo pine tree in Sierra del Coto, Alicante, in June," says José, "and was lucky to get this family together in one place. Short-toed eagles spend such a lot of time on the wing." The pine wood area where they nest is, though, under threat from expanding marble quarries.

Nikon F5 with 500mm f4 P IF ED lens; 1/250 sec at f4; Fujichrome Velvia 50; tripod, hide.

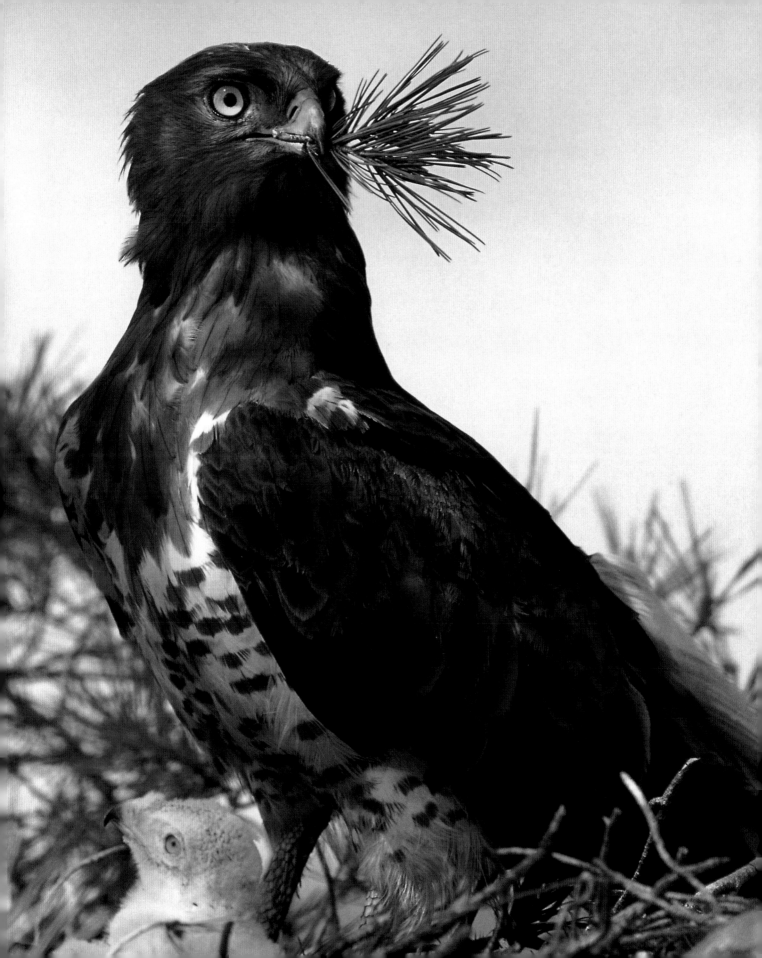

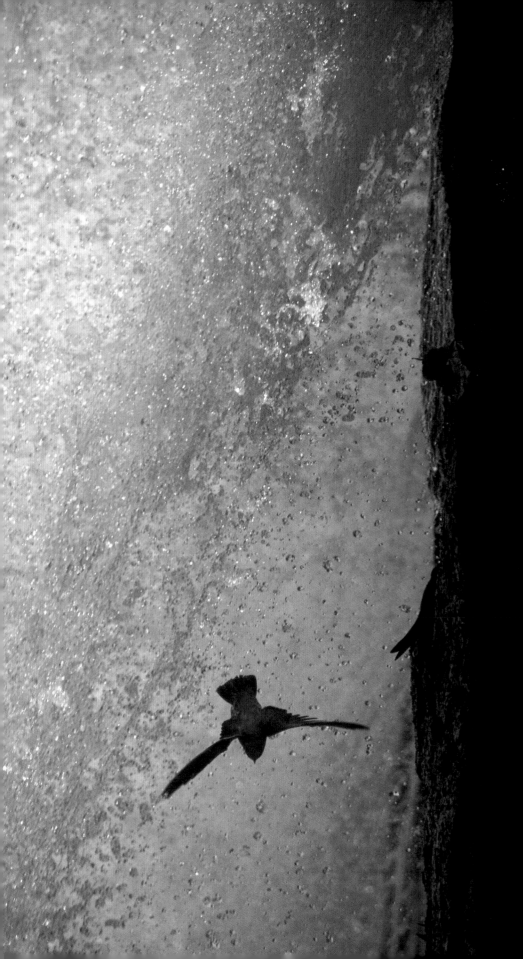

HIGHLY COMMENDED

John Aitchison
UK

SWIFT DIVE
At Argentina's famous Iguazu
Falls, great dusky swifts build
their nests on ledges behind
the water. To get to the nests,
they make a spectacular flight
through the water – an
ingenious but risky way to
prevent predators getting to
their young. Fascinated by this
behaviour, John positioned
himself on a bridge just
downriver of the falls to watch.
The swifts would fly under the
bridge and then make a sharp
turn right and steep ascent
through the waterfall edge.
But to exit, they had to fly
down behind the wall of water
until they gained enough speed
to punch through it. This was
the drama he set out to record,
positioned precariously at the
edge of the fall. Just how
precarious the birds' strategy is
was revealed next morning:
a massive overnight storm had
swept away all the nests.

Minolta X700, with 70-210mm lens;
1/500 sec at f4; Fujichrome Velvia 50.

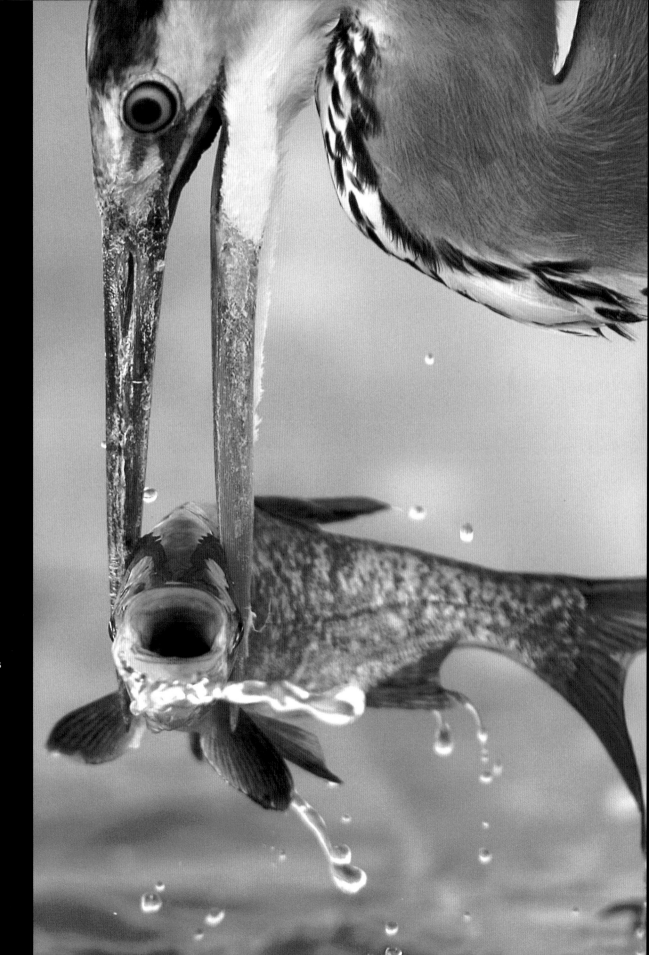

HIGHLY COMMENDED
Bence Máté
Hungary

DEATH SQUEEZE

Like a child squirting a bath toy, a heron squeezes the water out of a fish before swallowing it. Bence saw this brief, firm gesture many times as he watched grey herons on a lake near his home. But photographing the moment wasn't easy. First, the action was over in a flash. Second, to get the sharp image he wanted, he had to pre-set the focal length. Third, he could never anticipate where a heron would be when it caught a fish. In the end, it was a matter of taking dozens of shots and hoping for the best. "Most of the exposures show the bird's wing or its foot," he said, "but this one was exactly what I wanted."

Canon EOS 1N RS with Canon 300mm f2.8 IS USM lens; 1/1250 sec; Fujichrome Velvia 50; Gitzo tripod, hide.

Andy Rouse
UK

SURFING GENTOO
Andy Rouse faced two problems when photographing gentoo penguins surfing onto the shore in the Falkland Islands. The first was technical. The 'burst out and skid' action was over so quickly that the only way Andy could capture it was to set his camera to a very fast autofocus. "I would track a penguin as it porpoised under water – so when it committed itself to a wave, I was ready for it." The second problem wasn't so easy to resolve. "The penguins looked so funny, especially the few that landed on their backsides, that I spent half my time smiling or laughing. It made it impossible to take photos," he says. "In the end, I had to put my camera down and just enjoy the show."

Canon EOS 1DS mark II with 300mm f2.8 lens, 1/2000 sec at f4; 200 ISO processed by RawShooter software.

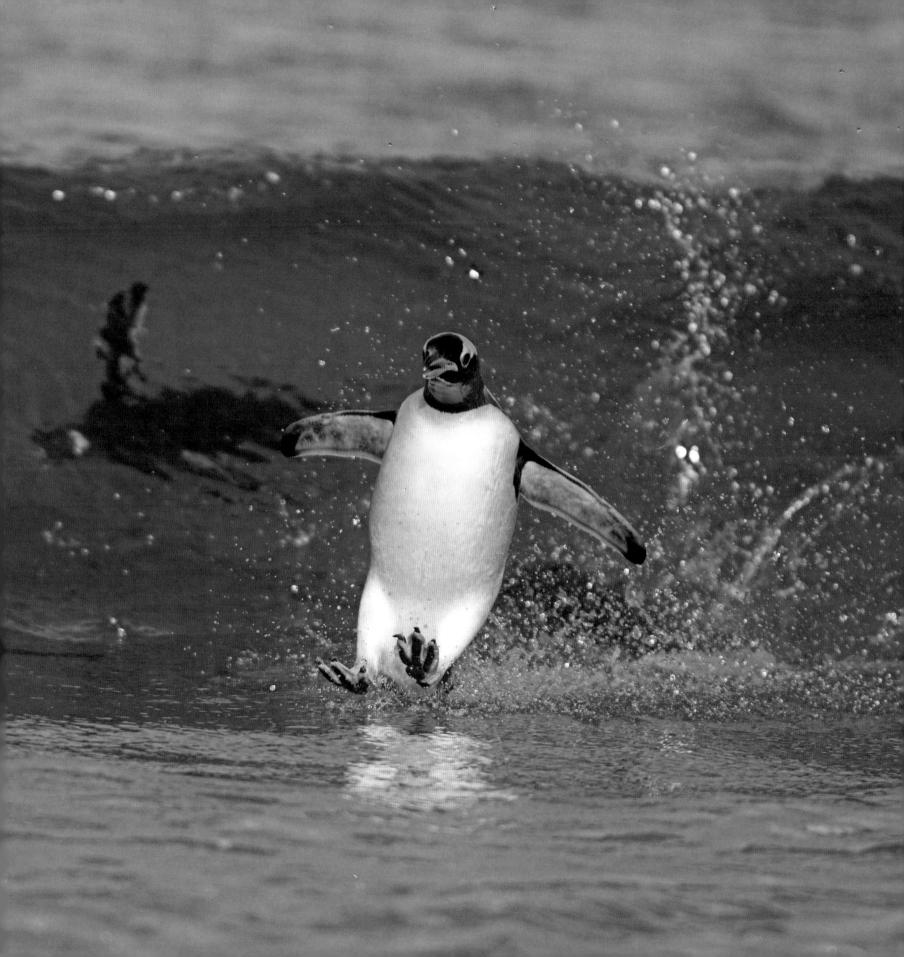

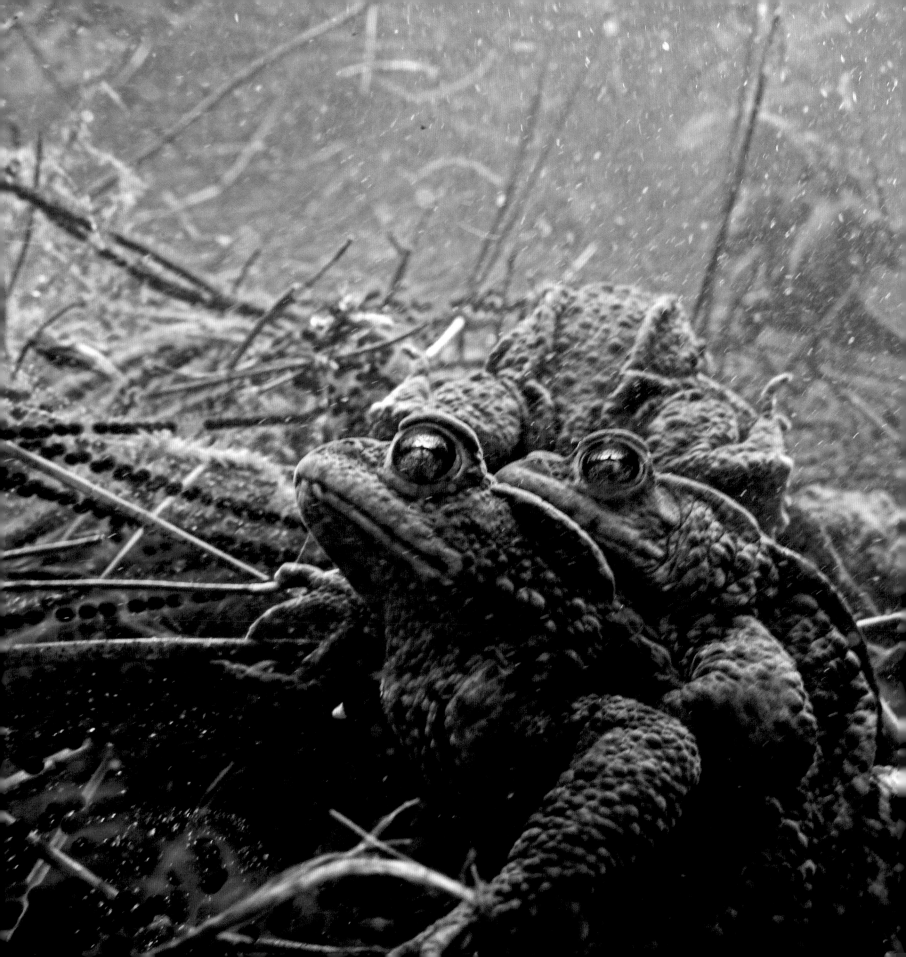

Behaviour
All other animals

This category offers plenty of scope for interesting pictures, given that species other than mammals and birds comprise the majority of animals on Earth and have behaviour that is often little known.

 WINNER

Ruben Smit
The Netherlands

COMMON TOAD ORGY

Each spring, common toads migrate in huge numbers to mate in the ponds of Veluwe, Holland – a spectacle that has always fascinated Ruben. What he wanted to reveal was the action under water. Wading into the cold, crystal-clear water, he held his camera as low as possible to the pond bottom to get a toad's-eye view of the squirming mass of mating toads and used a wide-angle lens to reveal the action and the resulting mass of egg strings. What he hadn't reckoned on was becoming part of the orgy himself. Mistaking his fingers for females, the muscular male toads gripped onto them with grim passion ("they squeeze very tightly"), finally putting an end to the photo session.

Canon EOS mark II with Sigma 20mm f1.8 lens; 1/25 sec at f18; 400 ISO; underwater housing (bag).

Alexander Mustard
UK

SHY HAMLET ROMANCE

While diving in Grand Cayman, Alexander spent many evenings watching hamlets spawning. Like a lot of reef fish, they mate at dusk. Of the 10 species in the Caribbean, the one Alexander really hoped to see was the shy hamlet. Finally, he came across this pair. Floating motionless so as not to disturb their natural behaviour, he watched them. Here the two embrace as the female (head down) starts to produce eggs for the male to fertilise. Hamlets are among the few higher animals that are hermaphrodites, and within a couple of minutes, the pair had swapped sexual roles, and the spawning caresses started again. Over about 20 minutes, they exchanged sexual roles six times.

Nikon D100 with Sigma 28-70mm lens; 1/180 sec at f16; 200 ISO; Subal underwater housing; Subtronic underwater flash.

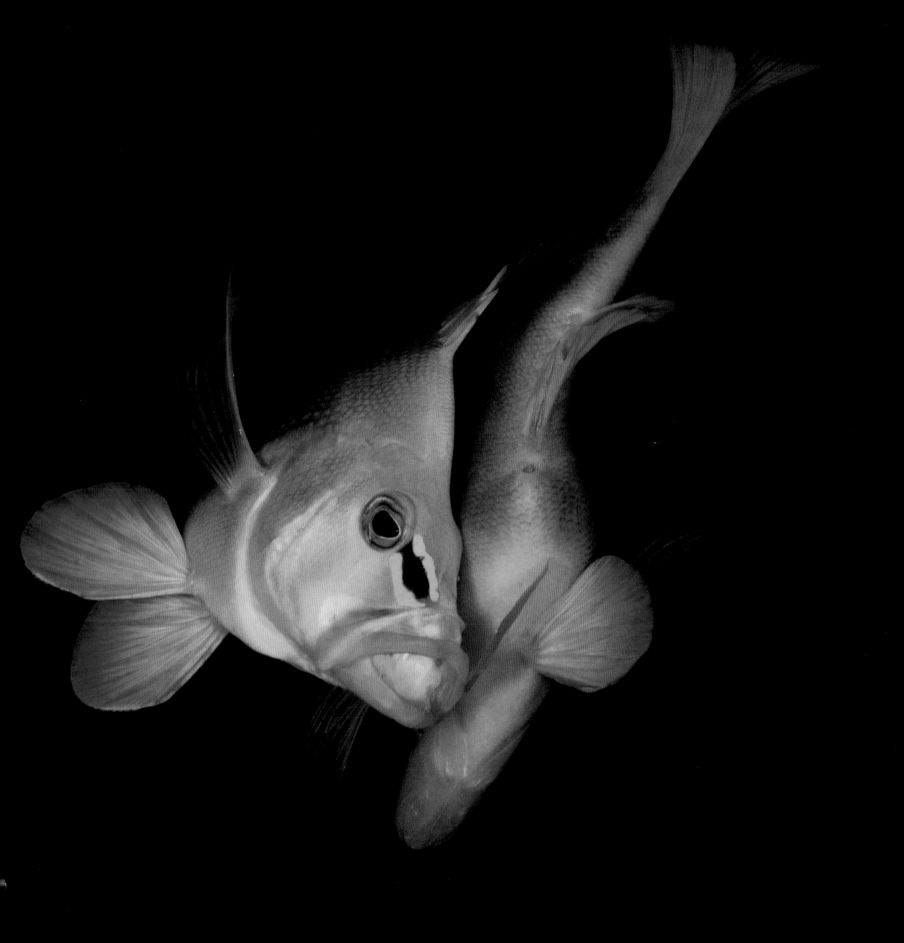

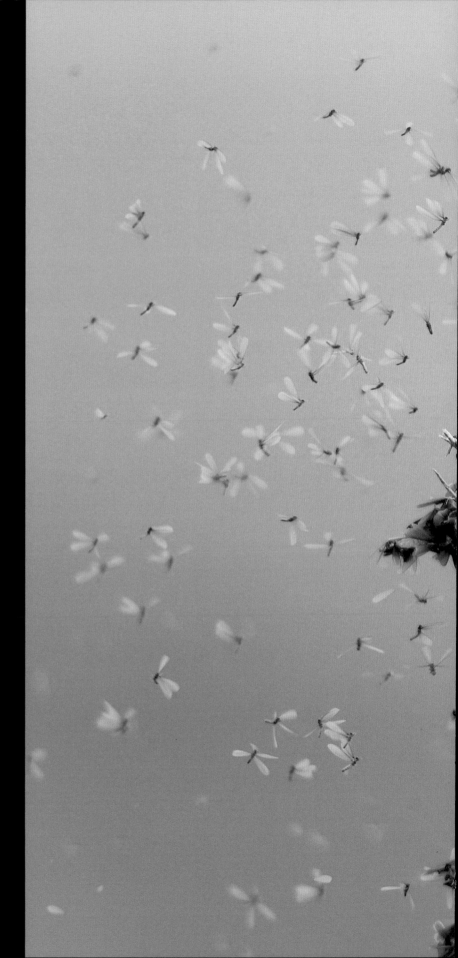

Joe McDonald
USA

WINGED TERMITE FEAST
The evening before Joe took this photograph in Kenya's Masai Mara Game Reserve, it had rained, which triggered an explosion of termites colonising a small sapling. Part of the shrub was dead, and a hollow branch acted as a funnel out of which the winged reproductive forms of the insect streamed on their way to a mating orgy. It's a common sight in the short rainy season, and many birds take advantage of this feast, either in the air or when the termites land and discard their wings to mate on the ground. Grey kestrels normally feed on rodents, small birds and reptiles, but this one tucked into the insects with relish, completely ignoring Joe's vehicle as he crept closer. "Periodically, clouds of termites erupted, sometimes coating the kestrel in scrambling bodies," says Joe, "but it ignored them and simply snapped up those swarming around its feet."

Nikon F5 with 300mm lens; Fujichrome Provia 100; strobe with fresnel lens; tripod with ball head.

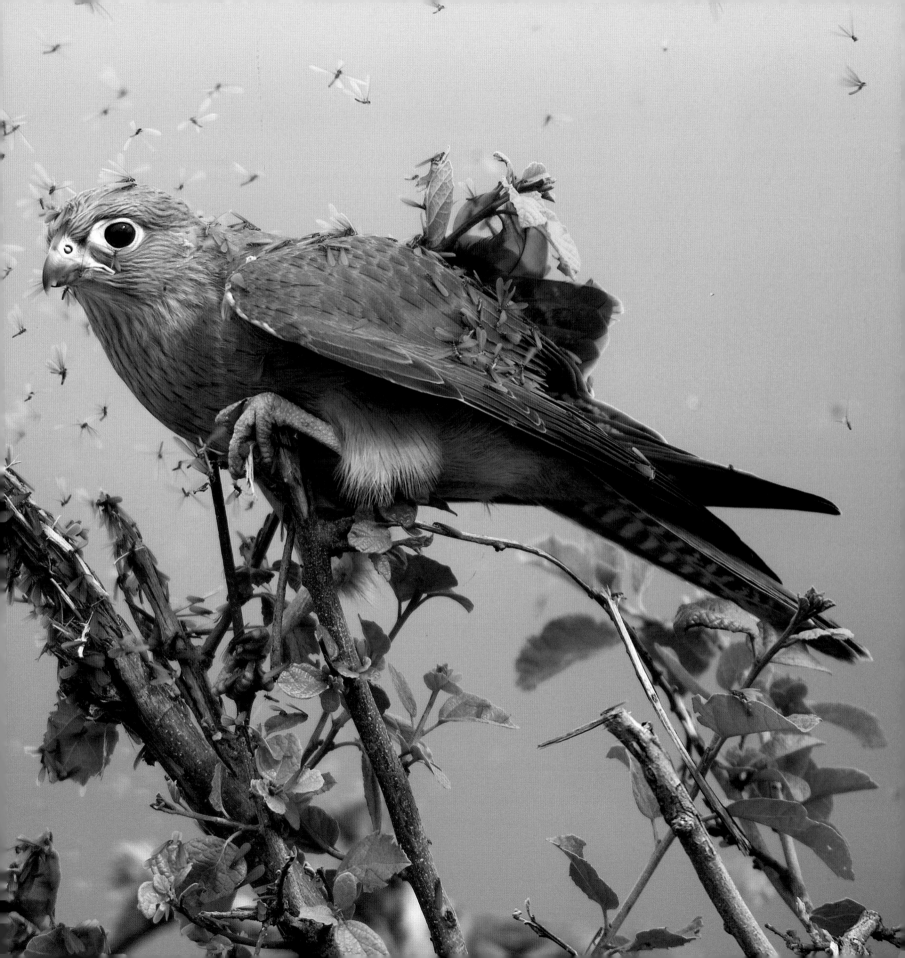

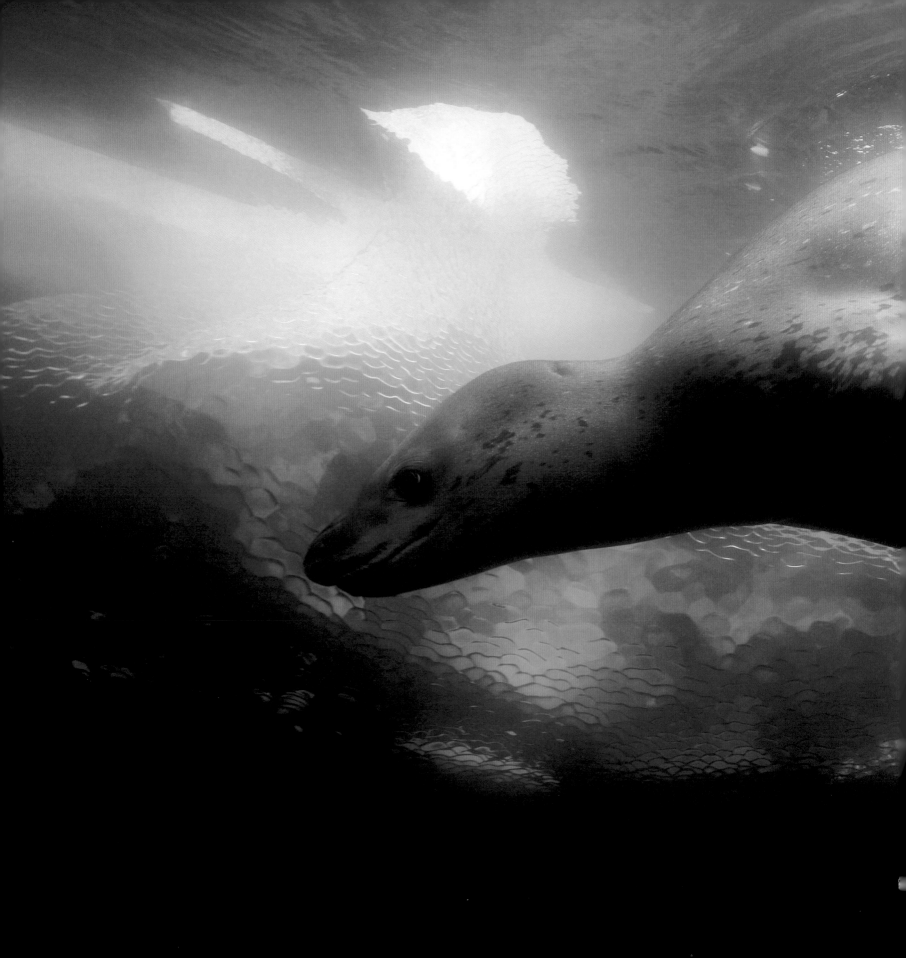

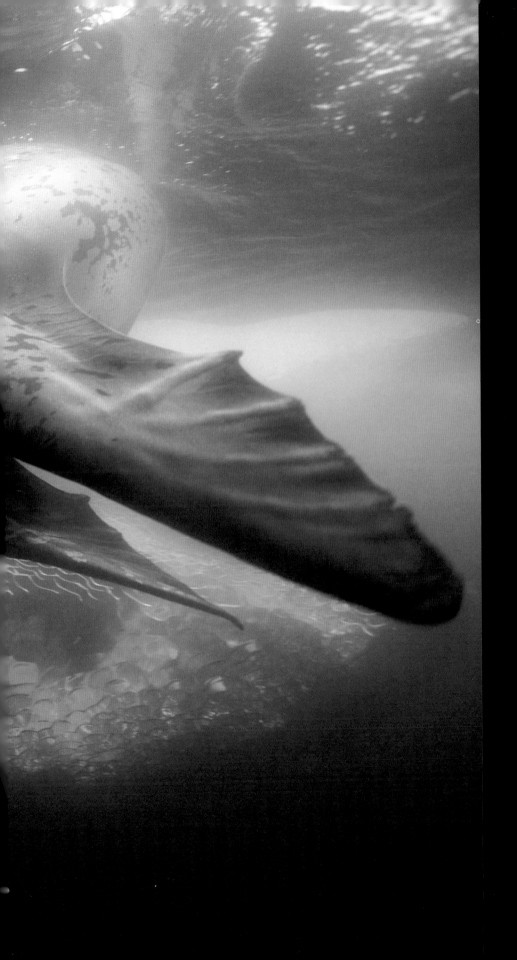

The underwater world

Marine or freshwater animals or plants feature in this category. The most important criteria are aesthetic ones, but interest value is also taken into account.

 WINNER

George Duffield
UK

LEOPARD SEAL PASS
Leopard seals can be shy or inquisitive and sometimes aggressive, but you don't know how an individual will behave until you're in the water with it. Antarctic water is also numbingly cold, often with terrible visibility. Only on the last day of a filming trip to Antarctica did George get a chance to dive with leopard seals in clear water. Three huge ones were swimming around a small berg of ancient, clear ice – a perfect underwater backdrop. This 3.6-metre-long (12-foot) individual was particularly curious about the human interloper and came closer and closer at every pass. This shot was the last shot George took of the seal as it swept by, close to his face. It was time to retreat. As he swam back to the boat, the seal followed, nipping at his fins all the way. A thrilling but sobering experience.

Canon 1DS mark II with 17-40mm f4 lens; 1/200 sec at f6.3; 320 ISO; Seacam housing.

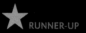

★ RUNNER-UP

Magnus Lundgren
Sweden

OCEAN RIDER
Boredom led to this unusual image. After a deep dive in Sogne Fjord in Norway – the world's second largest fjord – Magnus had to hang around on a decompression stop at 5 metres (16 feet 5 inches) to avoid decompression sickness. Exquisite starfish larvae, just 15 millimetres (0.6 inches) long, floated by in the current. To kill time, Magnus set himself the challenge of photographing them. "It took me ages to work out how to get them in focus," he says. "The trick was to drift with them in the current." Just as he perfected this technique, a starfish sailed by with a minuscule passenger – an amphipod (a tiny, shrimp-like crustacean) holding onto the larva's gelatinous, pulsating extensions. "It was a moment of true Lilliputian beauty."

Nikon D70 with 50mm macro lens; 1/250 sec at f16; 200 ISO; two strobes.

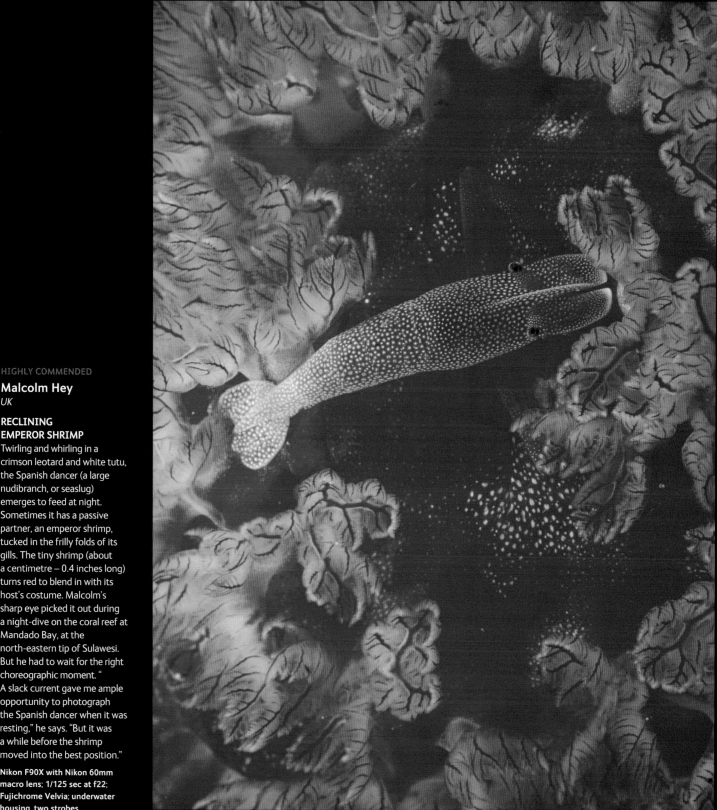

Malcolm Hey
UK

**RECLINING
EMPEROR SHRIMP**
Twirling and whirling in a
crimson leotard and white tutu,
the Spanish dancer (a large
nudibranch, or seaslug)
emerges to feed at night.
Sometimes it has a passive
partner, an emperor shrimp,
tucked in the frilly folds of its
gills. The tiny shrimp (about
a centimetre – 0.4 inches long)
turns red to blend in with its
host's costume. Malcolm's
sharp eye picked it out during
a night-dive on the coral reef at
Mandado Bay, at the
north-eastern tip of Sulawesi.
But he had to wait for the right
choreographic moment. "
A slack current gave me ample
opportunity to photograph
the Spanish dancer when it was
resting," he says. "But it was
a while before the shrimp
moved into the best position."

**Nikon F90X with Nikon 60mm
macro lens; 1/125 sec at f22;
Fujichrome Velvia; underwater
housing, two strobes.**

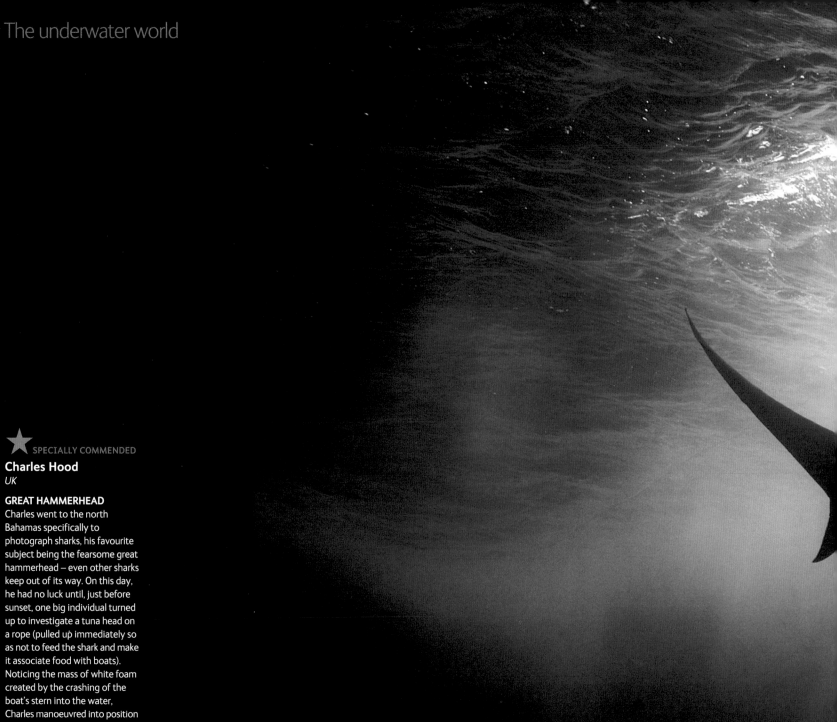

SPECIALLY COMMENDED

Charles Hood
UK

GREAT HAMMERHEAD
Charles went to the north
Bahamas specifically to
photograph sharks, his favourite
subject being the fearsome great
hammerhead – even other sharks
keep out of its way. On this day,
he had no luck until, just before
sunset, one big individual turned
up to investigate a tuna head on
a rope (pulled up immediately so
as not to feed the shark and make
it associate food with boats).
Noticing the mass of white foam
created by the crashing of the
boat's stern into the water,
Charles manoeuvred into position
so that the bubbles provided
a backdrop as the shark passed
between him and the boat.
"After several runs, the boat
crashed down just as the shark
swam into frame, producing this
dramatic silhouette. I only
noticed the pilot fish when
I downloaded the files."

**Nikon D100 with 28mm Nikkor
lens; 1/90 sec at f8; 200 ISO;
Sea & Sea housing.**

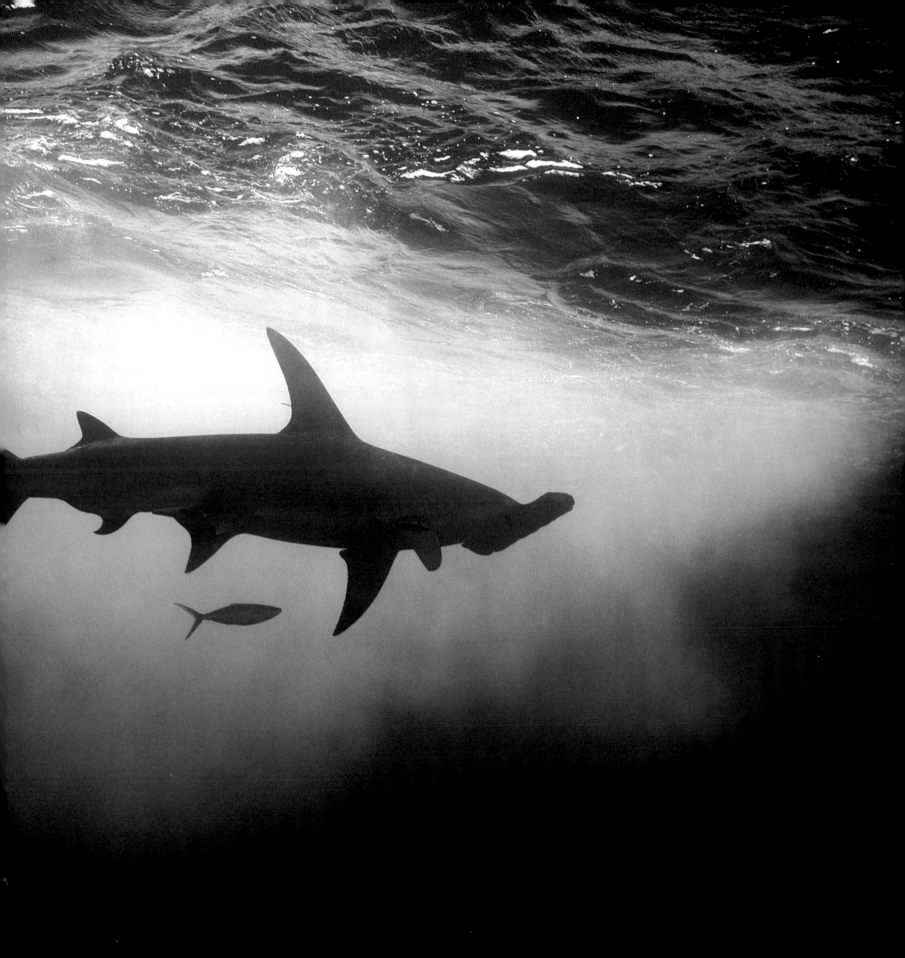

Michel Loup
France

PIKE POSE

Lurking beneath water lilies in a shallow, crystal-clear creek, utterly motionless save for the ripples of its pectoral fins, this pike didn't seem at all bothered by the spectacle of a person swimming by. Michel was snorkelling in Lake Illay, in Jura, eastern France, looking for atmospheric underwater scenes to photograph, and wasn't expecting to find such a cooperative fish. Several times he had to swim to the bank to change the film, but every time he returned, the pike was in the same place, resting on the bottom (probably digesting a meal). This final shot was taken as the pike slowly rose up and opened its mouth, posing for a couple of seconds before gliding away into the water lilies.

Nikonos V with 15mm lens; 1/60 sec at f11; Fujichrome MS 100-1000.

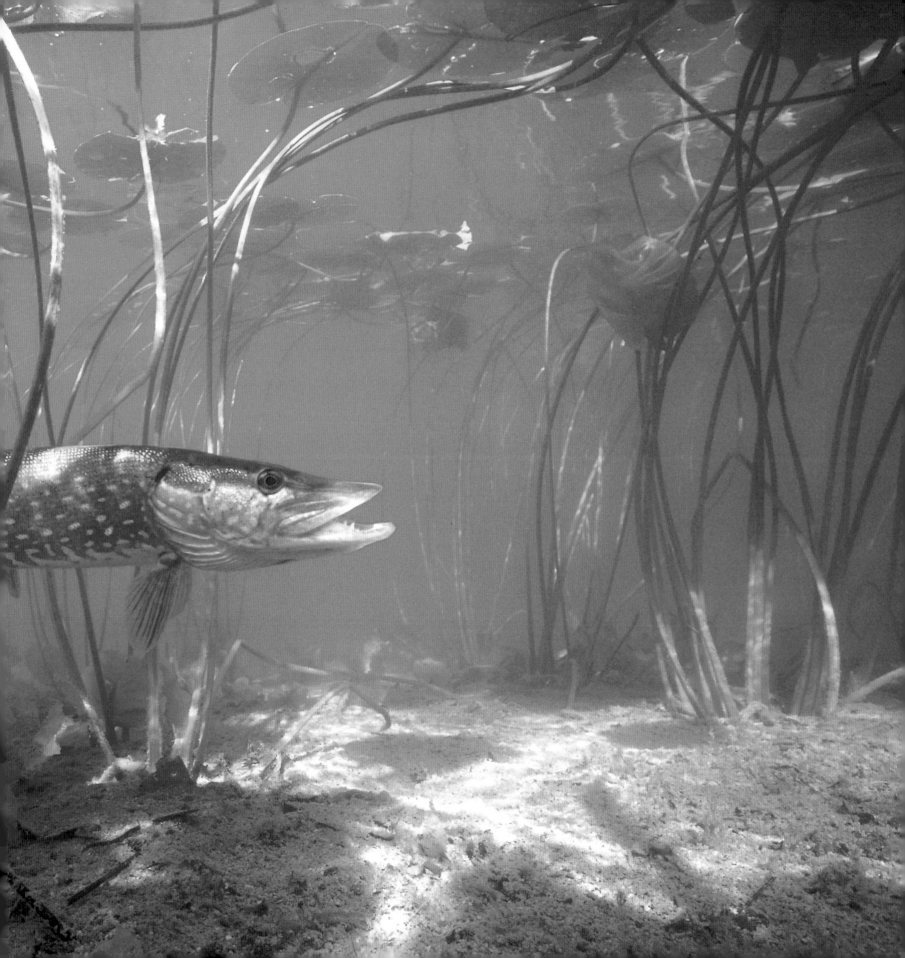

Tim Laman
USA

BLUE-SPOTTED GROUPER

While diving on coral reefs in Fiji, Tim came face to face with this blue-spotted grouper, or coral cod – a large reef predator in tropical waters of the Indo-west and central Pacific. "To give a sense of motion to highlight how groupers lurk and lunge for prey," says Tim, "I used a slow shutter speed as it swept by me, warning me out of its territory." Precise lighting has also highlighted the grouper's spectacular peacock-blue spots.

Nikon F100 with Nikon 105mm macro lens; 1/20 sec at f8; Fujichrome Velvia 50; Sea & Sea housing, flash.

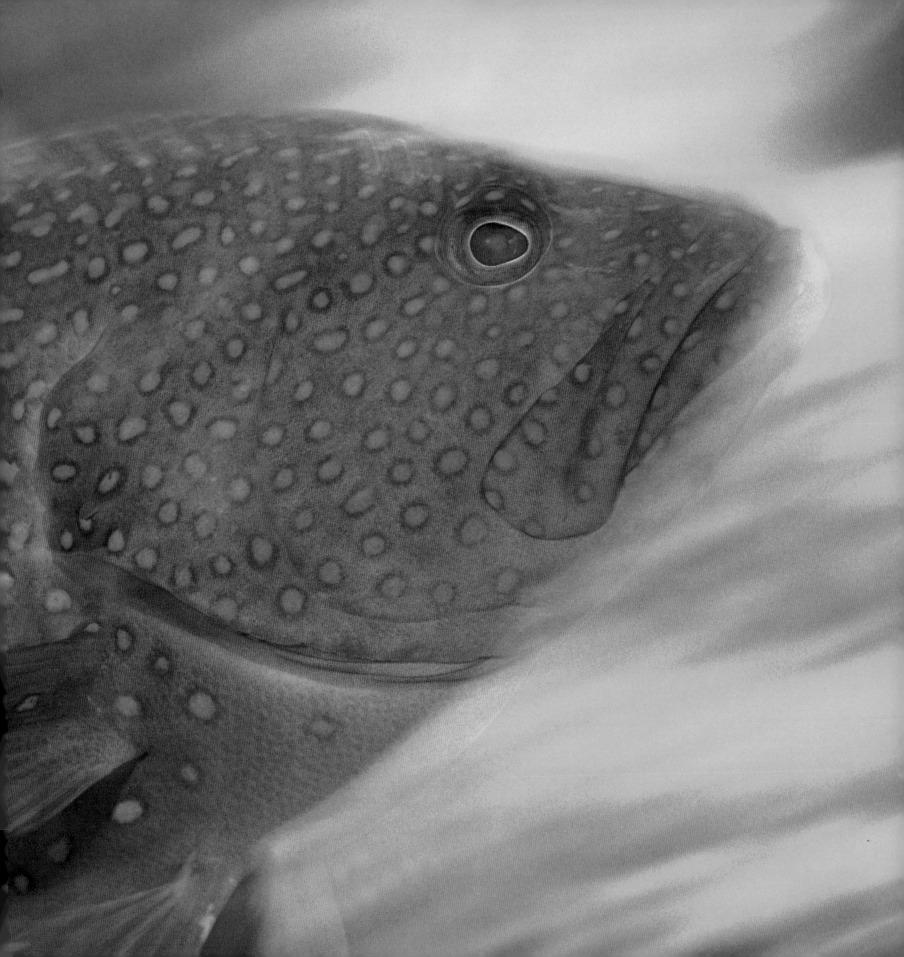

Urban and garden wildlife

Original pictures are what count here, showing wild animals or plants in obviously urban or suburban settings, including gardens.

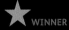 WINNER

Julian Smith
New Zealand

BOGONG SWARM
Some photographers spend months trying to get a winning shot. Julian Smith was simply killing time in a dusty Australian town, waiting for his car to be fixed. But as he wandered the streets for three days, he never stopped thinking as a photographer – and opportunity loves a receptive mind. On his last evening, he watched players on a rugby field and spotted the bogong moths swarming round the floodlights. "The locals told me that millions of bogongs often descend on the town in spring as they migrate south," he says. With his last frame on his last roll, Julian used a long exposure, hopng the moths' flutters would translate as scribbled signatures on the black sky. By the time he returned with fresh film, the lights were off, and the moths and the opportunity were gone.

Canon F1n with Canon 135mm f3.5 lens and 2x teleconverter; 8 sec at f7; Fujichrome Velvia 50; tripod.

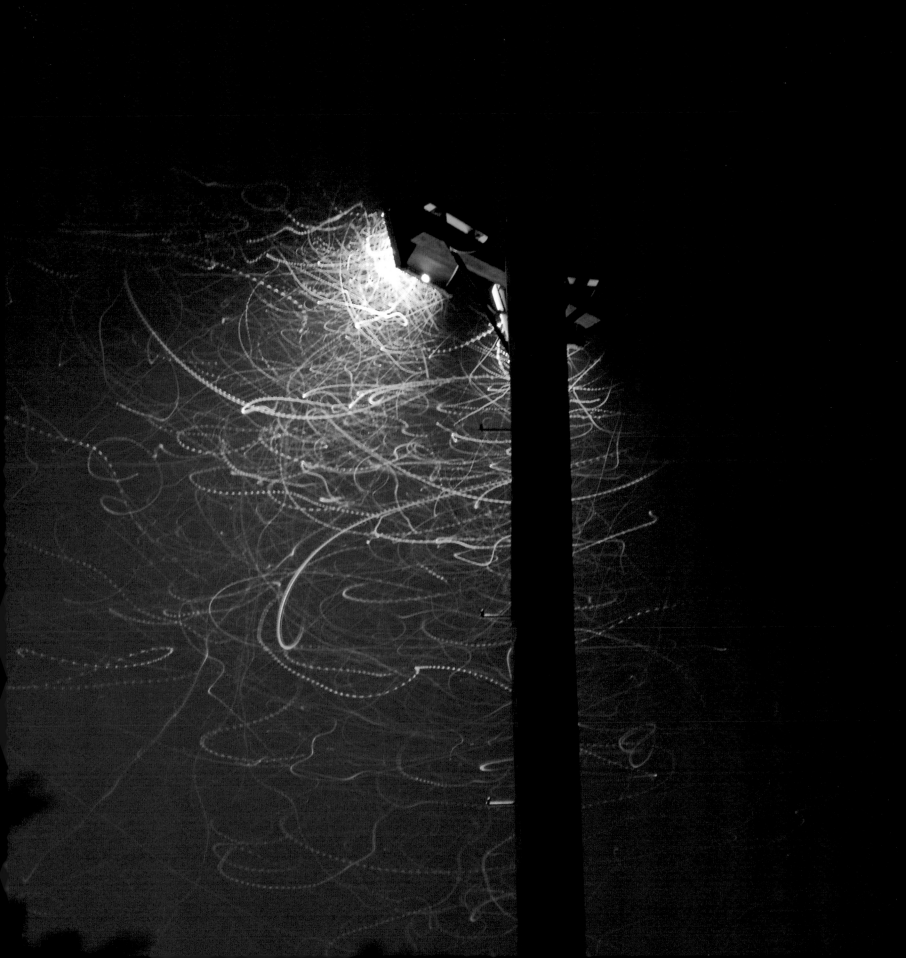

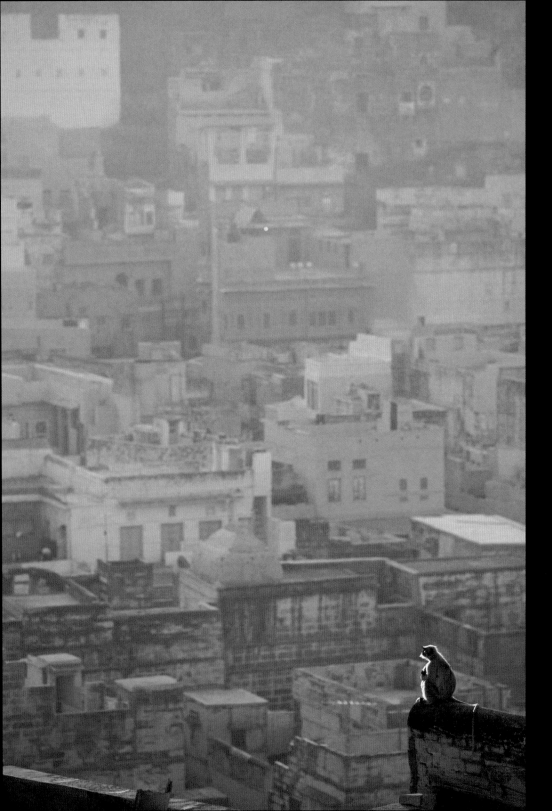

★ RUNNER-UP

**Jean-Pierre
Zwaenepoel**
Belgium

HANUMAN LANGUR SURVEYING THE CITY

According to Hindu legend, the heroic monkey god Hanuman dragged his burning tail across the rooftops of the island of Lanka, torching buildings during his quest to rescue Lord Rama's wife Sita from the demon king. This Hanuman langur is certainly at home high among the tiles and terraces of Jodhpur, in Rajasthan, India. She was one of a troop of about 30 langurs that Jean-Pierre photographed early one morning as the old city centre began to stir. "They cruised along the walls leisurely and elegantly, not unlike domestic cats," he says. This female stopped to sun herself in the early rays, her smoky-black feet, hands and face testimony to the ancient legend.

Nikon F100 with Nikon 180mm lens; automatic at f4; Fujichrome Velvia 100.

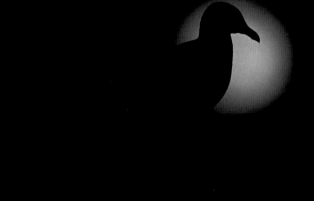

HIGHLY COMMENDED

Lorne Gill
UK

LAMPLIGHT ROOST
"When I saw this gull sitting on top of the light with the rising moon behind it," says Lorne, "I thought the scene looked sinister – akin to something from Alfred Hitchcock's *The Birds*. The gull, of course, had only practical intentions in mind. It was maximising its feeding opportunities in the short days of winter by roosting next to Arbroath's local chip shop, ready to pounce on fish-supper scraps." Being noisy and bold and increasing in numbers, herring gulls have become public enemy number one in many coastal towns. Urban success is the result of the gull's adaptability, swapping cliff-top life for that of roof-top nester and scavenger.

Nikon F5 with 300mm lens and 2x teleconverter; 1/60 sec at f5.6; Fujichrome Velvia 50; tripod.

Animal portraits

This category – one of the most popular in the competition – invites portraits that capture the character or spirit of the subject they focus on.

 WINNER

Alexander Mustard
UK

SNAPPER SHOAL
The Bohar snapper is as fearsome as it looks and one of the larger reef predators in the Red Sea (here, about 70 centimetres – 27 inches). Alexander travelled to Ras Mohamed National Park at the tip of the Sinai Peninsula, Egypt, in June to photograph snappers and other fish during their spawning season. Snappers are normally solitary, but when spawning, they are found in huge aggregations. Alexander wanted to illuminate the strange face of the fish, while at the same time give an impression of the menacing scale of the gathering. But it's snappers themselves that are in danger, as outside the safety of the park, fishermen will target shoals, catching them before the fish have had a chance to spawn.

Nikon D100 with Nikon 105mm f2.8 lens; 1/45 sec at f13; 200 ISO; Subal underwater housing, Cobra head and Subtronic flash.

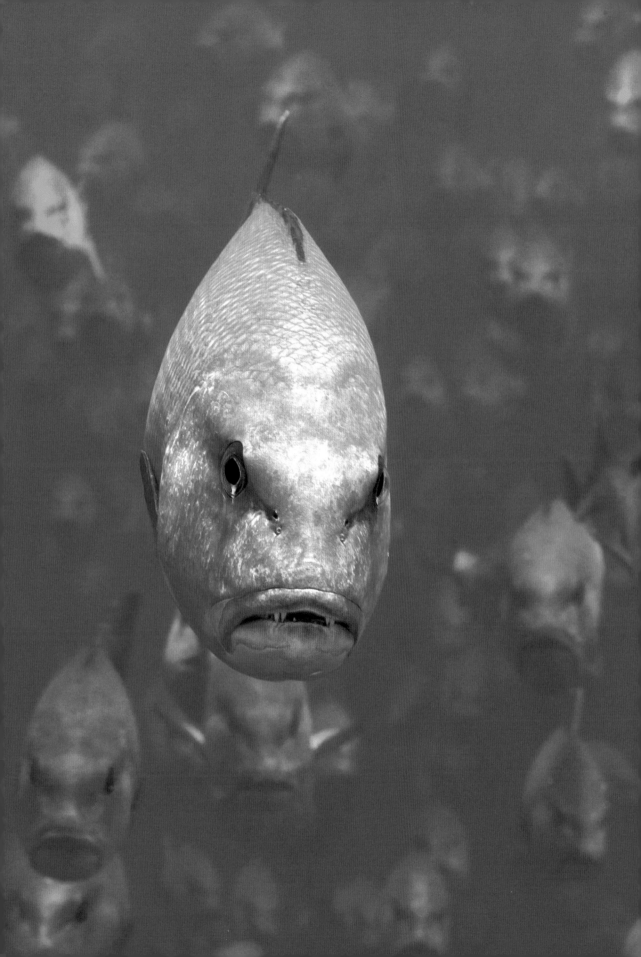

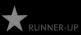 RUNNER-UP

Bence Máté
Hungary

FOX WASHING
A greedy gulp or two, and the entire stick of salami had vanished. The fox hadn't made it through the harsh winter by being shy. Mountaineers staying in a shelter 1,600 metres (5,250 feet) up in Romania's Transylvanian mountains had kept the fox alive with titbits, and it had become half tame. Bence spent five long days in the freezing shelter, salami and camera at the ready. On the fourth day, the fox showed up. After wolfing down the salami, it revealed the genteel side of its nature: the way it licked its paws clean was positively dainty.

Canon EOS 1N RS with Nikon 300mm f2.8 lens, EOS-Nikon converter and Nikon TC-301 2x and TC-14B 1.4x teleconverters; 1/60 sec at f8; Fujichrome Velvia 50; Gitzo tripod, hide.

 SPECIALLY COMMENDED

Scott W Sharkey
USA

GLARE OF THE GREAT OWL
Great horned owls are among
the first birds to nest, sitting on
eggs in winter. So when Scott
spotted a nesting female in
mid-February in a Minnesota
pine forest, he decided to return
in a month, when there would
be chicks and the likelihood
of a blanket of snow. Sure
enough, in mid-March a heavy
storm dumped 20 centimetres
(8 inches) of fresh snow.
Scott returned to the nest at
dusk, taking up position on a
slope overlooking the tree.
"I could tell she had an owlet,
because every so often her
lower body would jerk as her
chick wriggled under her," says
Scott. But he was anxious not to
disturb her by his presence, and
when the owl glared at him, he
took the hint and his final
photograph and left.

**Canon 20D with 500mm f4 lens
and 1.4x extender; 1/15 sec at f4;
mirror lockup, tripod.**

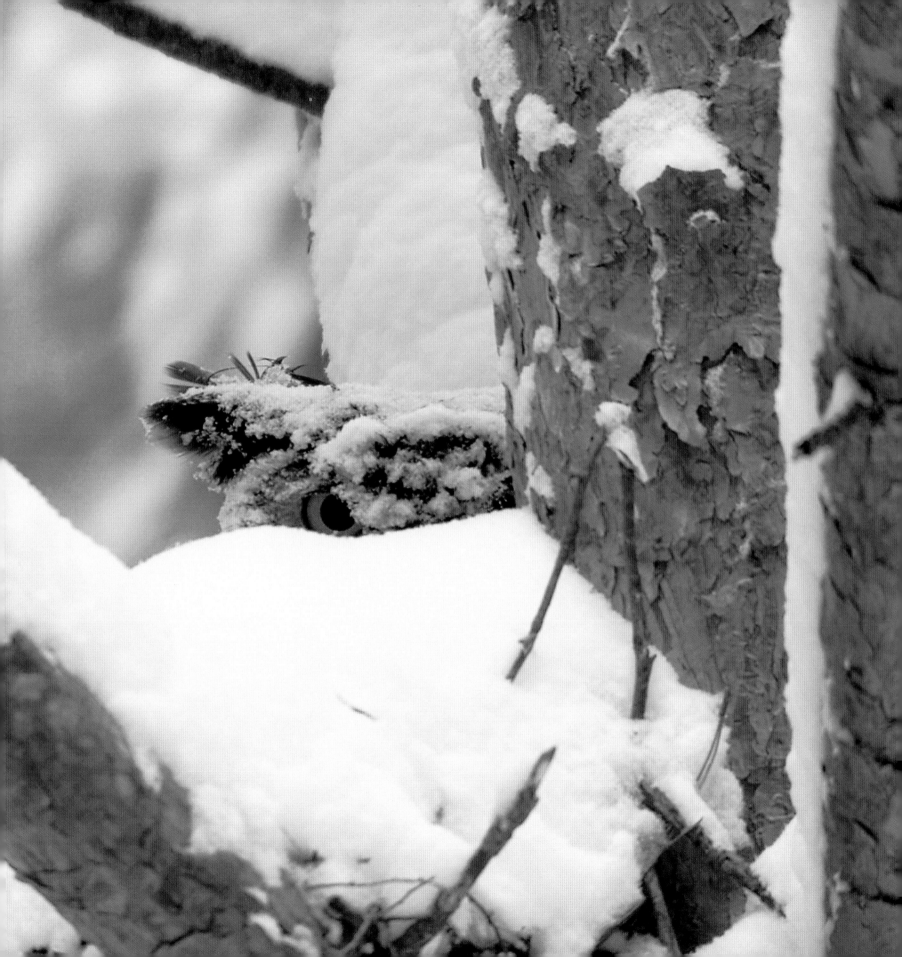

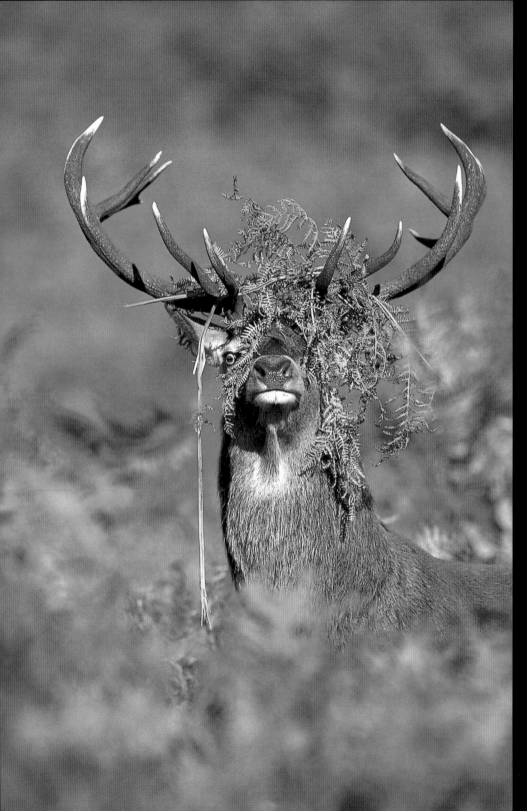

HIGHLY COMMENDED

Danny Green
UK

RED DEER HEADGEAR

So pumped up was this stag while defending his small harem from a rival stag that Danny managed to get to within just 6 metres (20 feet) of him. His headgear is bracken, caught up in his antlers during head-to-head combat in Bradgate Park, Leicestershire's medieval deerpark. "I'd watched these two stags every morning for three weeks during the autumn rut," says Danny. "They were extremely evenly matched and had just three or four females each, so the fights became increasingly frenetic. When he finally noticed me, he briefly made eye contact, giving me this mischievous portrait."

Canon EOS 1V with 500mm IS lens; 1/125 sec at f8; Fujichrome Velvia 50 rated at 80; tripod.

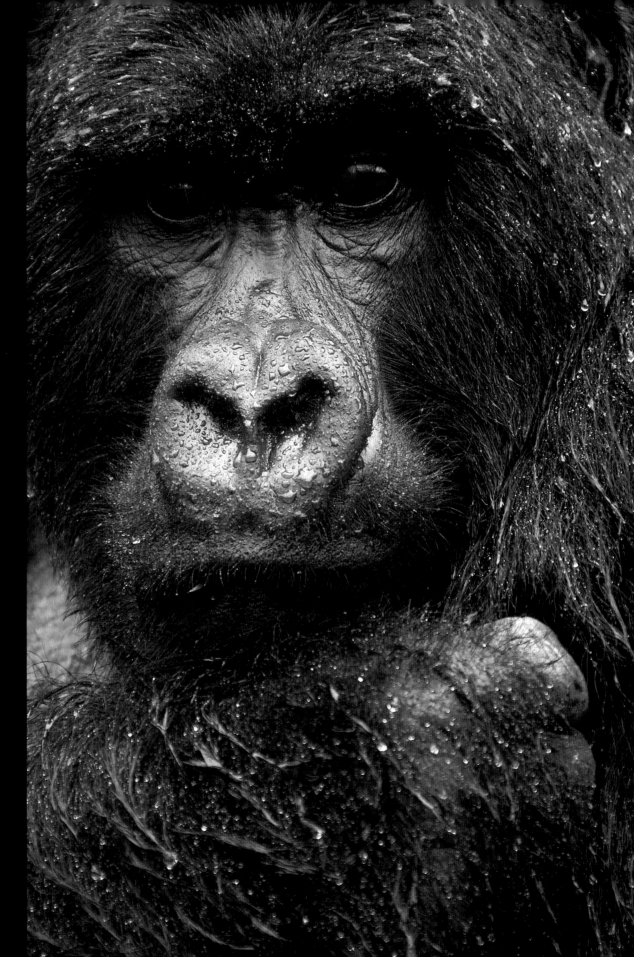

Joe McDonald
USA

GORILLA IN THE RAIN
The only region in the world where mountain gorillas are found is the Virunga Volcanoes – a misty, rainy refuge in Central Africa. Gorillas often take shelter when it rains, but this group in Rwanda seemed happy to wait out the day's downpour in the open. By the time Joe reached them, he was soaked, and his boots were full of water. The silverback (the male group leader) shuffled around several times but was unperturbed by the torrential rain, finally settling into this pose – just as there was a break in the rain that allowed Joe to unpack his camera gear. "I wanted to convey both character and atmosphere and so zoomed in," explains Joe. Fortunately, he didn't make eye contact – to a gorilla a sign of aggression.

Canon EOS 1D mark II with Sigma 120-300mm f2.8 lens; 1/85 sec at f5.6; 400 ISO.

Thomas Sbampato
Switzerland

WAITING FOR MOTHER

Whenever she sensed danger, the mother of this black bear cub would shoo it up a tree until the threat had passed. But on this occasion, she parked it up the tree so she could go fishing. It was August, peak salmon-spawning time, and the Anan Gorge in South-east Alaska's Tongass National Forest was teeming with leaping coho, pink and chum salmon. While she got busy hooking fish, the cub waited, peering down at Thomas and his clicking camera. Just 10 minutes later, the sated female was back to collect her youngster, and they ambled off into the forest together.

Minolta Maxum 9 with Minolta 400mm f4.5 lens; 1/250 sec at f4.5; Kodak VS 100; tripod.

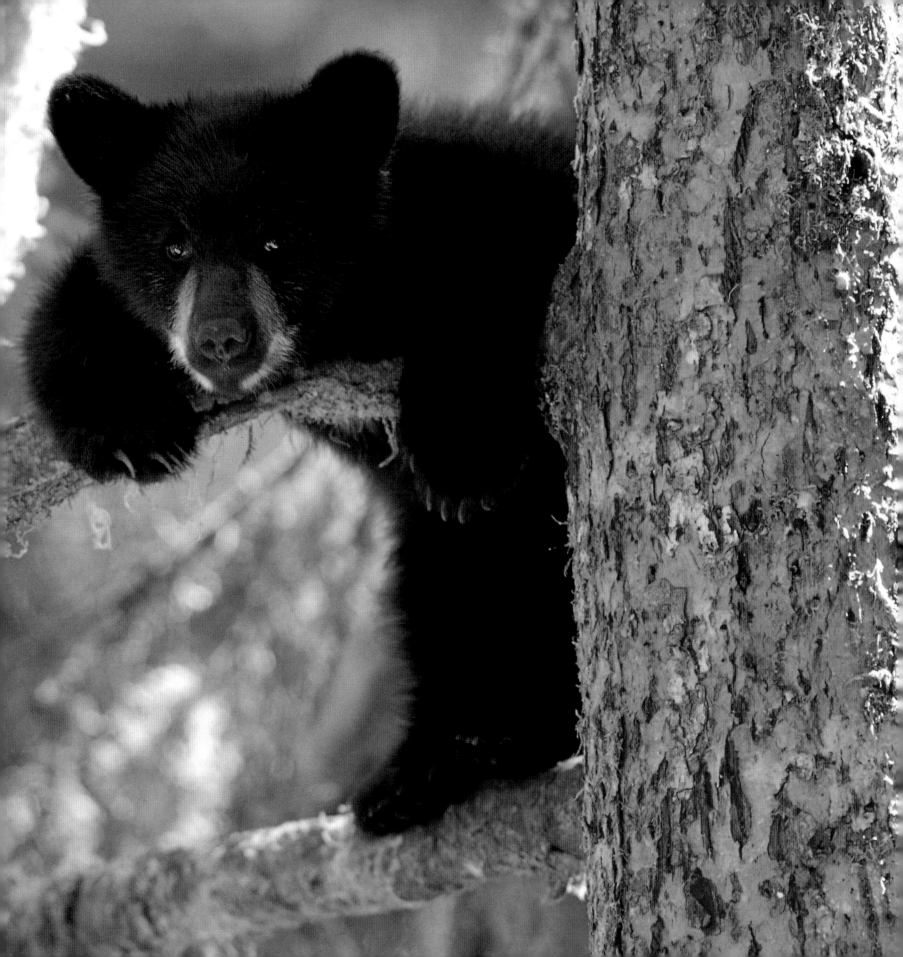

Jari Peltomäki
Finland

GREAT GREY OWL POUNCE
Living close to Oulu in central
Finland, Jari regularly sees great
grey owls (his favourite bird). In
the breeding season, the owls
spend most of their time in the
forests, but in winter they hunt
in the open fields. Jari ventures
out most days, camera in hand,
and the birds are used to him,
which means he doesn't need
a hide. Here the owl has just
pounced on a vole it's heard
moving under the thick snow.
Spread-eagled and vulnerable,
it still manages to retain its
dignity in the face of the camera.

**Canon 1D mark II, Canon IS USM
70-200mm f2.8 lens; 1/1000 sec at
f4; 400 ISO.**

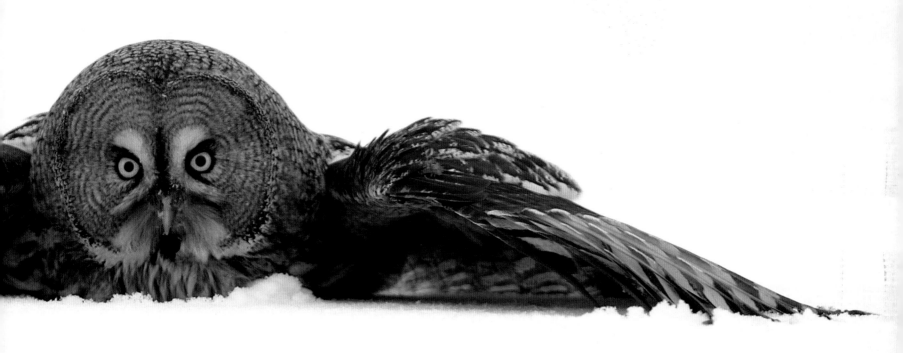

Nature in
black and white

These pictures are all black-and-white prints and are judged on
the quality of the prints as well as the aesthetic appeal.
The subject can be any wild landscape, plant or living creature.

**Luca Fantoni
& Danilo Porta**
Italy

BEECH IN THE MIST
Monte Barro is in the Lombardy
Prealps in northern Italy, not so
far from where Luca and Danilo
live. In summer, it's a hotspot
for flowers and insects. But in
any season, it's a wonderful
place to visit, with woodland
containing majestic, centuries-
old beeches. One particular
foggy grey November morning,
they discovered this individual,
"resembling a wise old patriarch
who had gathered his subjects
around in order to let them
know something important."
Looking skyward, the branches
and twigs appeared root-like,
as though delving upwards
to gain nourishment from
the heavens.

**Nikon F90x with Nikkor 20mm
lens; 1/60 sec at f8; Ilford FP4.**

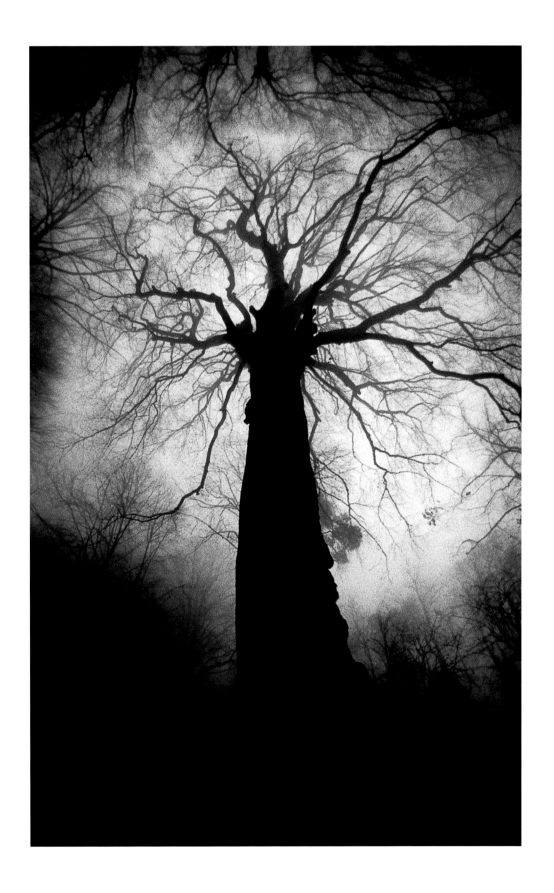

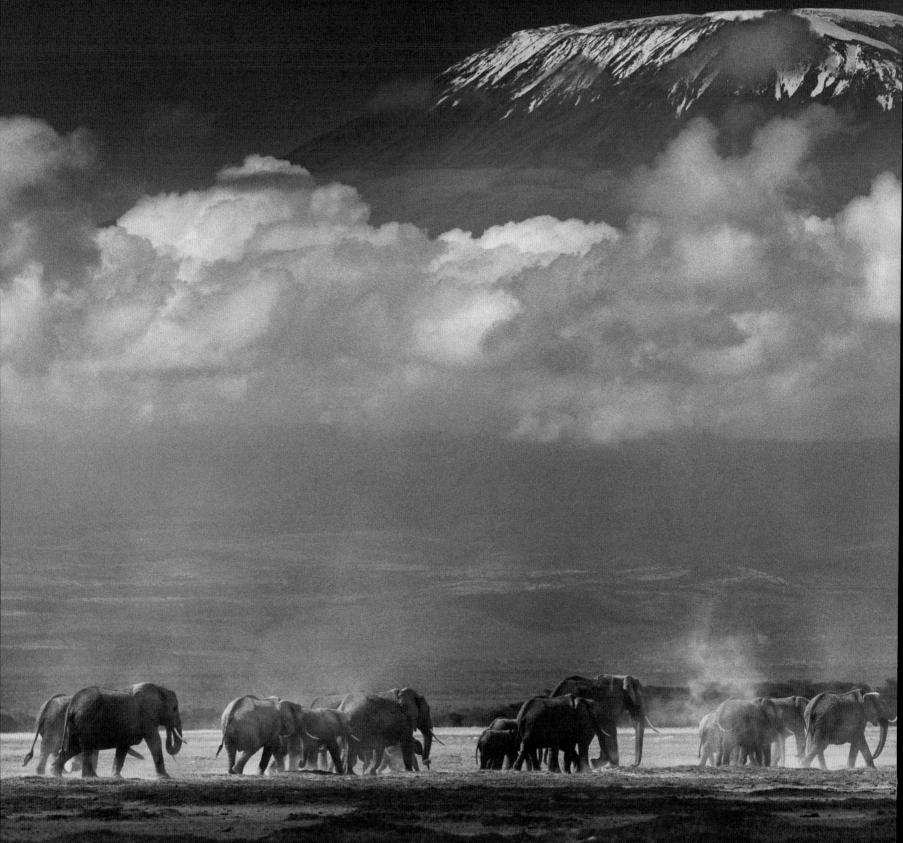

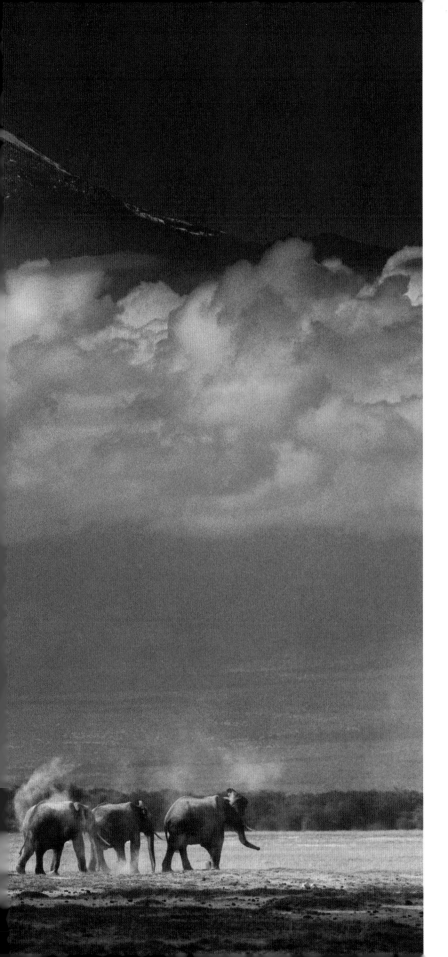

 WINNER

Martyn Colbeck
UK

**ELEPHANTS BELOW
MOUNT KILIMANJARO**
It was Martyn's birthday, and he
decided to take a day's break
from filming (making the third in
a trilogy of films documenting
the lives over 15 years of a
family of elephants in Amboseli
National Park). That morning,
the air was clear enough to see
the summit of Kilimanjaro more
than 40 kilometres (25 miles)
away. Martyn couldn't resist
going out to take photographs.
Several elements came together
to make this picture special: the
clarity of the view of the
mountain, the impressive clouds
and a line-up of elephants
dusting themselves to keep cool
as they travelled towards the
swamps. It was the best
birthday present he could have
hoped for. Moments later, cloud
obliterated the mountain, and
the line of elephants broke up.

**Mamiya 645 AFD with APO
300mm f4.5 lens; Agfa APX 100;
polarising filter.**

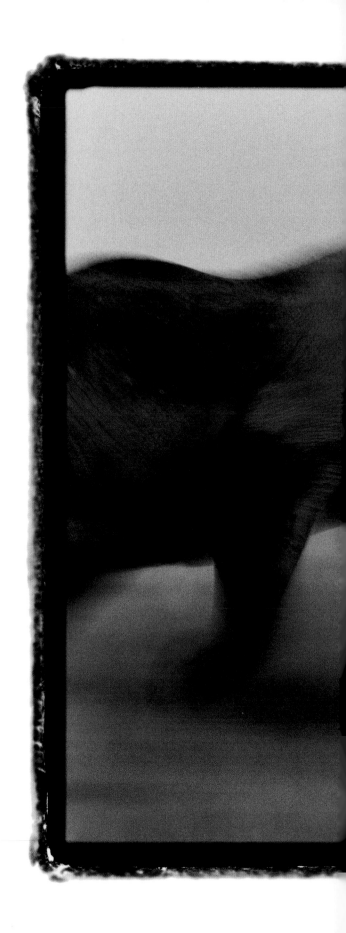

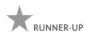 RUNNER-UP

Martyn Colbeck
UK

CLASH OF THE BULLS
Martyn encountered these two huge bulls late one evening in Amboseli National Park and could tell immediately by their manoeuvring that they were sizing up and about to fight. He got ready for the inevitable, terrifying thud and clank of ivory, setting the camera at a low shutter speed to blur the action and create a sense of movement and power. The bull on the right has stopped momentarily, trying to prevent himself being twisted off his feet. If he had succumbed, he might have been fatally speared by the winner, but he managed in this instance to twist free and flee (the more common outcome of such fights). Serious fights between bull elephants are rare, and competing bulls are usually of similar size and in 'musth' – a period of heightened sexual activity and aggression in a male elephant's sexual cycle.

Canon EOS 1V with Canon EF 300mm f2.8 lens; 1/15 sec at f2.8; Ilford Delta 100; fluid-head tripod.

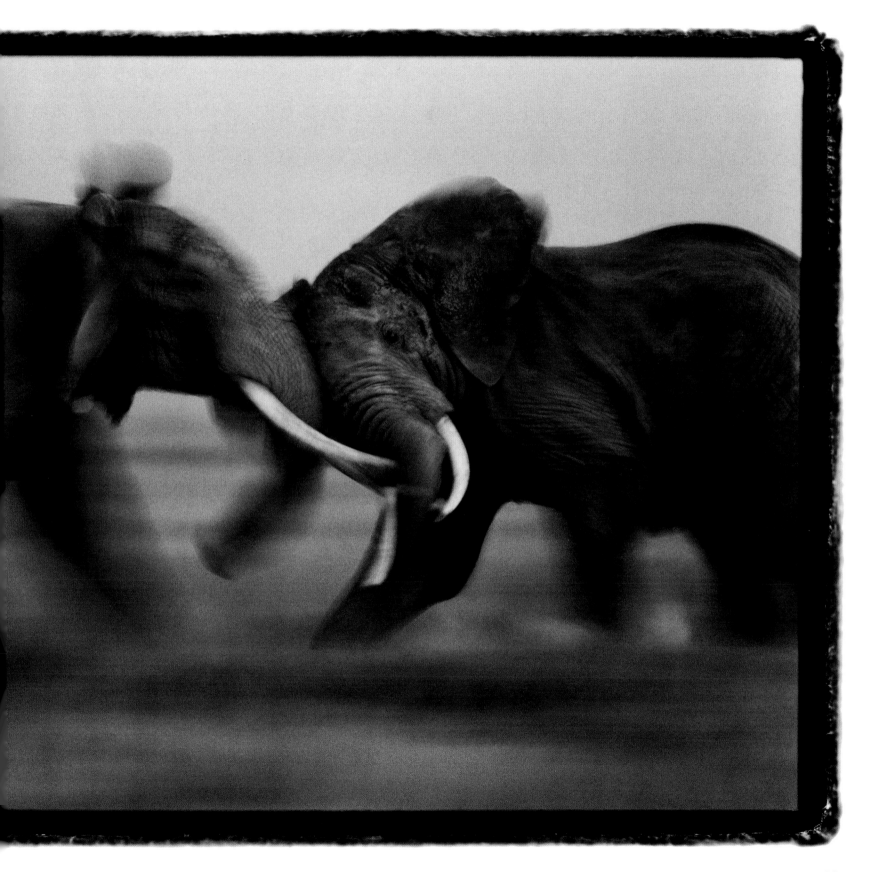

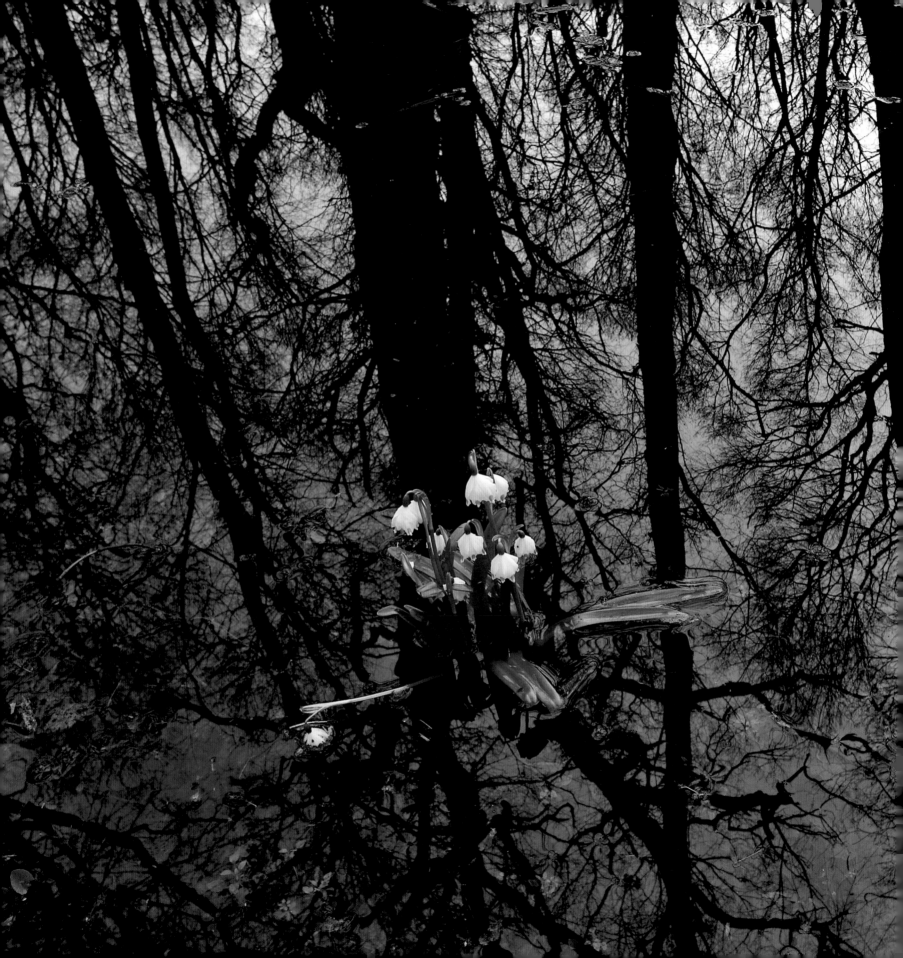

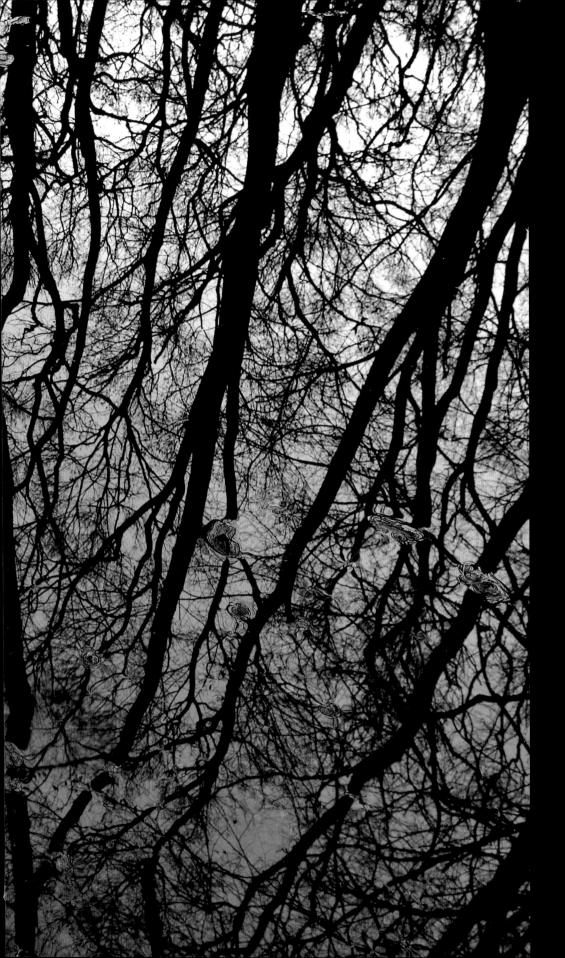

In praise of plants

The aim of this category is to showcase the beauty and importance of flowering and non-flowering plants, whether by featuring them in close-up or as part of the habitat.

 WINNER

László Novák
Hungary

SPRING SNOWFLAKES IN THE FLOODED FOREST

Every spring, László visits an ancient forest in western Hungary with his family to admire the millions of flowers that carpet the forest floor. This March, they were shocked to find that a river had burst its banks and part of the forest was a lake. László never travels anywhere without his photographic kit and a pair of rubber boots. What fascinated him most was the reflected forest of towering, leafless trees. Though the light was dull, it was ideal for bringing out the white of the petals of this drowning snowflake plant – a contrast against the soft brown of the water and dark, interlacing network of reflected branches.

Canon EOS 20D with Canon 17-40mm f4 lens; 1/6 sec at f11; 100 ISO; tripod.

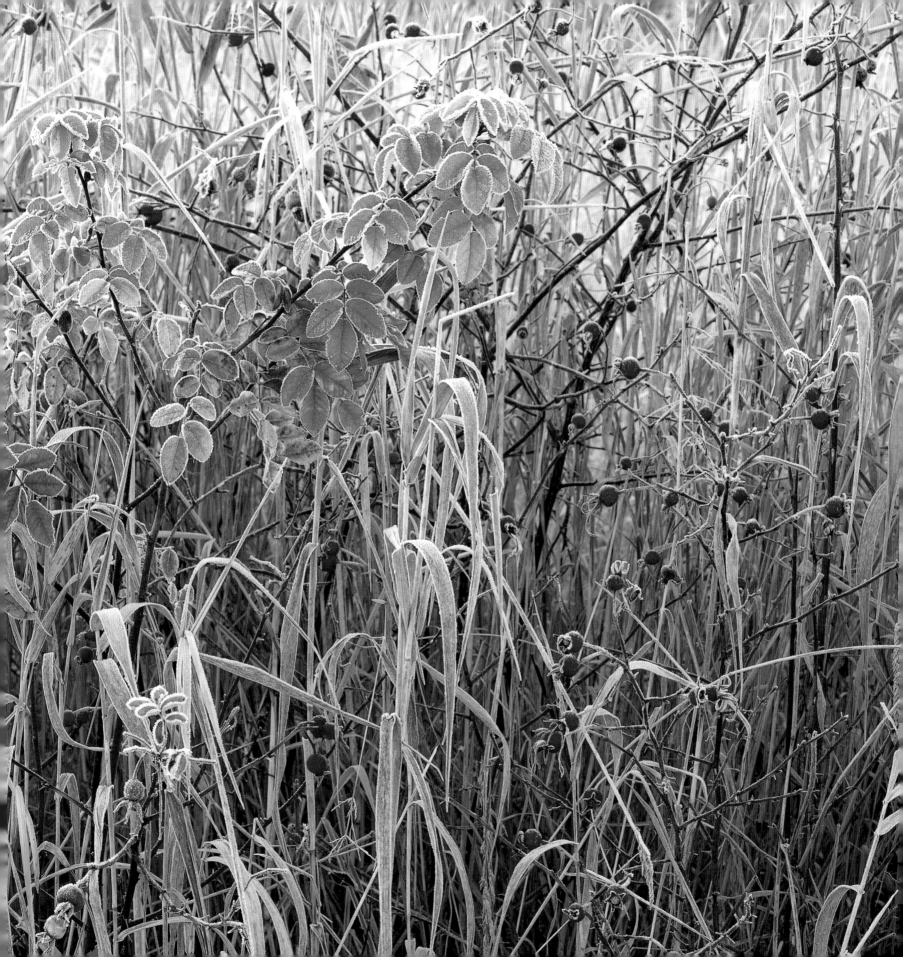

Tom Putt
Australia

ANCIENT SNOW GUM
This trunk – photographed in one of the coldest regions of Australia: Charlotte's Pass, in New South Wales – impressed Tom by the intensity of the contrasting colours of its bark and its twisted form and sheer bulk. The size of the snow gum compared to other, thinner trees in the forest suggests it is hundreds of years old. Mist and rain added a mystical feel to the alpine forest – a remnant of a once-vast area of forest badly damaged by a huge bushfire in 2003, which burnt more than a million hectares of state forests and national parks.

Canon EOS 20D with EF 17-35mm f2.8 lens; 1/20 sec at f10; 200 ISO.

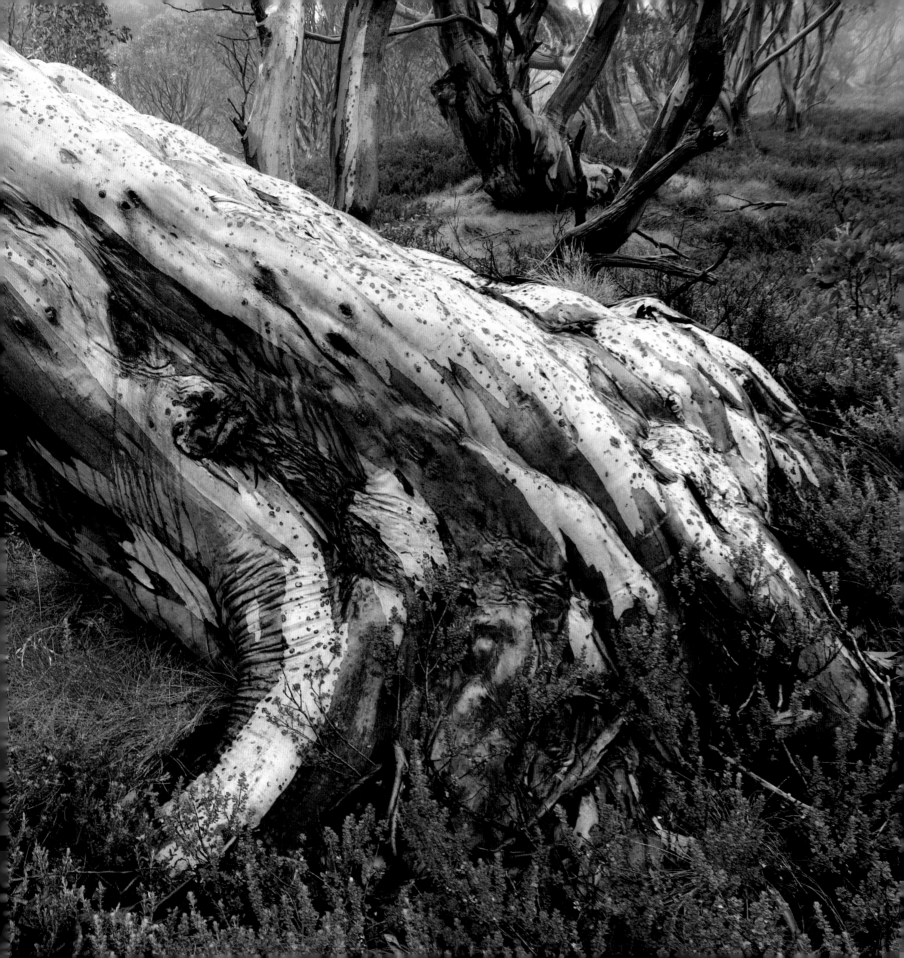

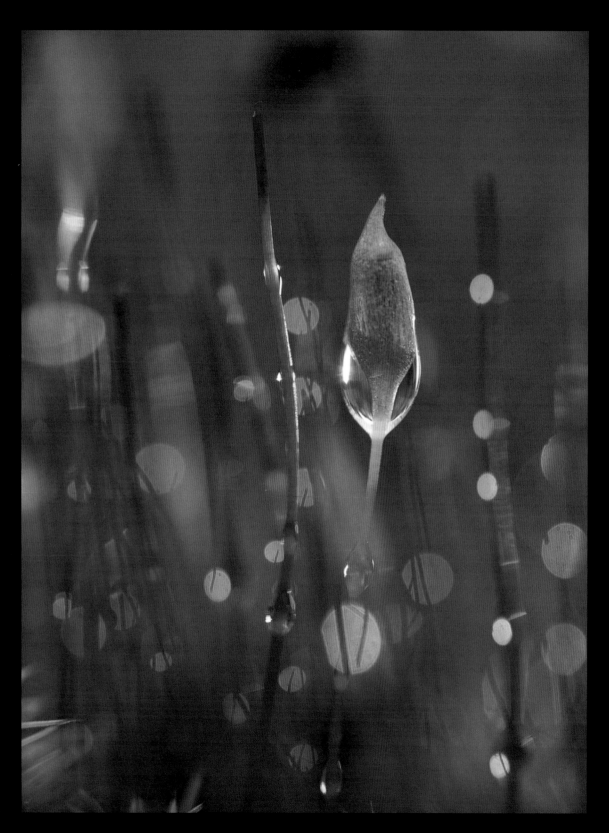

Torbjörn Lilja
Sweden

MOSS LANTERN

Torbjörn has always loved haircap moss. It's the way it shimmers, the way it moves in the breeze, he says. Last summer, he decided to devote himself to creating a portfolio of pictures that would reflect its many forms in different light and conditions. He took this particular picture late one evening, near his home in Byske, Västerbotten, after a light shower. The low sun had just broken through the clouds, back-lighting the carpet of moss. "Beadlets of moisture glimmered like small lanterns among the spore caps and leaves," he says.

Pentax 645 NII with Pentax 120mm f1.4 macro lens; 3 secs at f4; Fujichrome Velvia 50.

Composition and form

Here, realism takes a back seat, and the focus is totally on the aesthetic appeal of the pictures, which must illustrate natural subjects in abstract ways.

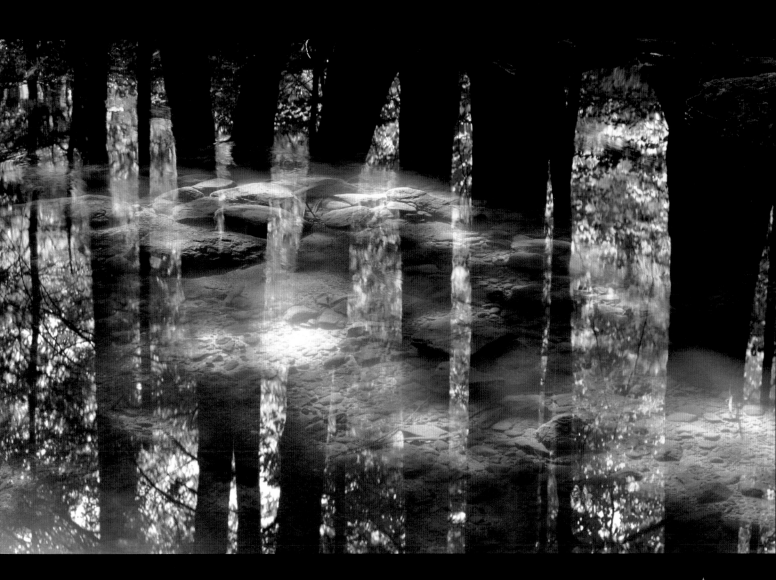

⭐ WINNER
Michel Loup
France

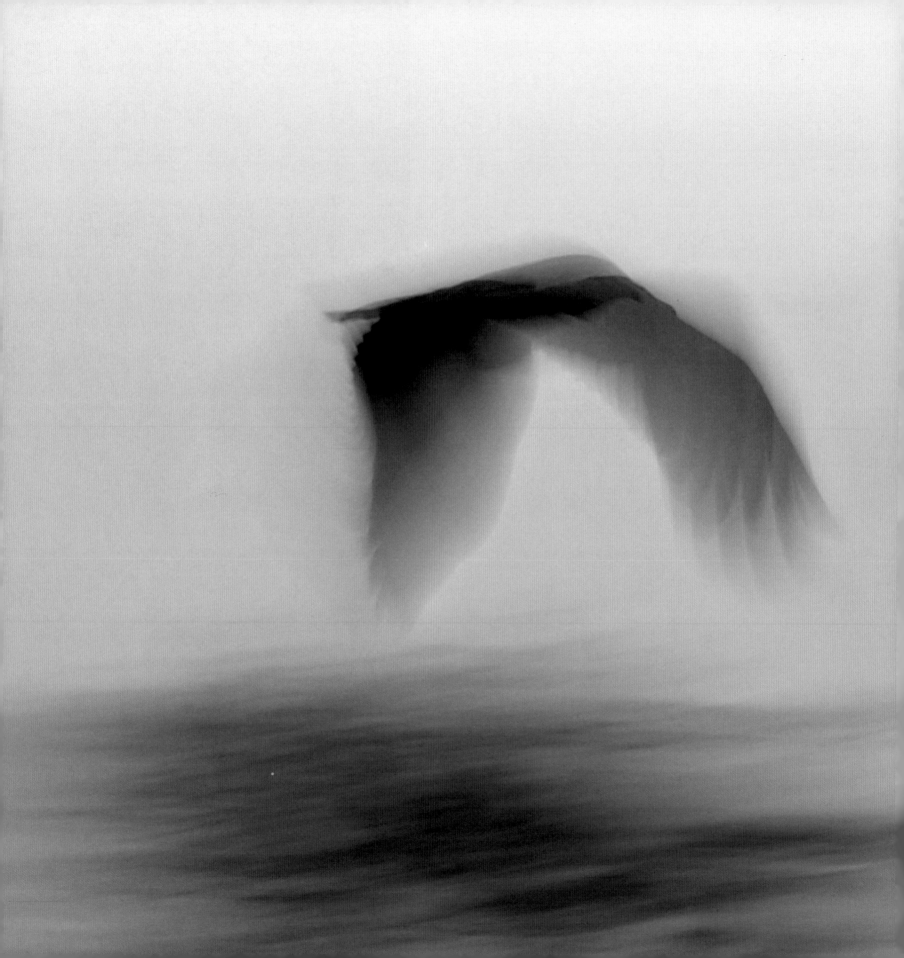

 RUNNER-UP

Alessandro Bee
Italy

DUSK FLIGHT

This is an African scene unlike any other. Instead of blue sky and an acacia-studded horizon, the background is colourless and the bird merely an impression. The picture was taken in the Serengeti at dusk, just as Alessandro was finishing a more conventional photography session with a lion pride. Two white-backed vultures appeared, flying low towards him. As the second passed by in the fast-fading light, he panned the camera using a slow shutter speed to transform the vulture and its shadow into an abstract image of movement.

Nikon D70 with Sigma 70-300mm f4-5.6 lens; 1/8 sec at f27; 200 ISO.

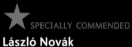 SPECIALLY COMMENDED

László Novák
Hungary

A SWIRL OF BRAMBLINGS
Three or four million. That's how
many migrating bramblings
local people claimed had been
roosting since December in
a forest near the village of
Manga in Slovenia. Incredulous,
László visited the forest on
the first day of 2005 to see for
himself. He knew that
bramblings congregate in vast
numbers in winter, but not in
those numbers. Half an hour
before sunset, the first small
flocks began to appear, along
with a handful of sparrowhawks
and buzzards. By the time the
sun nudged the horizon, the sky
quivered black with arriving
flocks, and their chuk-chuk flight
calls echoed through the valley.
As the sun set, László went into
the forest to try to capture in an
image the sense of activity and
noise. Every branch was thick
with birds, and László's clothes
were soon thick with their
droppings. The result, though,
was worth it.

Canon EOS 1DS with 500mm lens;
1/320 sec at f22; 400 ISO;
Gitzo tripod.

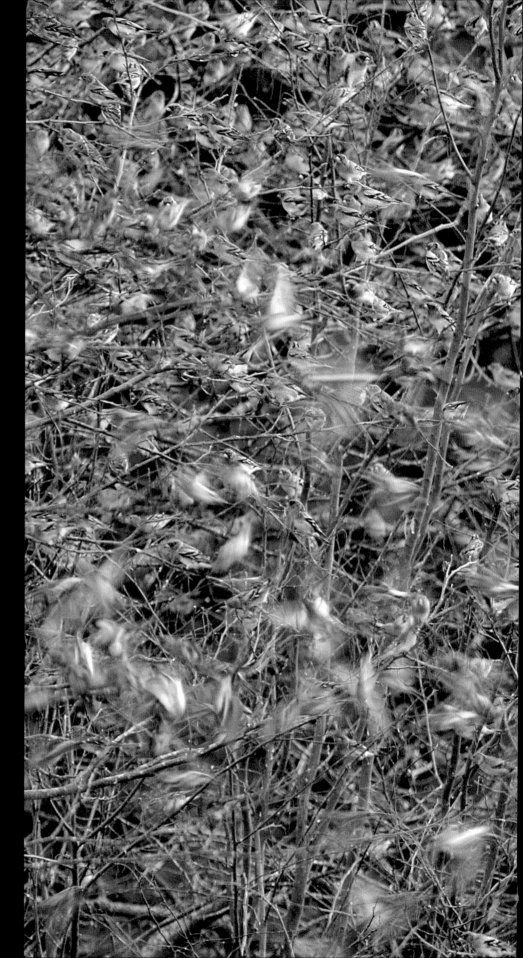

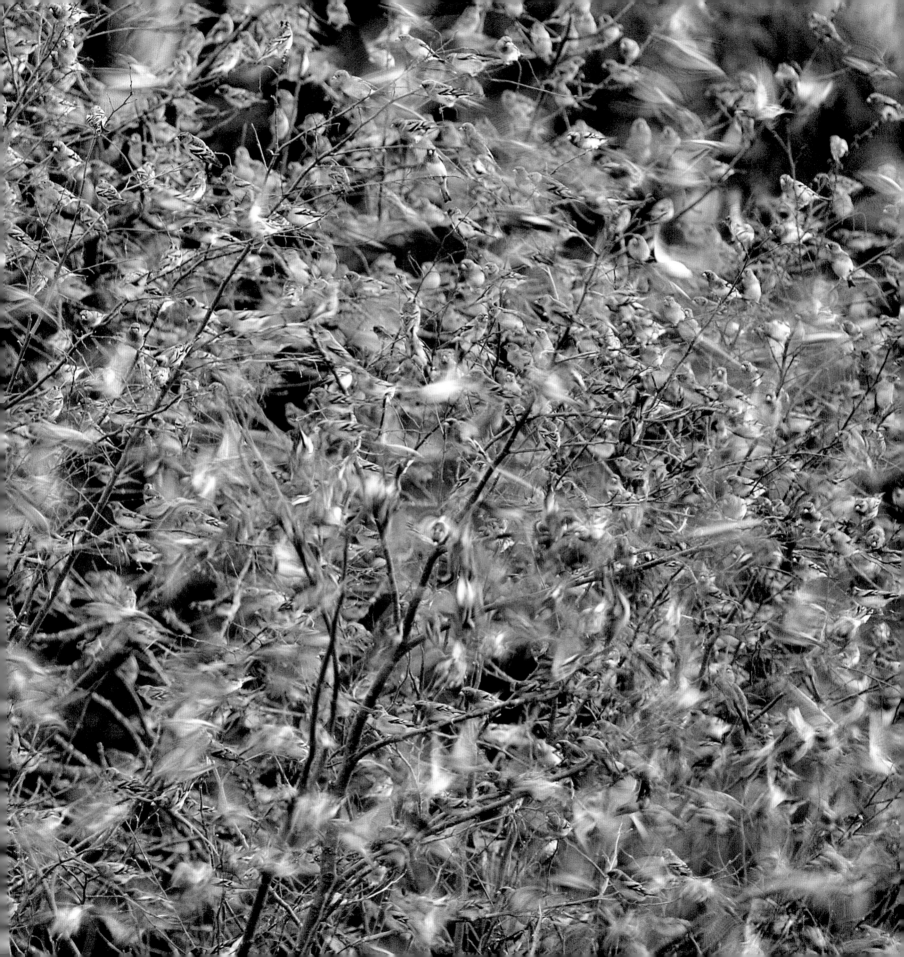

Ross Hoddinott
UK

WIND AND WEIR

One bright February day, Ross came across a small, fast-flowing weir along the Bude Canal in North Cornwall. Having already taken a few frames, he noticed that gusts of wind were creating a fine spray. Using a slow shutter speed to blur the rapid water and angling himself so the low morning sunshine would illuminate the spray, he waited for the wind to blow before releasing the shutter. "When I processed the RAW files," says Ross, "some images looked messy because of all the excessive spray. But this shot captured the strange effect I'd hoped for."

Nikon D70 with Sigma 100-300mm f4 EX IF lens; 1/6 sec at f32; 200 ISO; Manfrotto tripod.

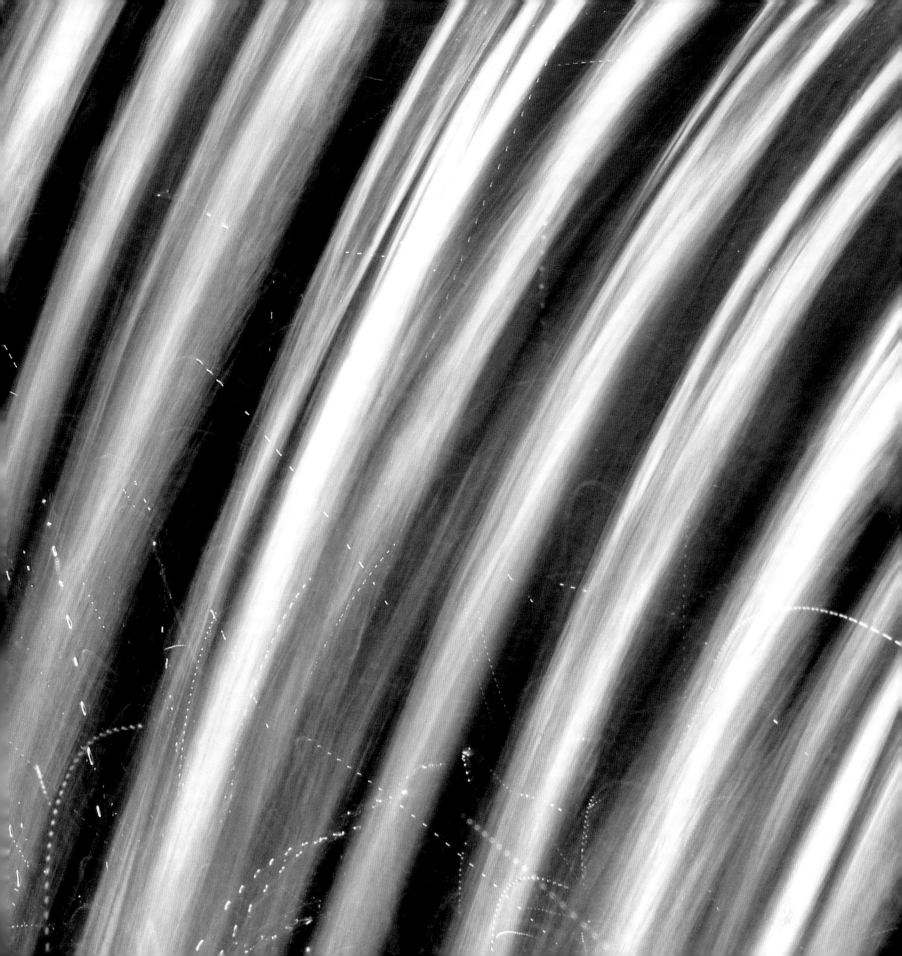

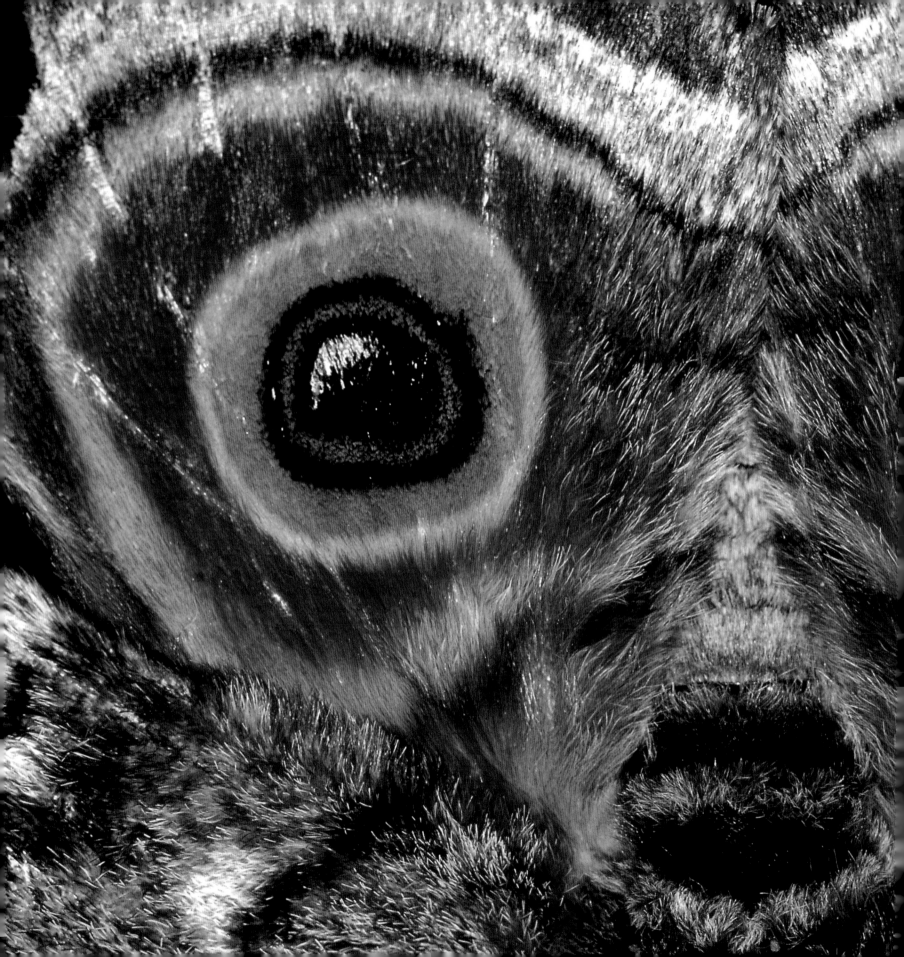

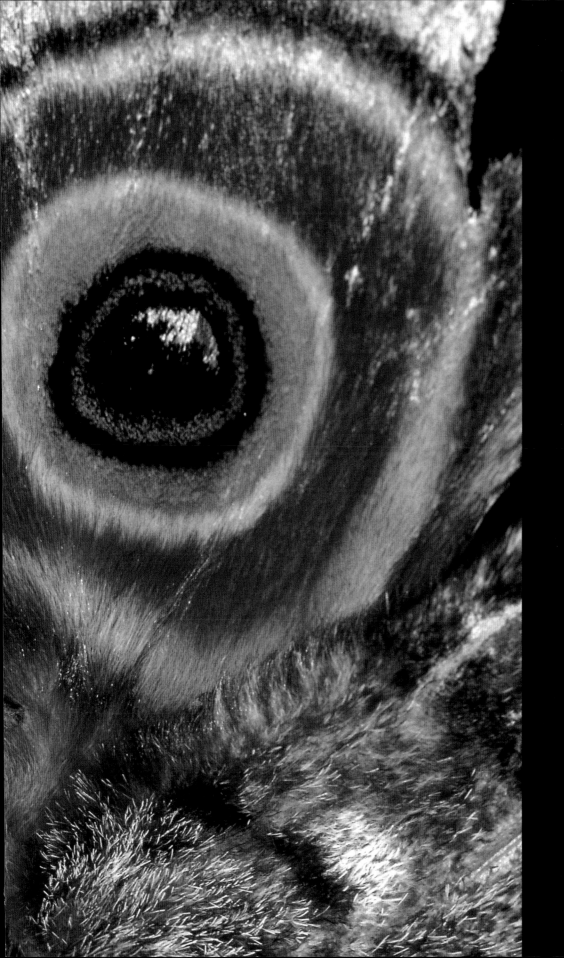

Carlo Delli
Italy

MOTH SURPRISE

Should a predator – a lizard, perhaps – get too close to this speckled emperor moth . . . boo! It finds itself staring into what look like the eyes of a nocturnal mammal. The eyes are utterly convincing – there's light-shine in the pupil, a yellow iris, a dark red socket and even pale, arched eyebrows. The moth's scales are pigmented in such minute detail that they even manage to convey a 3D illusion of hair growth on a furry face and pointy muzzle. Carlo started photographing the closed wings of this moth, which he found camouflaged among dead leaves in a forest in South Africa's Mkuze Game Reserve but got the shock of his life when this face suddenly flashed into his macro lens. Imagine, then, the effect on a lizard.

Canon T90 with Macro 100 Canon lens; probably 1/125 sec at f.4; Kodak 100 professional.

Wild places

This is a category for landscape photographs, but ones that must convey a true feeling of wildness and create a sense of awe.

 WINNER

Staffan Widstrand
Sweden

ICE RAINBOW
Stora Sjofallet National Park in far north Swedish Lapland is famous for its reindeer and spectacular sub-arctic landscape. Staffan spent several weeks there in January on a photo-story about Saami ecotourism. One sunrise, while reindeer-sledding, he witnessed the year's first rays of sun hit this mountain crag and create a rainbow in the icy fog. "None of us, not even the reindeer herdsmen, had ever seen a rainbow in temperatures as low as -25˚C (-13˚F)," said Staffan. Within five minutes, it had faded away, as if retreating into the heart of the mountain.

Nikon D70 with 200-400mm f4 lens; 1/125 sec at f11; 200 ISO; tripod.

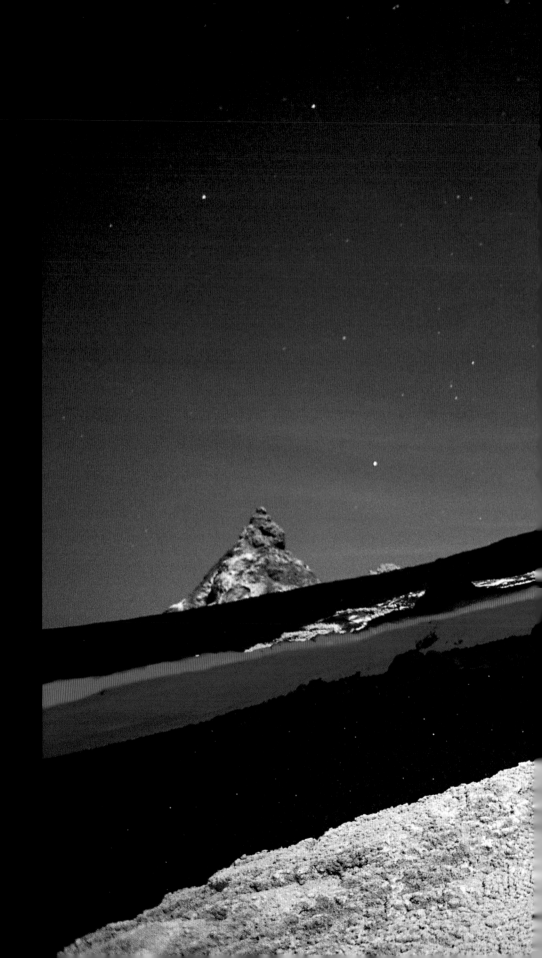

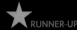 RUNNER-UP

Olivier Grunewald
France

LAVA BY MOONLIGHT
Looking like a highway out of Hell, this lava stream has been regurgitated from the belly of Ol Doinyo Lengai, Tanzania's Rift Valley volcano. The lava is the fastest flowing in the world, containing very little silicon and therefore being 'cold', merely about 510°C (950°F), compared to more than 1,100°C (2,012°F) for most other lavas. It's not hot enough to glow in the day, when it just looks like a mud river, but at night it's spectacular. What Olivier hoped to capture was a blood-red eruption lit by the moon. But to take such a picture, he first had to climb the volcano and camp at the summit. He then had to wait for the full moon and a clear sky unobscured by gas and steam from the vent, and finally to get as close as he dared to a lava flow. It took a week, but the result was a unique picture lit by celestial light.

Nikon F100 with 28mm f1.4 lens; 30 secs at f2; Fujichrome Provia 100 rated at 200; tripod.

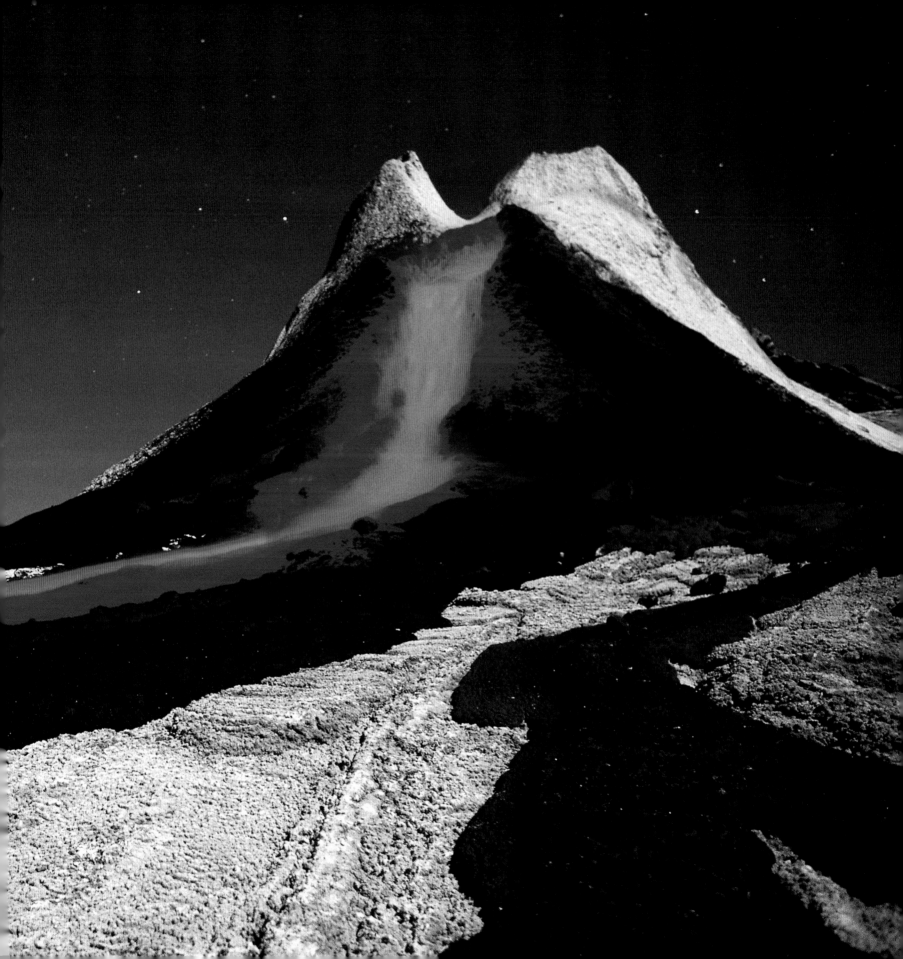

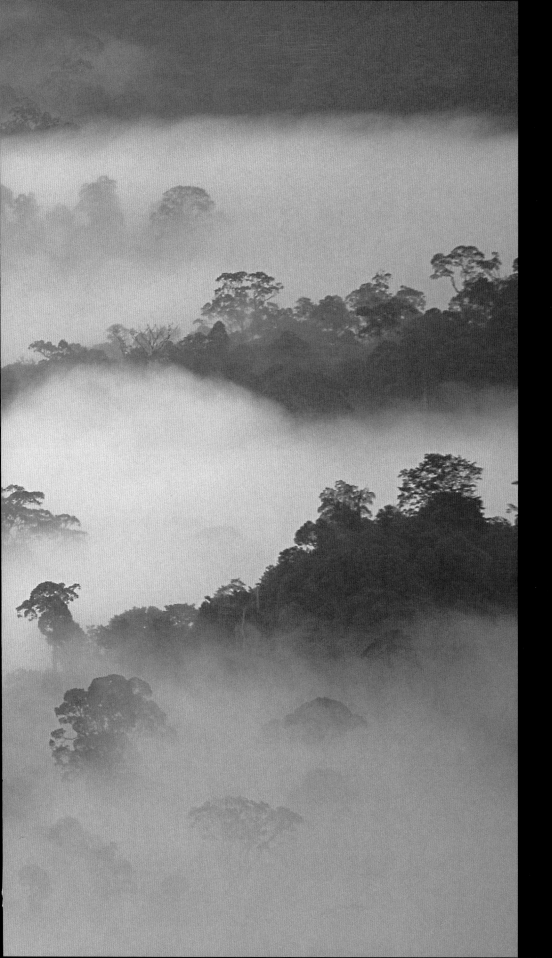

Thomas Endlein
Germany

RAINFOREST DAWN

Thomas Endlein had just one opportunity to climb a 100-metre (328-foot) observation tower at a small research station in Sabah, Borneo. He went up at dawn, before the sun had a chance to burn off the mist. Only the tallest trees, those 30-40 metres (98-131 feet) high, poked through the dense layer. "The pattern of mist changed so rapidly the view was never the same from one minute to the next," Thomas says. "I wanted to create the breathtaking mood of the rainforest. As the sun rose, the air became filled with the songs of birds and gibbons, but the very first noise I heard was a distant chainsaw."

Canon EOS 1N RS with 100-400mm lens; 1/60 sec (one f-stop overexposed); Fujichrome Astia 100; tripod.

113

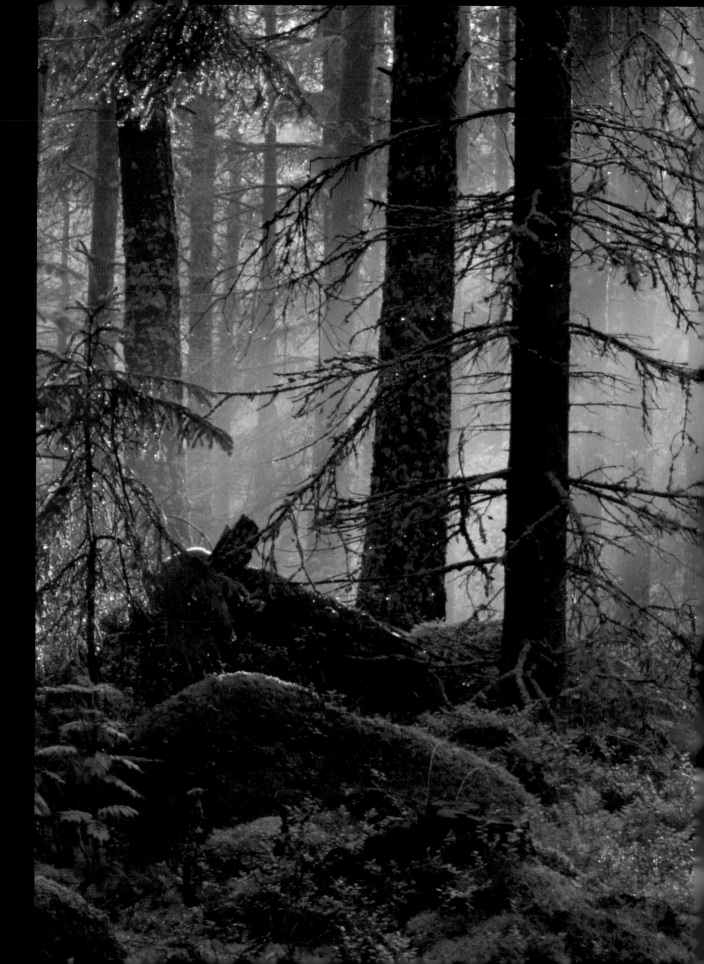

HIGHLY COMMENDED

Henrik Lund
Finland

AFTER THE THUNDERSTORM

One beautiful evening, just after a heavy thunderstorm, when the mist had started to rise, Henrik set off to photograph elk in a forest meadow where he knew they gathered to graze. Forest covers most of Emäsalo island in the Porvoo archipelago, and it was the forest that he ended up photographing. "The rays of evening sunshine had begun to warm it up again, and the whole place glowed," he remembers. "This is how I see Finnish nature – gold and green."

Canon EOS 300D with Canon EF 100-400mm f4.5-5.6 IS USM lens; 1 sec at f25; 100 ISO; Slik Pro 400DX tripod.

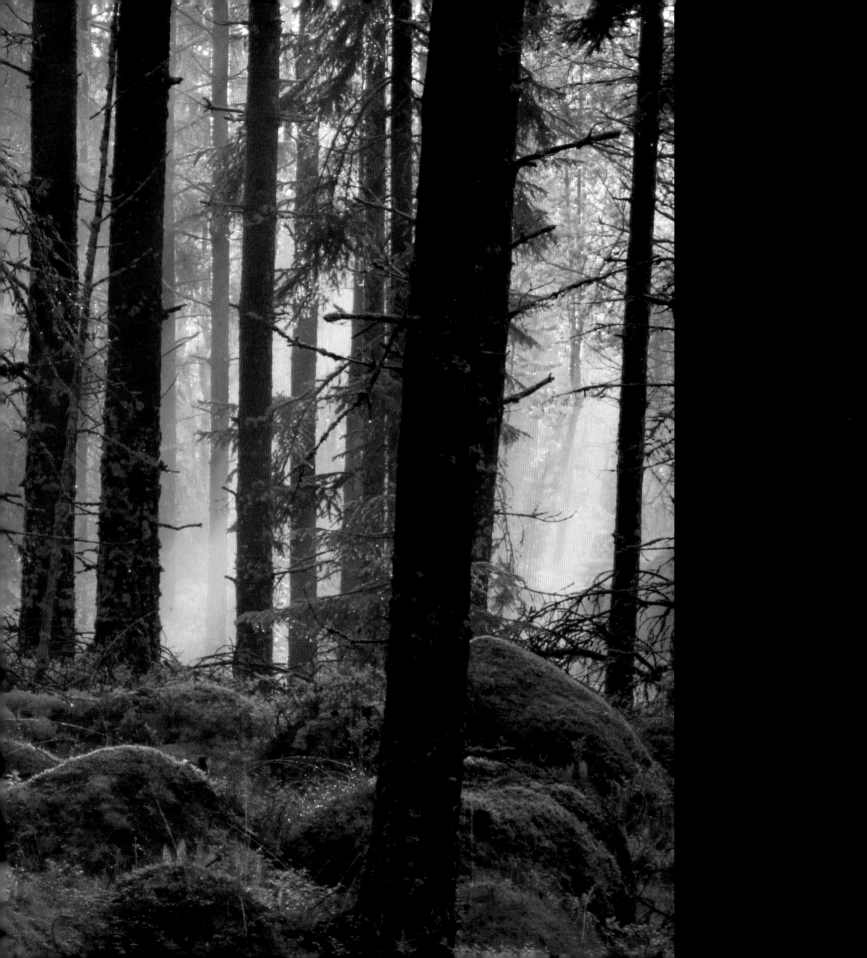

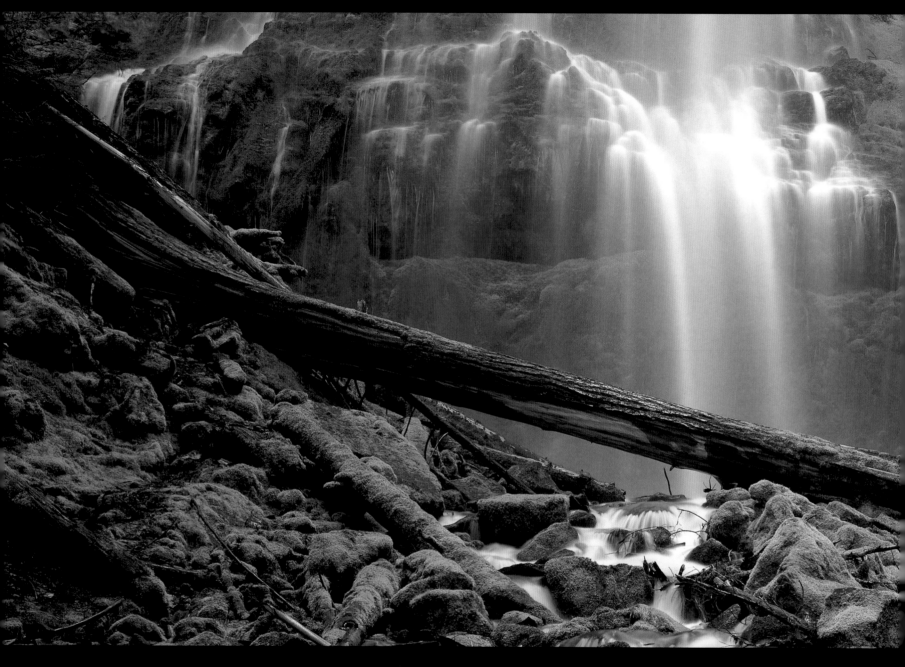

Jeremy Walker
UK

CASCADE MOUNTAINS
Jeremy had heard about the Proxy Falls in the Cascade Mountains, Oregon, USA, but as he says, "Words just don't do the location justice." The mountain range is an old-growth forest hotspot and includes spectacular lava formations. Springs dot the area. Following one of them down, Jeremy trekked for 45 minutes across an old lava flow, finally emerging at the Proxy Falls. Scrambling down to a rocky area t the foot of the falls "was like landing in another world. The moss just gave off a lovely, ethereal glow. The drenching I got in the process was well worth it."

Fuji 6x17 Panoramic with 180mm lens; 1 minute at f45; Fujichrome Velvia 50.

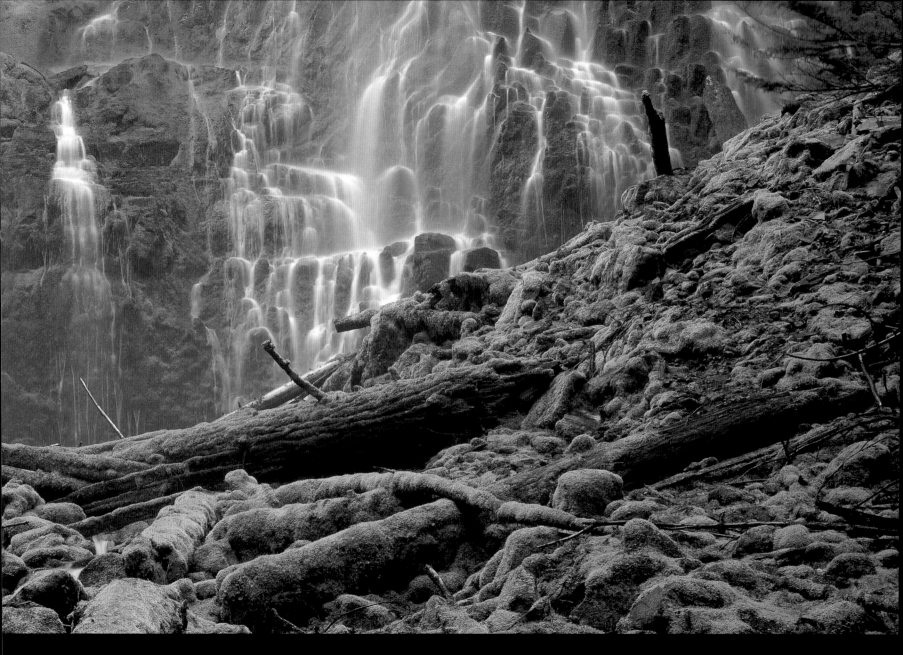

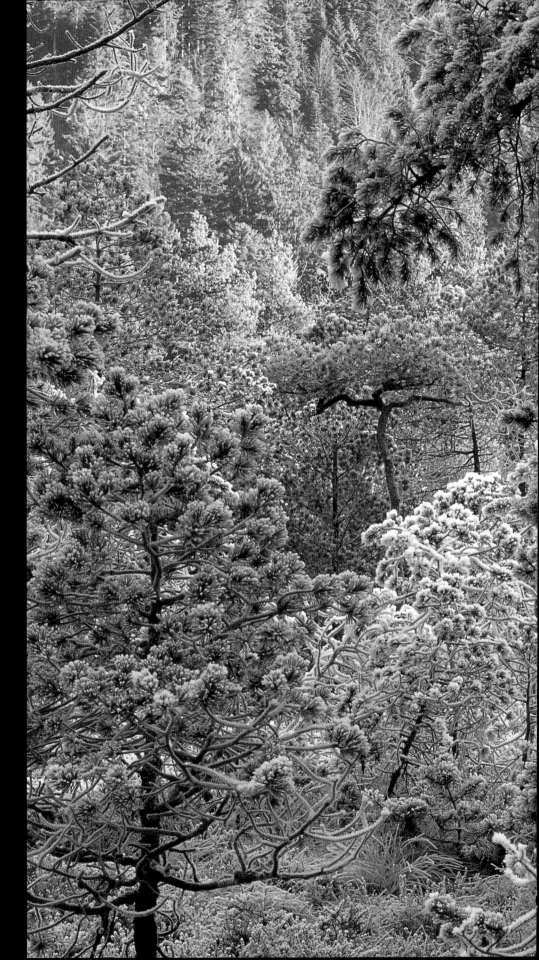

**Christophe
Sidamon-Pesson**
France

FROSTED PINES

In December, when
temperatures had dropped
below freezing, Christophe
travelled to the Ballons des
Vosges Natural Park in France
near the border with Germany.
"I love the atmosphere of
wilderness you find in the
peatland there," says
Christophe, who went
specifically to photograph the
frosted landscape. "In this
wooded peat-bog valley,
ice-crystals several centimetres
long covered every plant." On
the opposite side, the sun had lit
up the hillside forest, providing
a golden backdrop to the
monochromatic scene.

**Nikon F100 with 28-70mm lens;
Fujichrome Velvia 50; tripod.**

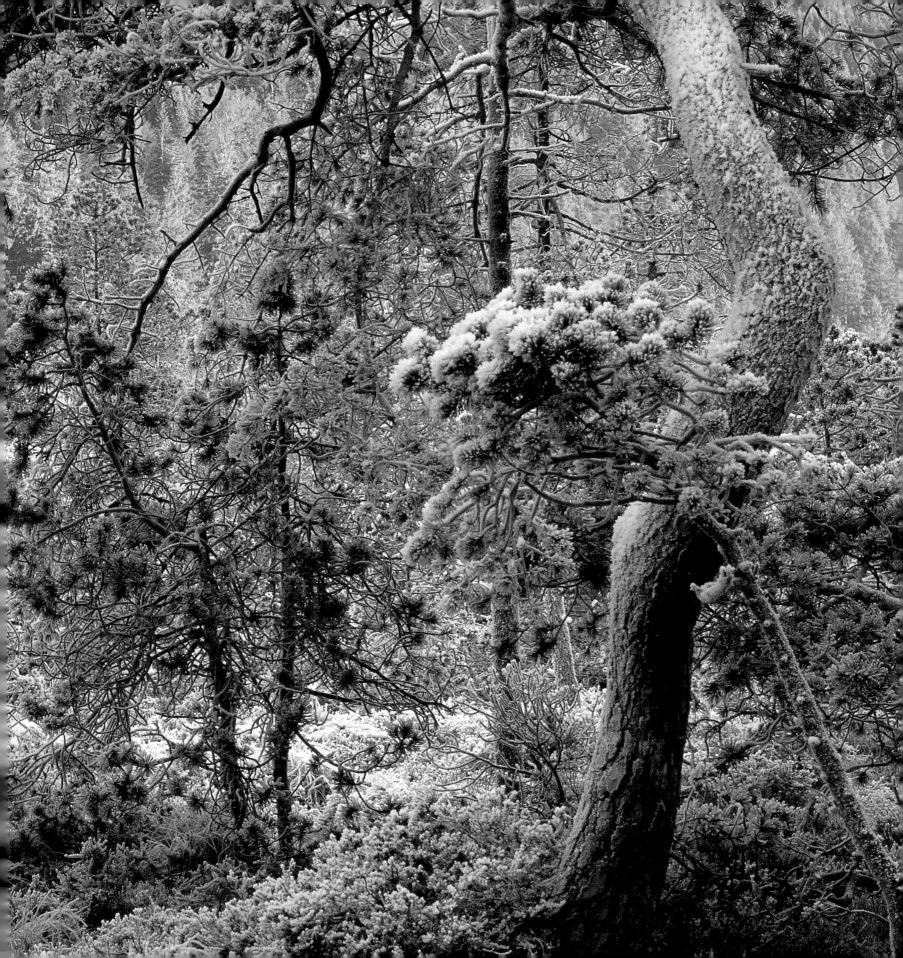

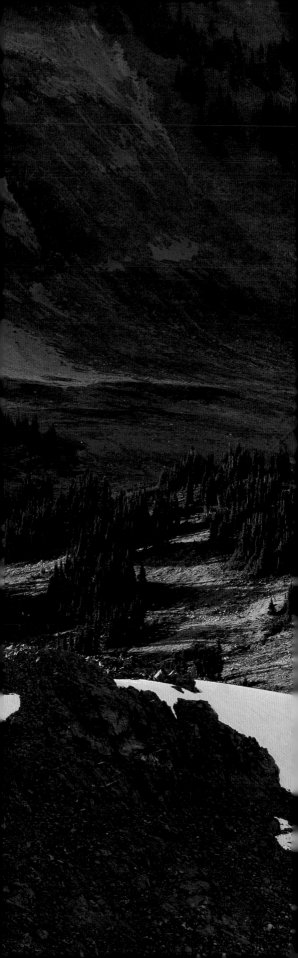

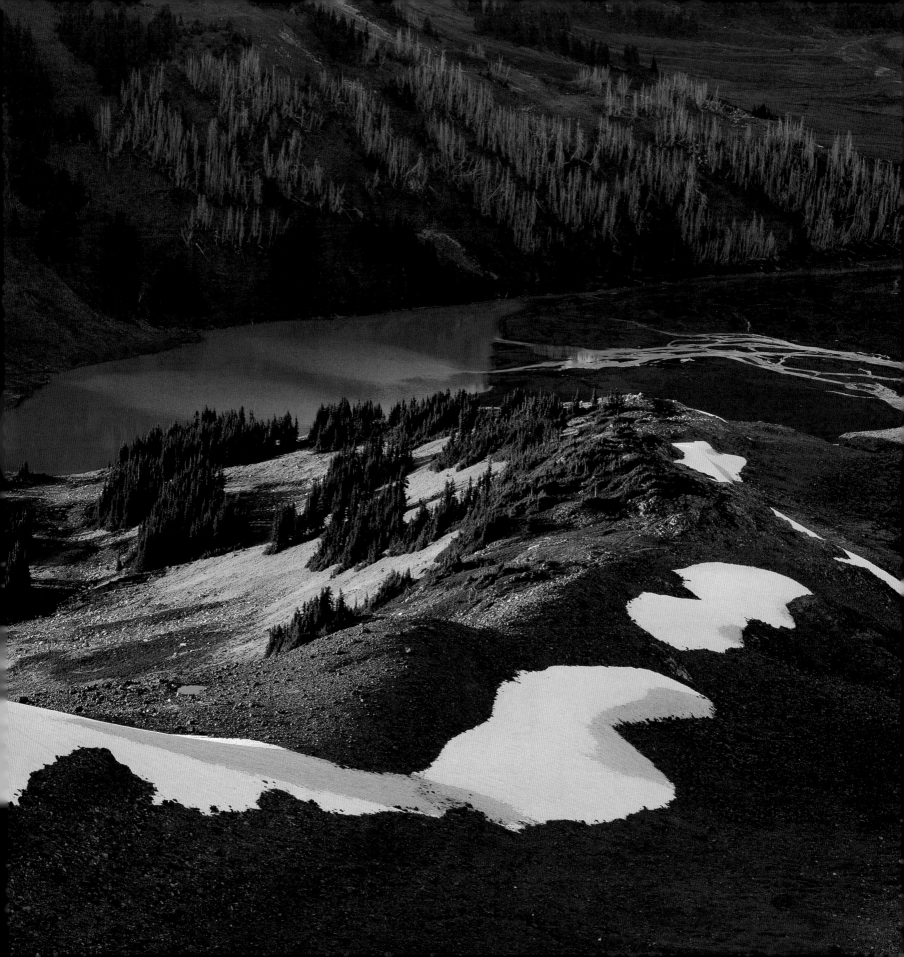

The world in our hands

These pictures must illustrate, symbolically or graphically, our dependence on and relationship with the natural world or our capability for damaging it.

 WINNER

Alessandro Bee
Italy

BEHIND BARS
While visiting a zoo near Turin in Italy, Alessandro caught the gaze of this old leopard. Only a few months before, Alessandro had been in the Serengeti watching leopards being leopards in the wild. The contrast couldn't have been greater. He was amazed how its eyes expressed so much emotion – anxiety, confusion, even fear. But worst of all was the leopard's defeated posture.

Nikon D70 with Sigma 400mm f5.6 lens; 1/250 sec at f5.6; 200 ISO.

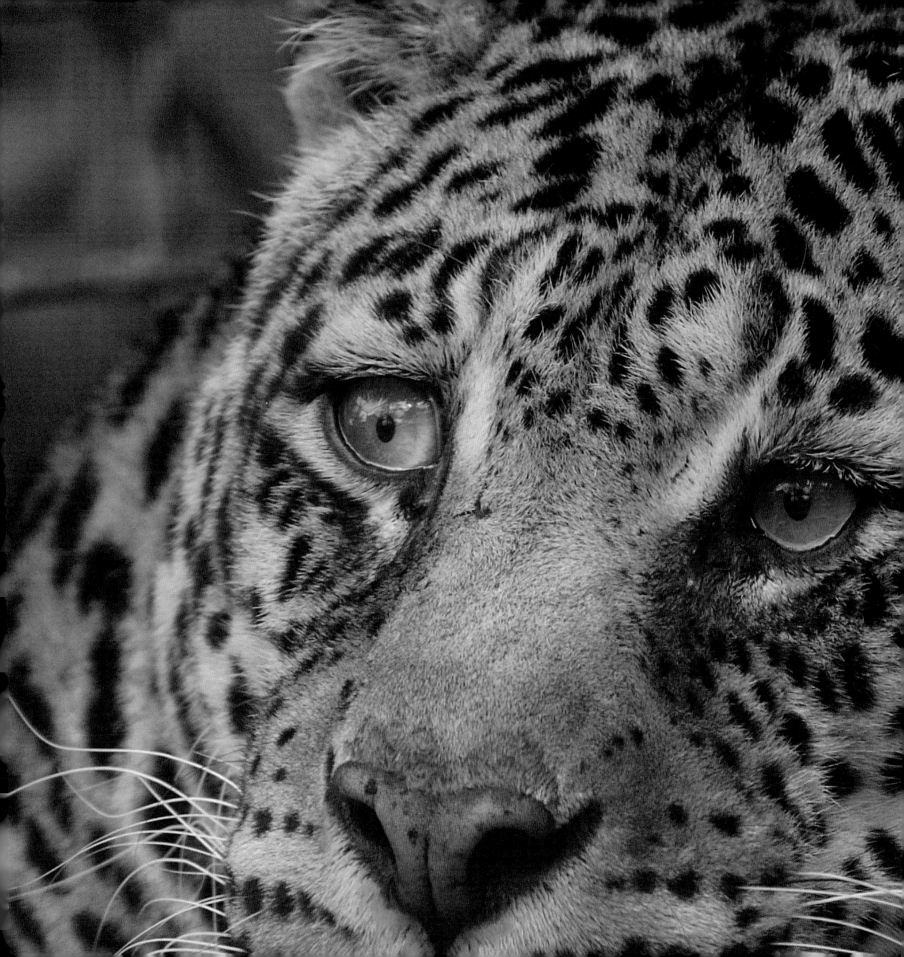

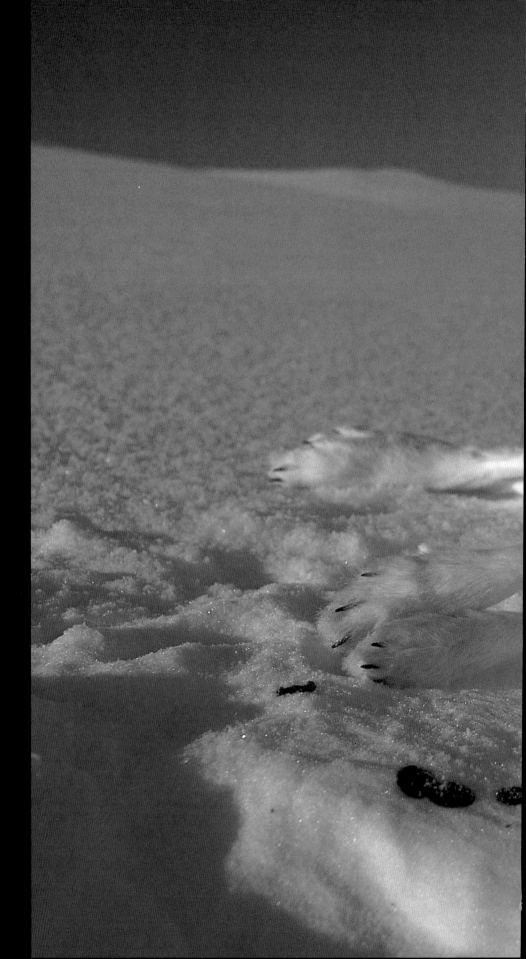

 RUNNER-UP

Erlend Haarberg
Norway

MOUNTAIN SHOT
Taken in Knutshø, central
Norway, in late February, this
image is unsettlingly beautiful –
the mountain hare's winter coat
and the pristine snow,
highlighted by the bright winter
sun and in contrast with the
blood. It was this stark contrast
(symbolic as well as actual) that
attracted the photographer to
the scene. The hunter with his
shotgun on the horizon was
pleased with his deed – hunting
hares above the tree line is not
usually this successful.

**Nikon F3 with Nikkor 28mm f2.8
lens; 1/250 sec at f11; Fujichrome
Velvia 50; polarising filter.**

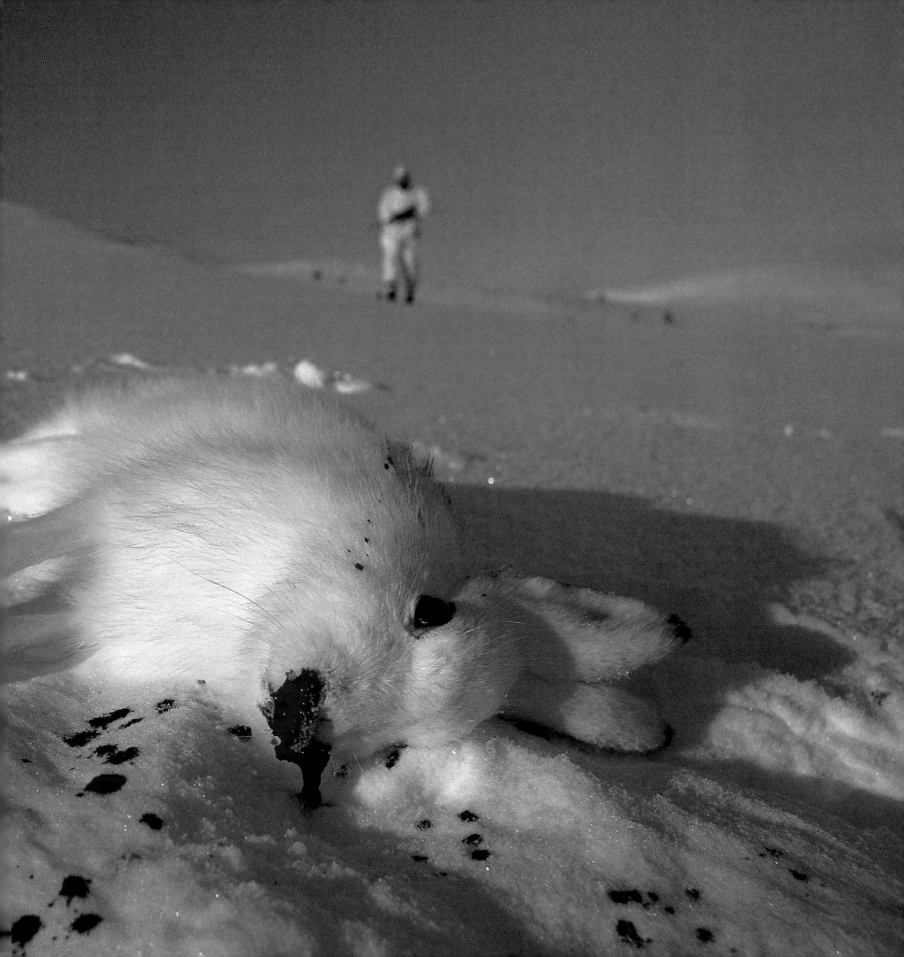

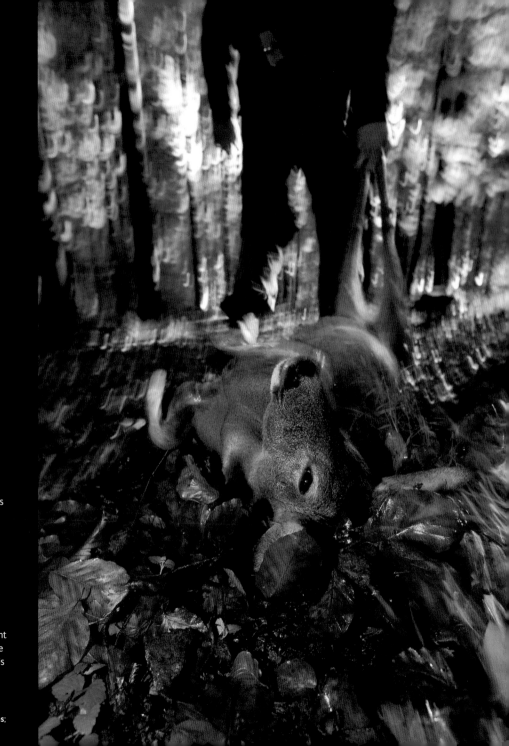

Klaus Echle
Germany

DEATH OF A DEER

Klaus Echle works as a forest ranger in Germany's Black Forest, where limited hunting is allowed. After getting a call from a hunter (here dragging the roe deer away to his vehicle), he was checking the kill when a hiker passed by. "He looked at the dead deer in pity," says Klaus, "but later, the same hiker will probably sit on a stump and eat his packed lunch without a second thought about the origin of the sausage in his sandwich. Killing for fun is barbaric. If you kill a deer, it should be for food, and you should eat it."

Canon EOS 3 with 20mm f2.8 lens; 1/16 sec at f11; Fujichrome
ensia II; flash

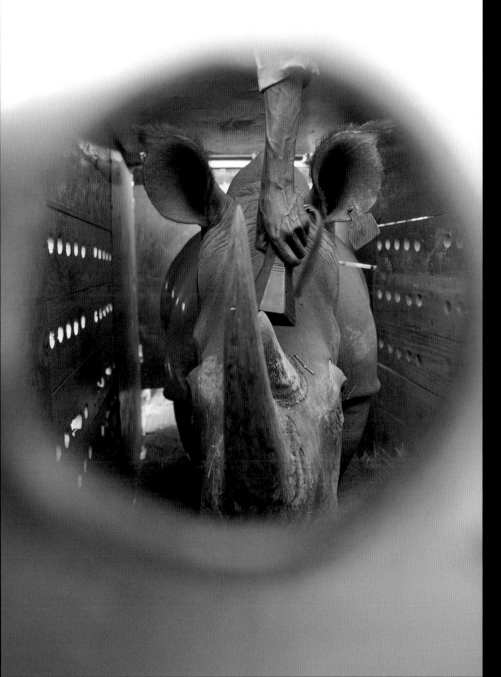

HIGHLY COMMENDED

Matthias Graben
Germany

WHITE RHINO – SOLD

Once a year, the world's biggest auction of African wildlife takes place in KwaZulu-Natal, South Africa – animals destined for wildlife parks and zoos. In 2003, when Matthias covered the event for a feature story, a white rhino was sold alongside more common species such as antelopes, zebras and giraffes. White rhinos were brought close to extinction because of poaching for their horn. Here, an official checks a microchip that has been implanted into the rhino's front horn to enable it to be identified should it be sold or killed. A tranquilliser dart sticks in its neck – preparation for transport to its new owner.

Nikon F90x with 24mm lens; 1/125 sec at f5.6; Fujichrome Sensia 100.

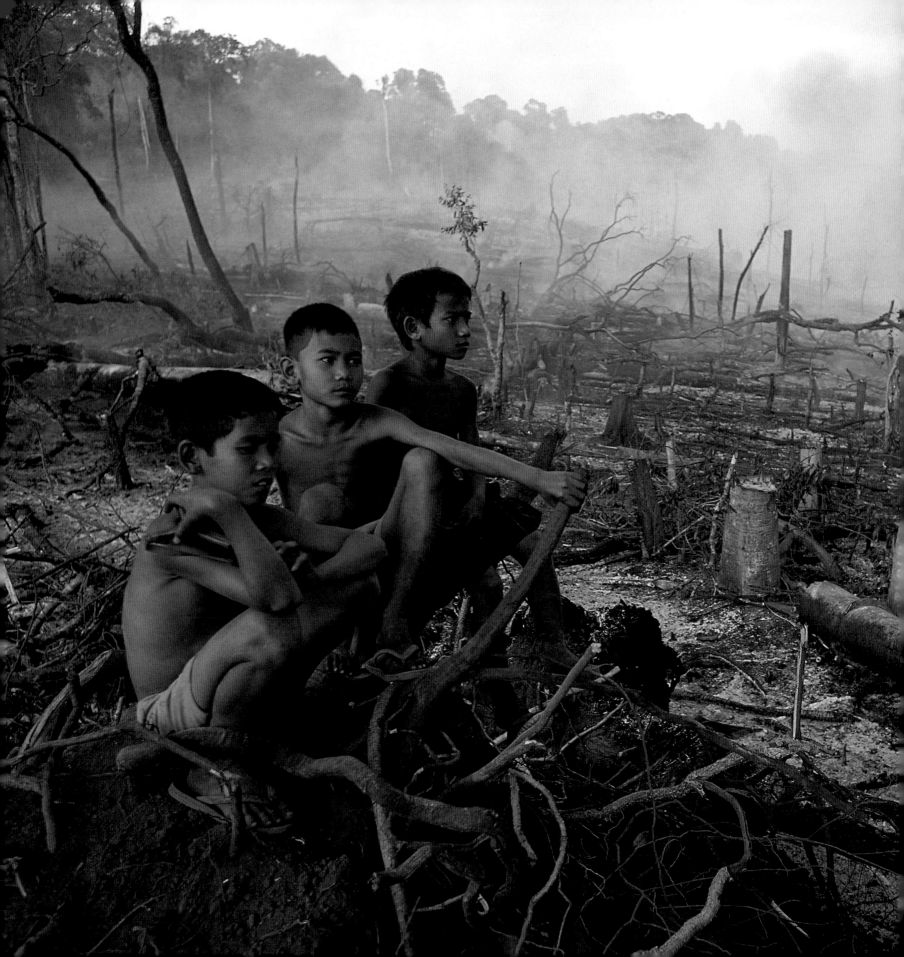

HIGHLY COMMENDED
Vincent Munier
France

FOREST IN THE BANK, CAMBODIA

In early 2005, Vincent went on a photographic assignment to northern Cambodia – his first trip to a rainforest in South-east Asia. What he found, though, was smouldering stumps as far as the eye could see. The plan is to replant the area with rubber trees for harvesting, but such plantations invariably end up as ecological deserts. The obvious consequences include the disappearance of many species of animals and plants and, for the local people, a poorer environment, which will ultimately affect their lives.

Nikon F5 with 17-35mm AFS lens; 1/60 sec at f11; Fujichrome Velvia 50.

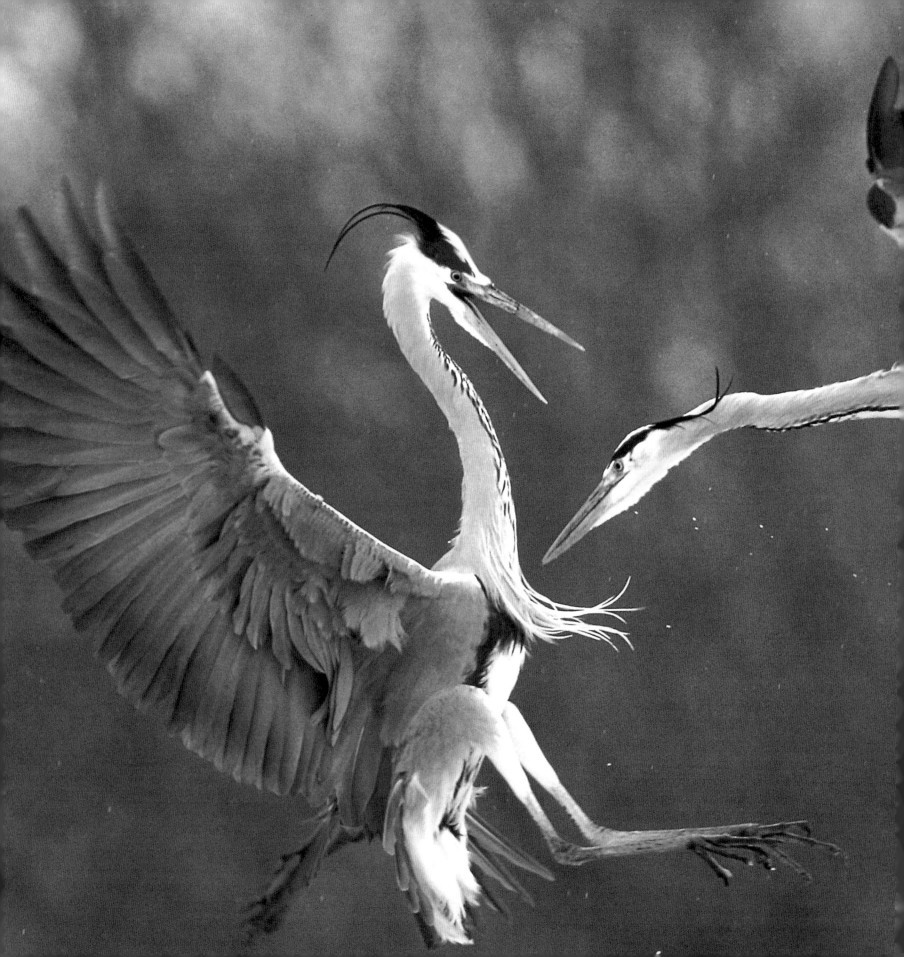

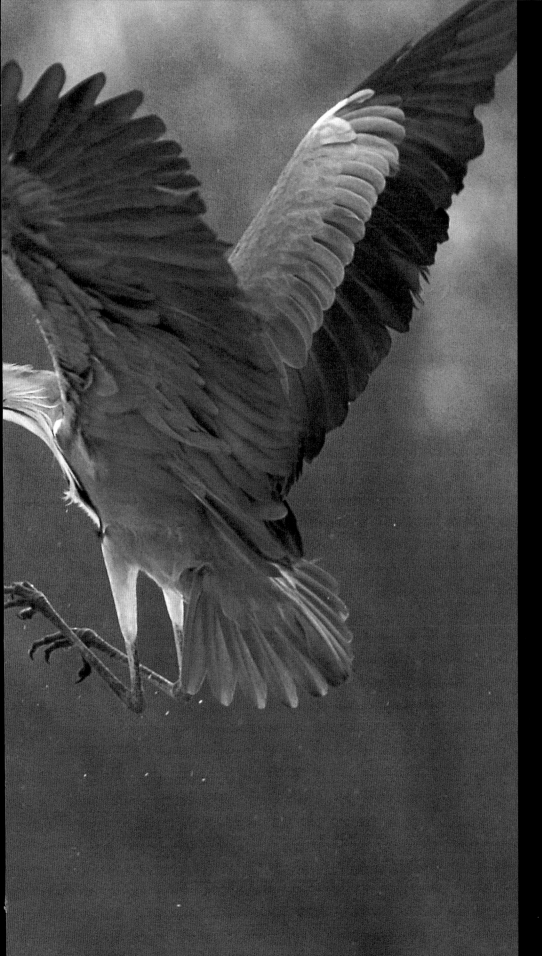

Eric Hosking Award

Bence Máté

This category, named after the famous British wildlife photographer Eric Hosking, aims to encourage and promote young photographers aged from 18 to 26. An entry comprises a portfolio of six pictures that demonstrates a range of ability.

In 2002, just four years after he began taking wildlife photographs, Bence won the Young Wildlife Photographer of the Year Award. He has gone on to win commendations and prizes every year since. At 20, he is a trained forester and is now leading nature photography trips in Hungary, while also building up a portfolio of his own work. He is passionate about nature and intends to earn his living as a wildlife photographer.

GREY HERON FIGHT

This is one of Bence's favourite pictures, not least because of the discomfort he endured to get it. In 2005, a harsh winter took Hungary by surprise. The lake near Bence's home in Pusztaszer rapidly froze over. Within a day or two, only a small patch of open water remained, and the hundred or so hungry grey herons and great white egrets began to steal fish from each other. Determined to photograph one of these desperate battles, Bence spent every day for more than a month huddled inside a sleeping bag in his hide in temperatures of -20°C (-4°F). While he finally got his prize, his subjects lost theirs. "As these two old herons quarrelled in the air, the fish fell to the ice and was snatched away by another hungry heron."

Canon EOS 1N RS with Nikon 300mm f2.8 lens, EOS-Nikon converter and Nikon TC-14B 1.4x teleconverter; 1/750 sec at f4; Fujichrome Velvia 50 rated at 100; Gitzo tripod, hide.

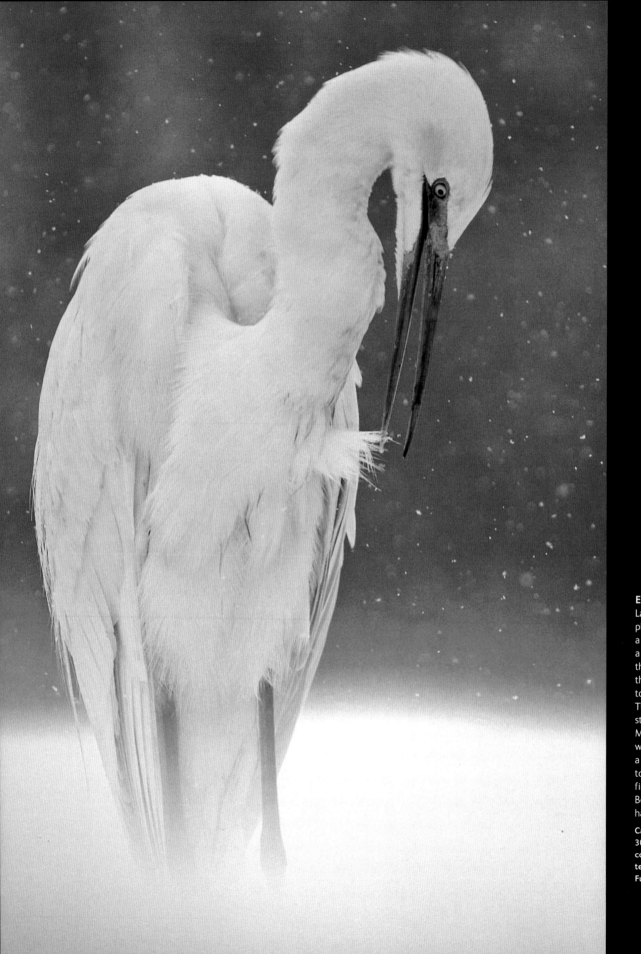

EGRET IN THE SNOW
Last winter, when Bence
photographed more than
a hundred egrets and herons at
a small lake in Hungary, he says
that "conditions were so terrible
that every day natural selection
took place before my eyes.
The weakest birds died, the
stronger ones survived." By
March, 30 per cent of the birds
were dead. This picture of
a great white egret was taken
towards the end of winter in the
final snowfall of the year, and
Bence feels sure the bird would
have survived to breed.

**Canon EOS 1N RS with Nikon
300mm f2.8 lens; EOS-Nikon
converter, Nikon TC-301 2x
teleconverter; 1/750 sec at f5.6;
Fujichrome Velvia 50; hide.**

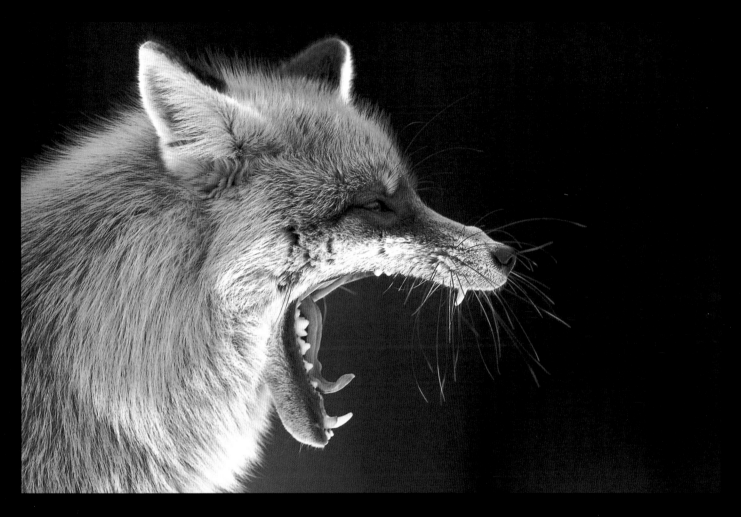

YAWNING FOX

In 2005, an unprecedented amount of snow fell in the Transylvanian mountains. When Bence heard that tourists were feeding a hungry fox from one of the mountain huts, he set off to photograph it, even though this meant walking a long way laden with heavy equipment and five days' supplies. The result was a series of memorable portraits (see p76), all taken in just one session.

Canon EOS 1N RS with Nikon 300mm f2.8 lens, EOS Nikon converter andNikon TC-301 2x teleconverter; 1/250sec at f5.6; Fujichrome Velvia 50; Gitzo tripod.

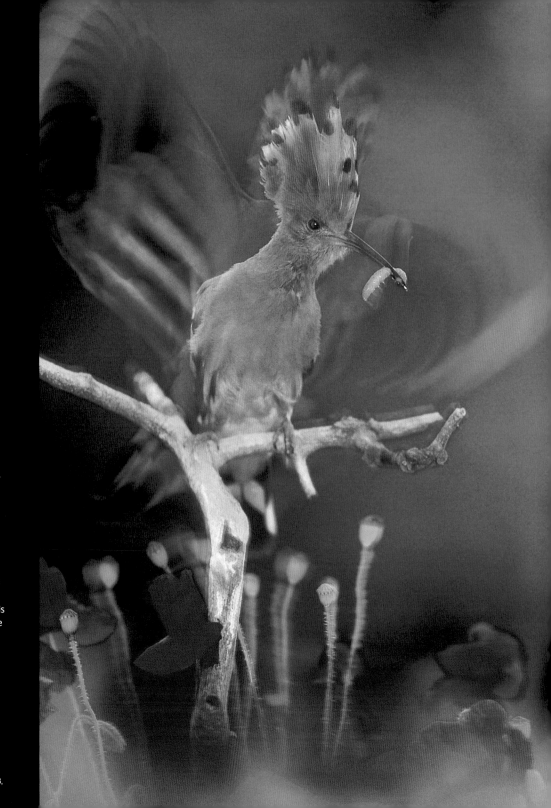

HOOPOE PROVIDER

A keen birdwatcher, Bence wanders for hours in the countryside near his home in Pusztaszer looking for photographic opportunities. On this occasion, he had discovered a male hoopoe feeding grubs to a female nesting in a hollow. Hoopoes used to be common around farms in southern Hungary, but in the past 20 years, they have become a rare sight. He took this shot at sunset, using flash in the fading light. "I pressed the button just before the male opened his wings to fly to the nest," he says. "The flash went off but the exposure was long enough to also show his wings moving in natural light."

Canon EOS 1N RS with Nikon 300mm f2.8 lens, EOS-Nikon converter, Nikon TC-301 and 2x teleconverter; 0.6 sec at f5.6; Fujichrome Velvia 50; Nikon SB28, SB25 and Canon 550EX flashes, Gitzo tripod, hide.

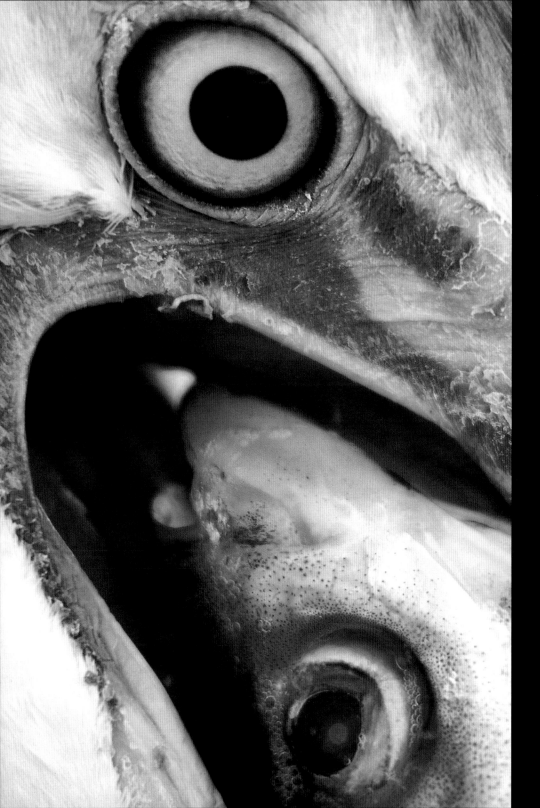

GREY HERON MOUTHFUL

The grey heron had to act fast. It had finally managed to jostle its way through the hungry throng to the small ice hole on the frozen lake. And it had landed itself a precious catch. But the fish was too big to gulp down in one go, and the other half-starved herons instantly crowded round and tried to steal the fish right out of its beak. The heron, however, outwitted them all. It bent its head down and pressed the fish, half-swallowed, onto the ice, just 3 metres (10 feet) from Bence's hide. Then it waited, eyeball to eyeball with its catch. The other herons couldn't prise the fish out from that ice-lock. Five minutes later, they had all turned their attention elsewhere.

Canon EOS 1N RS with Canon 300mm f2.8 IS lens; 1/1250 sec at f8; Fujichrome Velvia 50; tripod

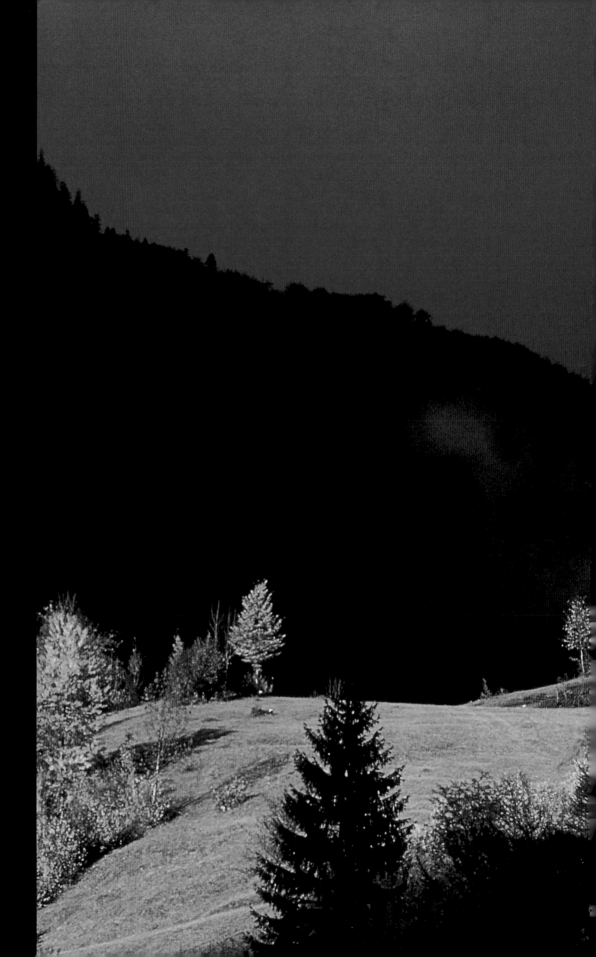

**TRANSYLVANIA
IN AUTUMN**
After five days of rain over the
Bihari Hills in Romania, the dark
clouds parted slightly, and
the late-afternoon sun lit up
the autumn trees. "I had no
more than a few minutes to take
photographs, but I took more
shots then than during the rest
of the trip," says Bence.
"The dark clouds contrasted
sharply with the sunlit
hillside, emphasising the
colour-saturated forest."

**Nikon 8008s with Nikon 105mm
2.8 lens; 1/125 sec at f4;
Fujichrome Velvia 50.**

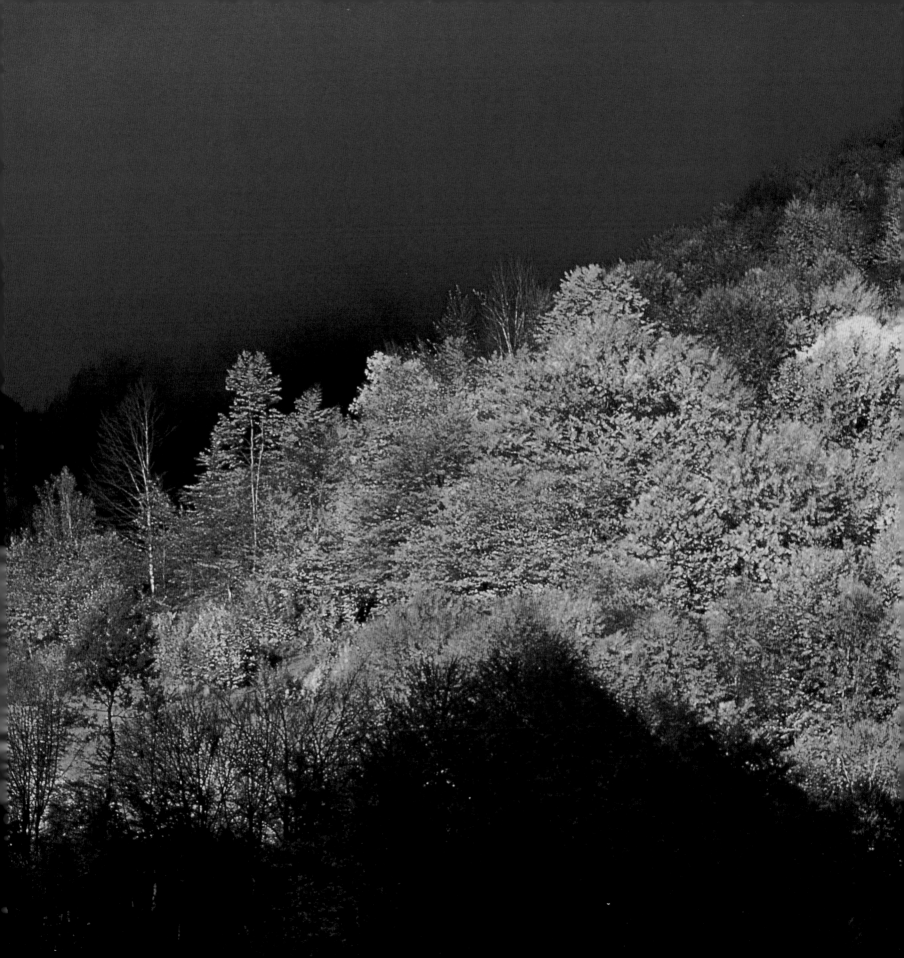

Young Wildlife Photographer of the Year
Jesse Ritonen

This award is given to the photographer whose single image is judged to be the most striking and memorable of all the pictures entered by young photographers (17 or under).

 WINNER

Jesse Ritonen
Finland

INQUISITIVE JAY
Last January, on his tenth birthday, Jesse received what he had been wanting since he was seven – an SLR digital camera. In February, his father took him for a couple of days to a hide in Utti, Finland, to photograph birds. Jesse has been interested in wildlife since he could first walk, and so this was a very special trip for him. The weather was overcast, but several jays, crows and two goshawks visited them. This jay came in the early morning and perched on the snowy branch of a pine tree opposite, staring directly into Jesse's camera. "I was so excited," says Jesse, "to have such long eye-contact with a wild bird."

Nikon D70 with Nikon 70-200mm f2.8 ED VR lens and 2x teleconverter; 1/320 sec at f5.6; tripod, hide.

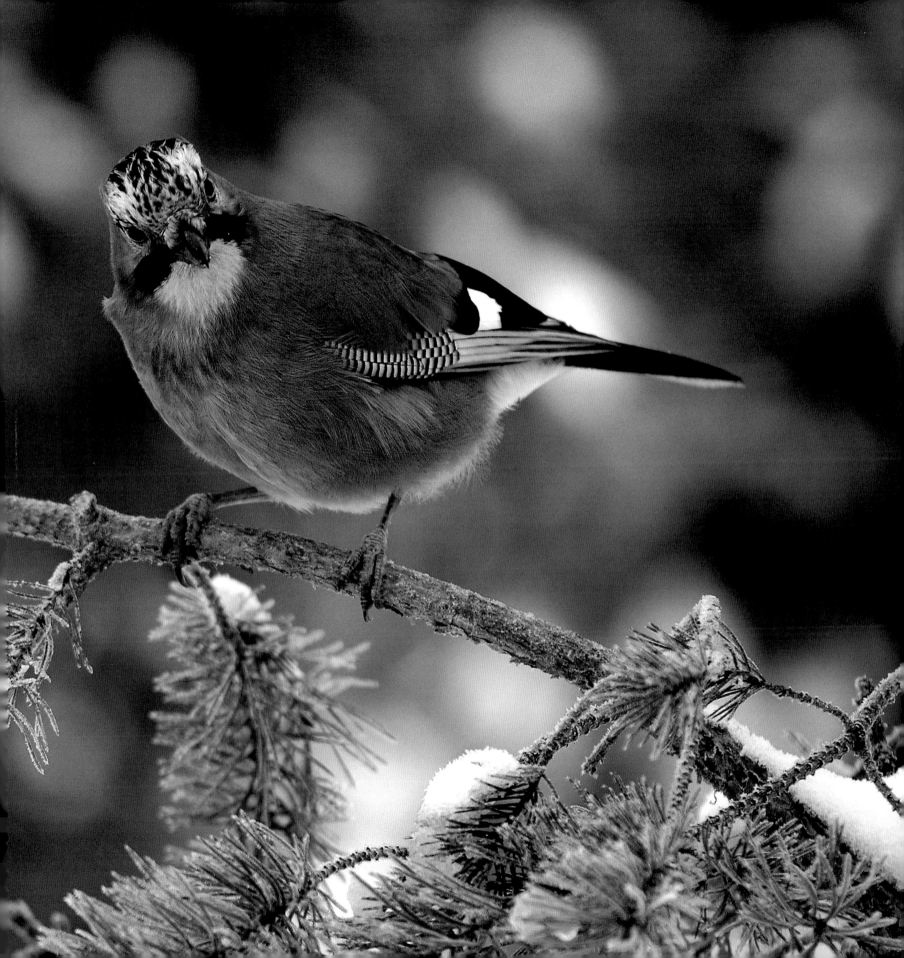

15-17 years

 WINNER

Matthew Burrard-Lucas
UK

CHIMPANZEE MEDITATION
On the fourth and final day of
a family holiday in Tanzania,
Matthew followed a troop of
about 40 chimpanzees in the
Mahale Mountains. He watched
them eat termites using grass
stalks as tools and witnessed
numerous noisy disputes. But
the poor light, together with the
chimps' black coats confused
the camera's autoexposure, and it
was frustratingly difficult to
get fast enough shutter speeds.
"To take the photograph,"
explains Matthew, "I edged closer
on my stomach, trying to ignore
the angry safari ants that were
crawling all over me." This image
of the alpha male looking
thoughtfully into space was more
than Matthew had hoped for.

**Canon EOS 300D with 55-200mm
Sigma lens; 1/200 sec at f5; 800 ISO.**

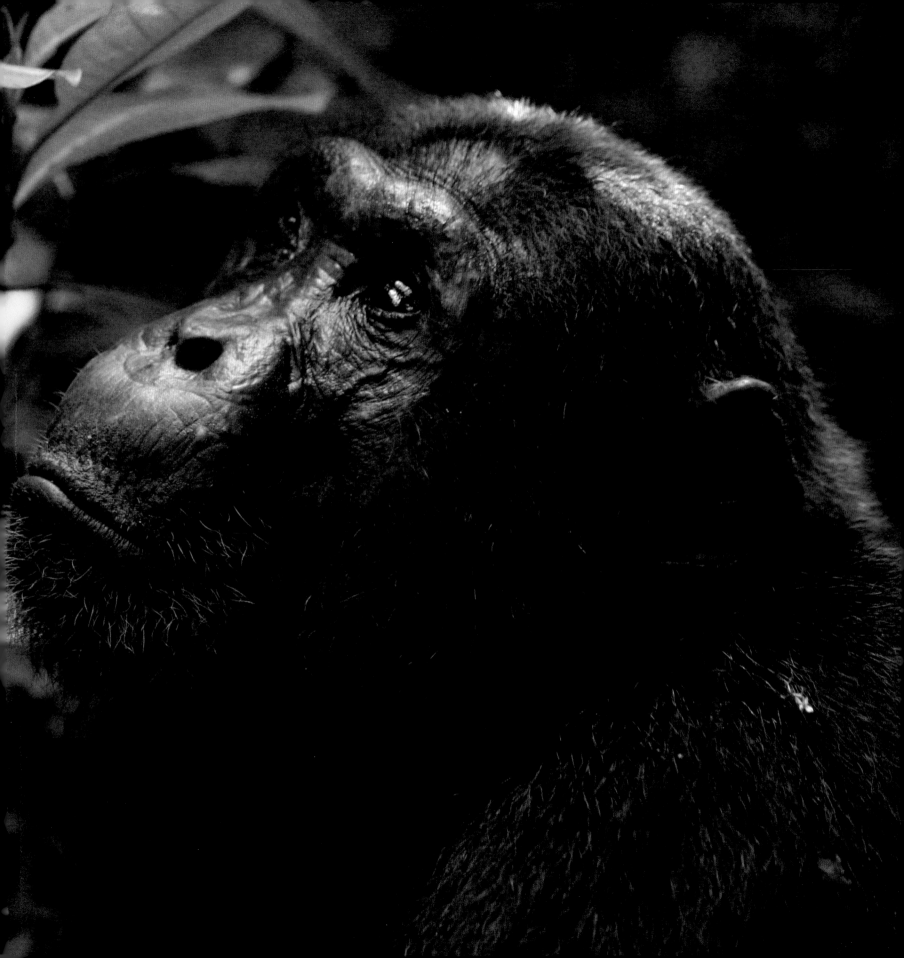

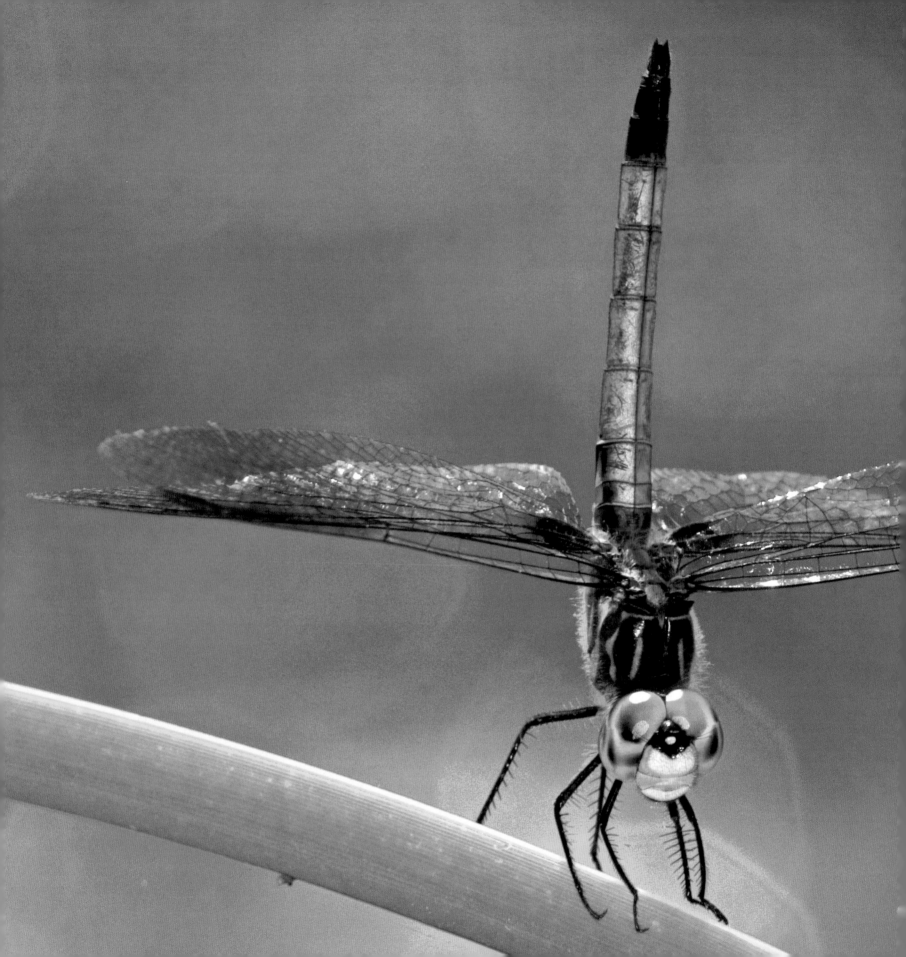

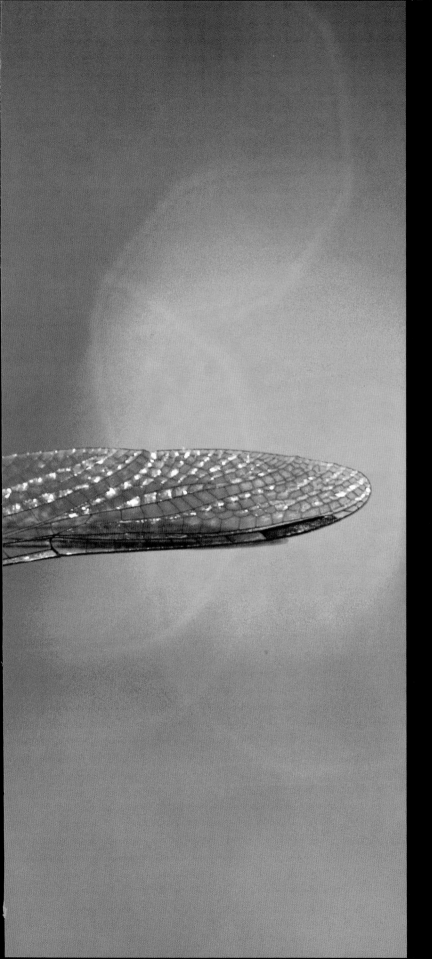

 RUNNER-UP

Nicholas M Murphy
USA

BLUE DASHER

With its long grasses, cattails
and muddy shallows, the Little
Bee Creek that runs through
Nick's family ranch in central
Texas attracts masses of
dragonflies. Blue dashers are
particularly abundant. On a hot,
sunny day, Nick found this male
sitting on its hunting, look-out
perch and 'obelisking' – pointing
its abdomen straight up to
minimise exposure to the sun.
Attracted by its pose, he used
perfect lighting, framing and
focus to set off its dashing
colours and huge, green eyes
against the water.

Canon EOS 10D with Canon EF
70-200mm f2.8 USM lens
and Canon EF 2x Extender II;
1/180 sec at f16; 200 ISO; Canon
550EX flash.

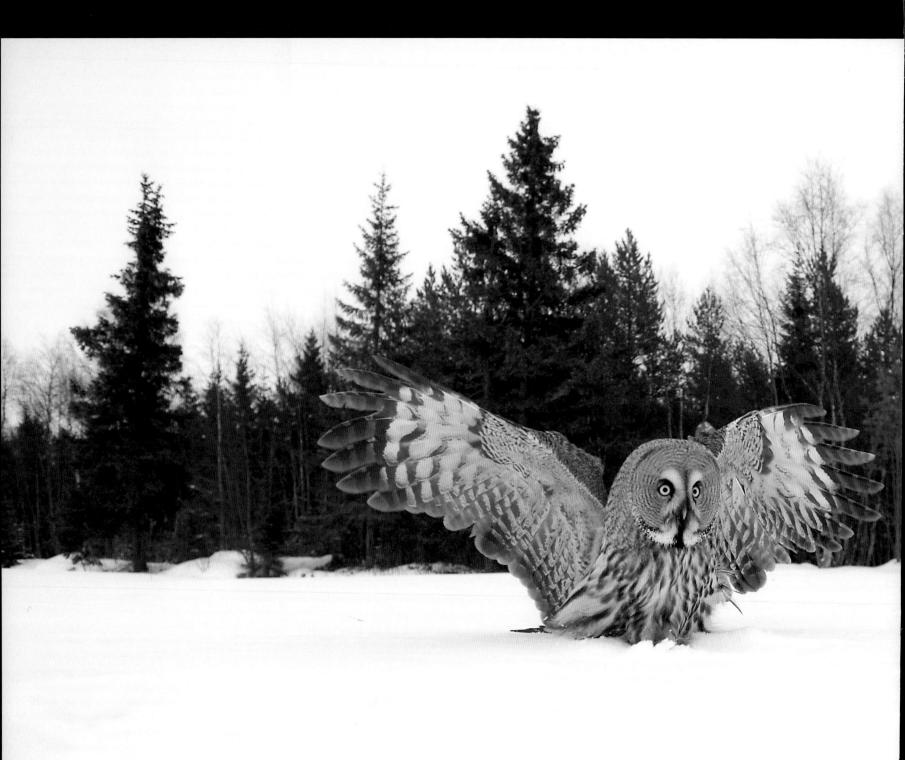

 SPECIALLY
COMMENDED

Mateusz Kowalski
Poland

OWL LANDING
A big white sheet, a toy mouse
and a piece of string – that was
the tool kit Mateusz used to get
his picture. The previous day, he
and a friend had spent hours
searching for great grey owls in
Oulu, Finland. They knew where
the owls hunted, but it wasn't
until the boys were on their way
home that they finally spotted
one perched on a tree near
a snow-covered field. That
evening, the boys hatched
a plan. "We went back to the
field next morning and lay
under the sheet, ready with our
cameras and wide-angle lenses,"
Mateusz explains. "The toy
mouse was outside. We tugged
the string to make the mouse
twitch a few times, and the owl
soon flew down to investigate.
But it wasn't fooled and took off
again almost immediately. Still,
it gave me enough time to get
some interesting shots."

**Canon EOS 1D mark II with Canon
16-35mm f2.8 lens; 1/1600 sec at
f2.8; 400 ISO**

Mateusz Kowalski
Poland

WHITE-WINGED TERN PARENT AND CHICK

The year 2004 was a bumper one for white-winged terns – rare long-distance migrants – that nested in large numbers on the Biebrzanski National Park in north-eastern Poland. Mateusz noticed several chicks sitting in the middle of a small track in the marshes, squawking for food. Occasionally, an adult would oblige and swoop down to pop a grub into an open beak. But some of the chicks lost patience with the slow service. "They hopped up onto the posts along the side of the road, from where they could demand food from their parents more effectively," says Mateusz. He watched for a while to work out a composition and then returned the next day in camouflage gear. "But to get the shot I wanted wasn't easy, and I took loads of pictures before I got two birds in the right position."

Canon EOS 1D mark II with Canon 300mm f2.8 lens and 2x teleconverter; 1/1250 sec at f5.6; 200 ISO.

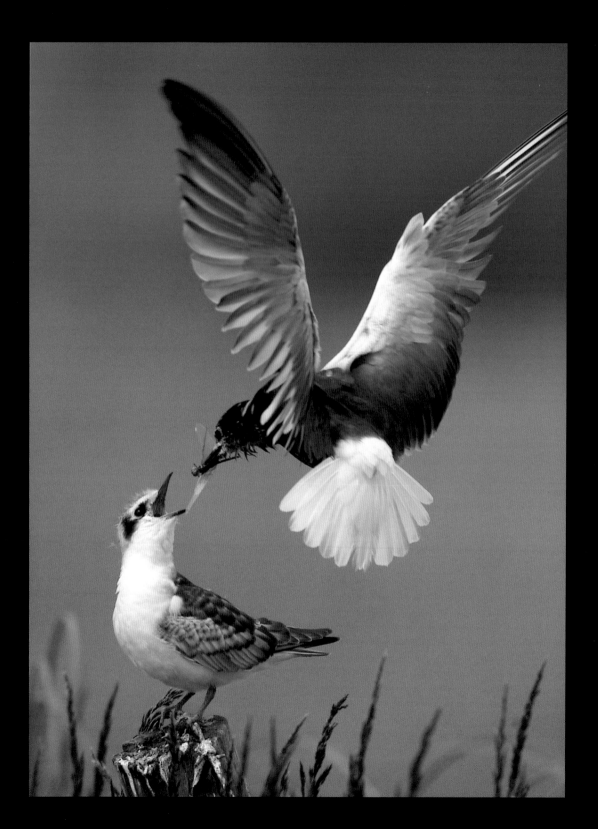

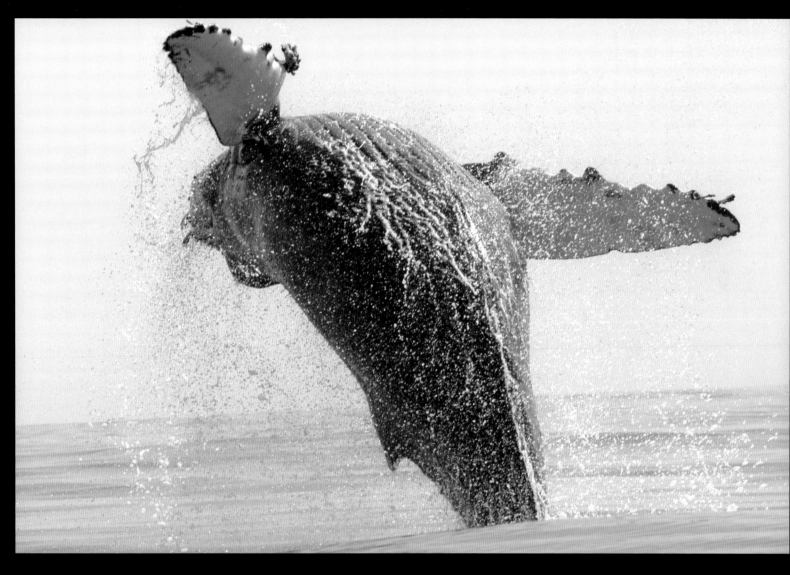

11-14 years

Alexei Calambokidis
USA

HUMPBACK BACKFLIP
Images of breaching humpbacks are not uncommon, but this individual is performing an impressive blackflip – surprisingly gymnastic for an animal that can weigh up to 30 tonnes. Alexei was on his first week-long journey at sea on board an old North Sea trawler off the Queen Charlotte Islands, British Columbia, helping his marine-biologist father. After three days of being seasick, he ventured out in an inflatable boat early one morning when the sea was calm. "Whales were doing amazing things everywhere I looked," he said, "and this humpback breached time after time." Breaching may be a form of signalling to other humpbacks, a way to dislodge parasites or simply a whale's way of having fun.

Nikon D100 with Nikkor 200mm f2.8 lens; 1/1600 sec at f10.

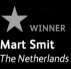 **WINNER**

Mart Smit
The Netherlands

RED SQUIRREL POSE
You'd be hard pressed to take a portrait of a tame animal as perfectly as this, let alone a lively wild one holding not just any piece of wood but a gnarled, silver stump. The squirrel was one of four that played right in front of Mart's hide in a Norwegian forest. It suddenly stopped its antics and posed for him in the early evening light.

Canon EOS 10D with Canon 100-400mm lens; 1/250 sec at f6.3; 400 ISO; Gitzo 1228 tripod.

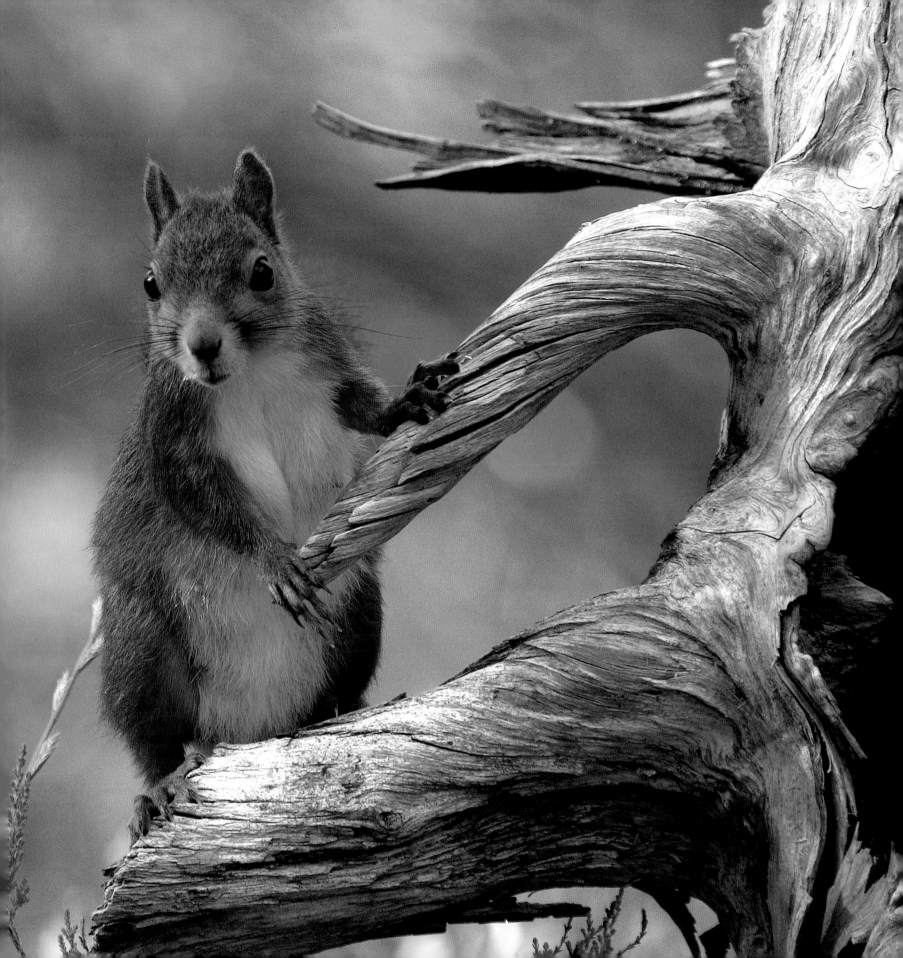

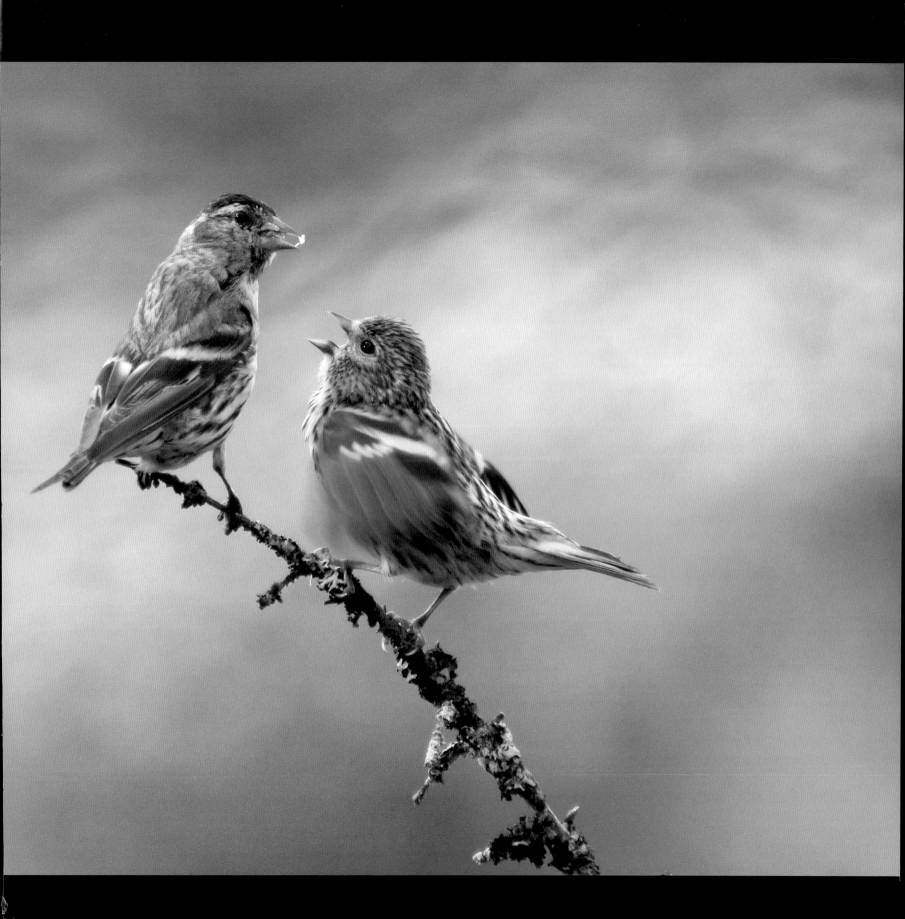

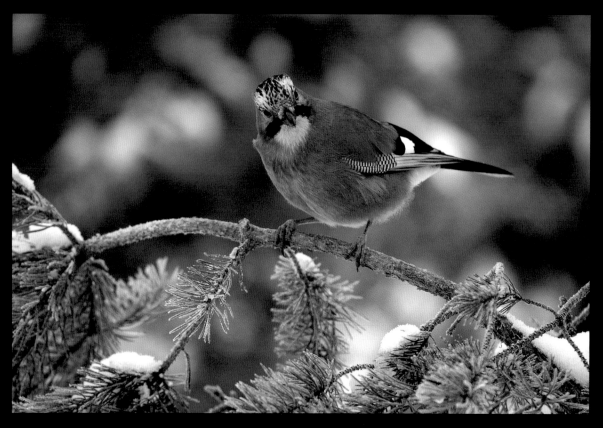

10 years and under

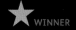 WINNER

Jesse Ritonen
Finland

INQUISITIVE JAY

(See page 138.)

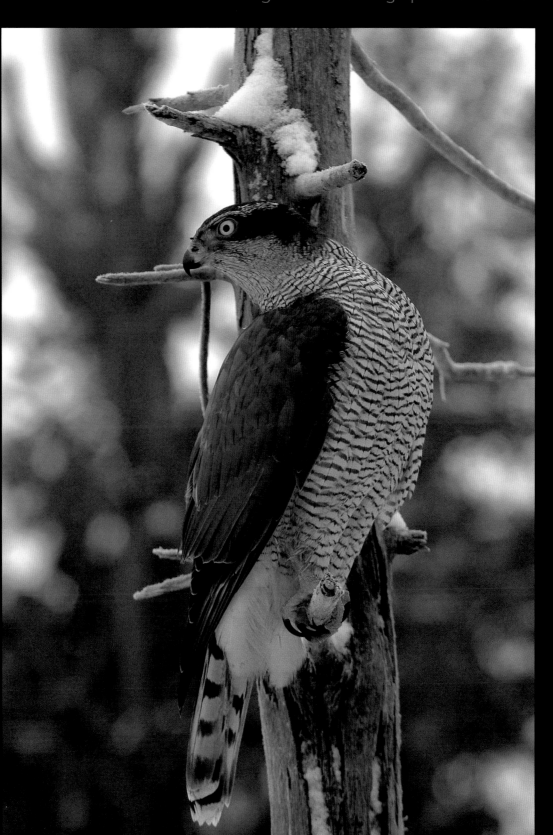

Jesse Ritonen
Finland

GOSHAWK GLARE
This picture was taken in the same hide as Jesse's winning shot (see page 138), which was about 30 kilometres (18.5 miles) from his house. On the second day of the photography trip – a special treat for him – he saw an old female goshawk fly in, chase away the other birds and perch on a tree looking very proud. "I particularly like her pose," he says, "and I couldn't get over the brightness of her orange eyes."

Nikon D70 with Nikon 70-200mm f2.8 ED VR lens, 2x teleconverter; 1/400 sec at f5.6; tripod, hide.

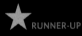 RUNNER-UP

Marco Fantoni
Italy

EYE-TO-EYE WITH AN IBEX

Marco had set his heart on getting a close-up of the magnificent headgear of a male ibex. It was summer, and Marco was on holiday with his father and brother in the Gran Paradiso National Park, home to about 3,000 ibex. When he spotted this male preoccupied with grazing, he decided to try his luck and creep as close as possible. He got to within about 3 metres (10 feet) before the ibex sensed something was up. "As I crawled behind a little hill, the ibex suddenly raised his head sharply, still holding grass in his mouth, and looked at me."

Nikon F80 with 300mm Nikkor lens; 1/125 sec at f8; Fujichrome Velvia 50.

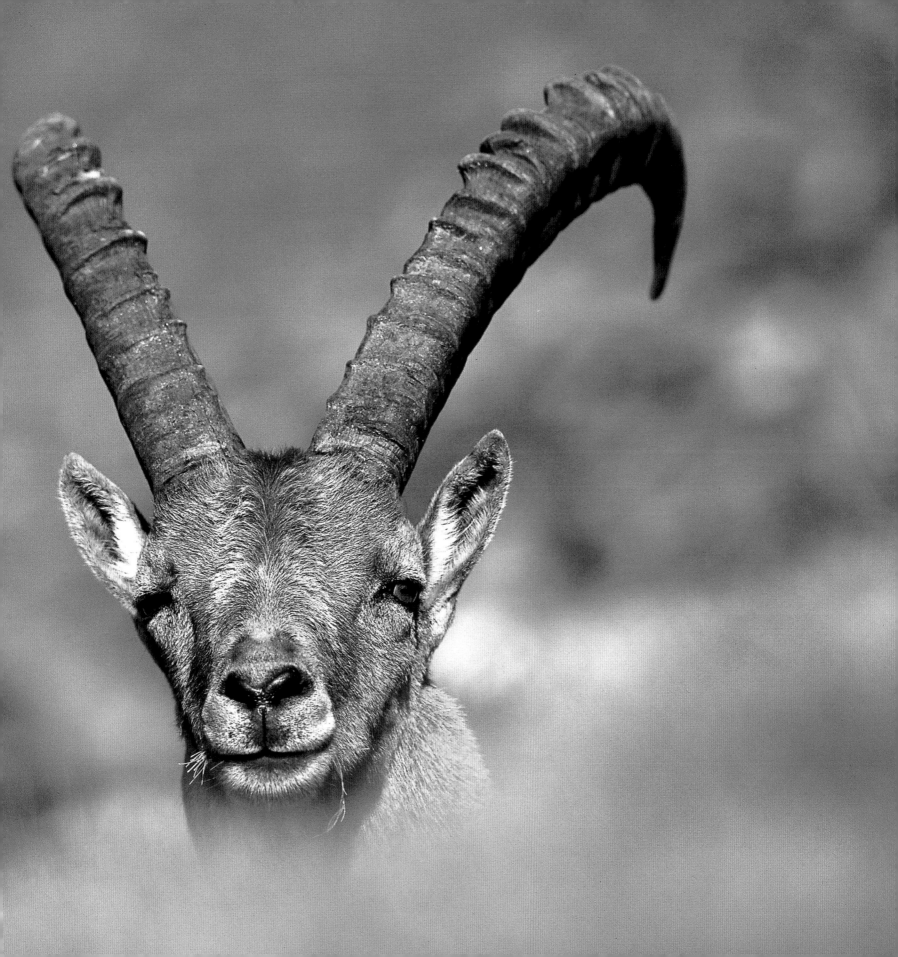

Index of photographers

The numbers before the photographers' names indicate the pages on which their work can be found.

All contact numbers are listed with UK international dialling codes. These should be replaced if dialling from other countries.

50
John Aitchison (UK)
jml.otterfilms@tesco.net
01546 870659

44
Maik Aschemann (Germany)
maik.aschemann@web.de
0049 177 4034302
www.maik-aschemann.de
info@maik-aschemann.de

100

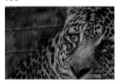

122
Alessandro Bee (Italy)
alessandrobee@hotmail.com
0039 349 4987080
www.alessandrobee.it

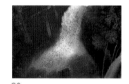

20
Sérgio Brant Rocha (Brazil)
sergiobrant@terra.com.br
0055 61 273 5442

140
Matthew Burrard-Lucas (UK)
mattbl@photogalaxy.co.uk
01732 461354

147
Alexei Calambokidis (USA)
calambokidis@cascadiaresearch.org

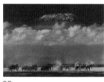

88

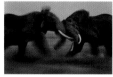

90
Martyn Colbeck (UK)
martyncolbeck@compuserve.com
0117 946 6612

AGENT: Oxford Scientific Films
enquiries@osf.uk.com
www.osf.co.uk

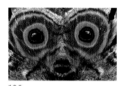

106
Carlo Delli (Italy)
bubu.yoghi@libero.it
0039 0584 762061

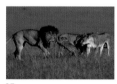

35
Michel Denis-Huot (France)
denishuot@aol.com
0033 2 35 46 29 70
www.denis-huot.com

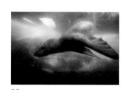

60
George Duffield (UK)
george@duffieldphotography.com
07768 815702
www.duffieldphotography.com

126
Klaus Echle (Germany)
Echle.Alpirsbach@t-online.de
0049 761 29099135

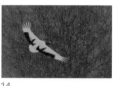

14

18
Martin Eisenhawer (Switzerland)
Martin.eisenhawer@gmx.ch
0041 31 862 1120
www.eisenhawer-naturephotography.com

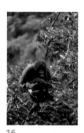

16

23

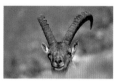

112
Thomas Endlein (Germany)
endlein@biozentrum.uni-wuerzburg.de
0049 160 95756871
www.endlein.org

42
Yossi Eshbol (Israel)
eshbol@bezeqint.net
00972 52 8410014

AGENT: Frank Lane Picture Agency
info@flpa-images.co.uk
www.flpa-images.co.uk

87
Luca Fantoni & Danilo Porta (Italy)
fantoniluca4@virgilio.it
0039 6069943
danilo.porta@libero.it
0039 6980834

154
Marco Fantoni (Italy)
fantoniluca4@virgilio.it
0039 6069943

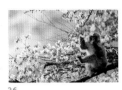

36

38

Yukihiro Fukuda (Japan)
fukuda-photo@office.email.ne.jp
0081 48 265 8167
http://www.fukudayukihiro.com

94

120

Adam Gibbs (Canada)
adam@adamgibbs.ca
001 604 520 0263
www.adamgibbs.ca

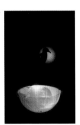

73

Lorne Gill (UK)
lorne@wolfhill.free-online.co.uk
01821 650455

127

Matthias Graben (Germany)
contact@wild-life-pictures.de
0049 231 9416666
www.wild-life-pictures.de

80

Danny Green (UK)
danny@dannygreenphotography.com
01509 551768
www.dannygreenphotography.com

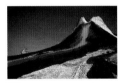

110

Olivier Grunewald (France)
bernadette.gilbertas@wanadoo.fr
0033 1 42 54 30 43

124

Erlend Haarberg (Norway)
erlehaar@frisurf.no
0047 99 263 230

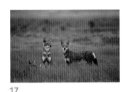

17

A L Harrington (UK)
harry@harringtonphotography.com
01295 277452
www.harringtonphotography.com

AGENTS: USA – Aurora Photos
www.auroraphotos.com
Rest of the world – Alamy
www.alamy.com

63

Malcolm Hey (UK)
mdh@malcolmhey.co.uk
01845 577864
www.malcolmhey.co.uk

104

Ross Hoddinott (UK)
info@rosshoddinott.co.uk
01288 321328
www.rosshoddinott.co.uk

AGENT: Nature Picture Library
info@naturepl.com
www.naturepl.com

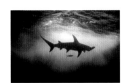

64

Charles Hood (UK)
charleshood@mac.com
07712 622440
www.charleshood.com

AGENT: Oceans-Image
info@oceans-image.com
www.oceans-image.com

144

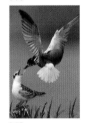

146

Mateusz Kowalski (Poland)
foto@mateuszkowalski.art.pl
0048 609 318 527
www.mateuszkowalski.art.pl

46

68

Tim Laman (USA)
tim@timlaman.com
001 781 676 2952
www.timlaman.com

AGENT: National Geographic Image
Collection ngimages@ngs.org
www.ngsimages.com

98

Torbjörn Lilja (Sweden)
t.lilja@byske.com
0046 91210882

12 & 99

66

Michel Loup (France)
loupmichel@wanadoo.fr
0033 6 85 04 9275
www.michelloup.com

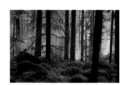

114
Henrik Lund (Finland)
henrik.lund@lundfoto.com
00358 40 5400876
www.lundfoto.com

62
Magnus Lundgren (Sweden)
magnus@aquagraphics.se
0046 40 917022
www.aquagraphics.se

AGENT: Aqua Graphics
0046 708 753610

51

76

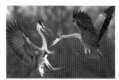

130

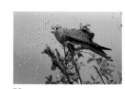

132

133

134

135

136
Bence Máté (Hungary)
bence@matebence.hu
0036 204166002
www.matebence.hu

AGENT: Sam Zalányi
foto@matebence.hu

58

81
Joe McDonald (USA)
hoothollow@acsworld.com
001 717 543 6423
www.hoothollow.com

34
Mary Ann McDonald (USA)
hoothollow@acsworld.com
001 717 543 6423
www.hoothollow.com

30
Thorsten Milse (Germany)
info@wildlifephotography.de
0049 521 2089170
www.wildlifephotography.de

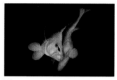

28
Kristin J Mosher (USA)
kjmosher@mac.com
00255 741 261491
001 315 699 0752

AGENTS: Danita Delimont
danita@danitadelimont.com
www.danitadelimont.com
Oxford Scientific Films
enquiries@osf.uk.com
www.osf.co.uk

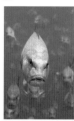

128
Vincent Munier (France)
photo@vincentmunier.com
0033 6 07 12 00 97
www.vincentmunier.com

AGENT: Nature Picture Library
info@naturepl.com
www.naturepl.com

142
Nicholas M Murphy (USA)
nick.murphy@worldnet.att.net
001 512 825 6225

56

74
Alexander Mustard (UK)
alex@amustard.com
07876 523110
www.amustard.com

32
Elliott Neep (UK)
elliott@enwp.co.uk
07788 577404
www.enwp.co.uk

92

László Novák (Hungary)
novaklaszlo@invitel.hu
0036 88 438 859

102

84
Jari Peltomäki (Finland)
jari@finnature.fi
00358 40 591 9120
www.finnature.com

AGENTS: NHPA nhpa@nhpa.co.uk
www.nhpa.co.uk
Birdphoto.fi www.birdphoto.fi

10 & 40
Manuel Presti (Italy)
manuel@wildlifephoto-presti.com
0049 173 5237668
www.wildlifephoto-presti.com

26
Todd Pusser (USA)
tpusser@carolina.net
001 910 944 2683

96
Tom Putt (Australia)
tom@tomputt.com
0061 3 9596 1310
www.tomputt.com

22
Frédéric Réglain (France)
contact@frederic-reglain.com
0033 2 41 80 08 21
www.frederic-reglain.com

138 & 152

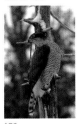

153
Jesse Ritonen (Finland)
jari.heikkinen@ppq.inet.fi
00358 400884212

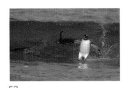

52
Andy Rouse (UK)
sales@andyrouse.co.uk
07768 586288
www.andyrouse.co.uk

AGENT: ARWP www.arwpltd.com
sales@andyrouse.co.uk

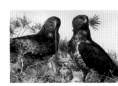

48
José B Ruiz (Spain)
jbruizl@hotmail.com
0034 96 596 1330
www.josebruiz.com

AGENT: Nature Picture Library
info@naturepl.com
www.naturepl.com

82
Thomas Sbampato (Switzerland)
thomas@sbampato.ch
0041 1 883 7140
www.sbampato.ch

78
Scott W Sharkey (USA)
swshark@aol.com
001 952 944 2715

118
Christophe Sidamon-Pesson
(France)
c.sidamon-pesson@wanadoo.fr
0033 4 92 45 44 94
www.c-sidamon-pesson.com

AGENT: BIOS bios@biosphoto.com
www. biosphoto.com

148

150
Mart Smit (The Netherlands)
mart@martsmit.nl
0031 224 541290
www.martsmit.nl

54
Ruben Smit (The Netherlands)
rubensmit@planet.nl
0031 317422657
www.outdoorvision.nl

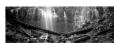

70
Julian Smith (Australia)
julian@anaustralianplace.com
0061 403 033 236
www.anaustralianplace.com

116
Jeremy Walker (UK)
jeremy@jeremywalker.co.uk
01935 872537
www.jeremywalker.co.uk

108
Staffan Widstrand (Sweden)
photo@staffanwidstrand.se
0046 70 657 33 24
www.staffanwidstrand.se

AGENTS: Corbis
info@corbis.com www.corbis.com
Nature Picture Library
info@naturepl.com www.naturepl.com
Naturbild
info@naturbild.se www.naturbild.se

24
Hans Wolkers (The Netherlands)
hans.wolkers@npolar.no
0031 252 212320

72
Jean-Pierre Zwaenepoel (Belgium)
jp.zwaenepoel@pandora.be
0032 50 40 50 24